AMERICAN FOLK ART: EXPRESSIONS OF A NEW SPIRIT

AMERICAN FO

Publication made possible by a grant from United Technologies Corporation

_K ART EXPRESSIONS OF A NEW SPIRIT

Museum of American Folk Art, New York
Dr. Robert Bishop, Curator
Susan Klein, William Secord, & Gerard C. Wertkin, Associate Curators

ACKNOWLEDGEMENTS

The Exhibition, "*American Folk Art: Expressions of a New Spirit,*" was initially suggested to the Museum by Mabel H. Brandon, a good and helpful friend, and by Gordon Bowman of United Technologies Corporation. Both the exhibition and catalogue have been made possible by United Technologies. The museum is grateful to Harry J. Gray, Chairman and Chief Executive Officer of that corporation, for providing unusually imaginative and generous support.

No project of this magnitude becomes a reality without dedicated efforts by numerous individuals. The Museum would like to thank Arthur Vitols, Helga Photo Studios; Patricia L. Coblentz, general editor; and consultants Judith A. Jedlicka and Jeff Waingrow for their help.

The insight, intelligence, and high professionalism brought to the design and production of this catalogue by Derek Birdsall make us exceedingly grateful to him.

It is also appropriate to express our gratitude to the many individuals who have donated or provided the funds for the Museum to acquire many of the objects in this exhibition. These individuals include Mrs. Eva Feld, who recently established the Eva and Morris Feld Folk Art Acquisition Fund, Mr. and Mrs. Harry Kahn, and Mr. and Mrs. Paul Martinson. Their names and the names of other generous friends who have assisted our efforts to build a representative collection of American folk art, are recorded in the captions accompanying the illustrations.

Museum staff members who have made significant contributions to the project are Cordelia Rose, registrar; Pat Locke, assistant to the registrar; and Lillian Grossman and Mary Ziegler, production assistants.

Dr. Robert Bishop
Director, Museum of American Folk Art
Curator of the Exhibition
New York, November 1982

We are delighted to be able to join with the Museum of
American Folk Art in this major exhibition and catalog;
and we are especially pleased that the show, and this book,
will be seen in several nations outside our own borders.
We hope everyone who visits the exhibit and reads this book
thoroughly enjoys "Expressions of a New Spirit."

Harry J. Gray
Chairman and Chief Executive Officer
United Technologies Corporation

AMERICAN FOLK ART

FOREWORD

American art has been extensively re-evaluated in the early 1980s. Abstract Expressionism of the 1950s and 1960s is no longer quite as fashionable. Realism and figurative painting which began to once again dominate national artistic circles in the 1970s continues to gain in popularity; and folk art, that once-neglected expression of the common man, now attracts as much attention as all other forms of American art.

Ever since the early years of the 20th century when American artists returning from study abroad became aware of an indigenous American artistic expression which they called "folk art," the world has sought an adequate definition for those words. They are used to describe an incredible array of artistic effort in a multitude of media from an extensive timespan—over 300 years. Despite the broad range and varying media used by the folk artist, there are some valid generalizations which can be made. Folk art at its best is pragmatic, utilitarian, and beautiful. Nina Fletcher Little, one of the earliest scholars in the field, sees folk art existing on many levels:

Two kinds of art have flourished side by side in nearly all nations. Very often their courses have run independently of each other. One we call fine art. Created by the great masters largely for the rich and ruling classes and the church, fine art served the Doges of Venice and the Kings of France.
In America it served the gentry of the South and the merchant princes of New England. It was sponsored by the great families of great states.

The other category includes American folk art. This is the art of the people—often anonymous or forgotten men and women. In the first group we see the glory and majesty of the ages. In the second we discover the character and interests of a people and the forces that molded their lives.

American folk art is not an unskilled imitation of fine art. This must be stressed for in it lies the personal flavor of folk art. It lives in its own world and is responsive to its own surroundings. It was produced by amateurs who worked for their own gratification and the applause of their families and neighbors, and by artisans and craftsmen of varying degrees of skill and artistic sensitivity who worked for pay.

. . . It is sometimes spoken of as "popular art," but folk art assumes the presence of an original artist whereas popular art includes products of the printing press. Currier & Ives, for example, produced popular art. The phrase "primitive art" is also used, but this has a wide range of meanings. It is applied to the often highly developed skills of prehistoric

peoples, to the work of dedicated amateurs, and to the consciously naive style of such internationally recognized artists as the Douanier Rousseau. While all American folk art was "provincial art" in the sense of being remote from the cultural centers of Europe, that phrase suggests rural as contrasted with urban origin, and in this sense is inexact. Folk art flourished in the towns as well as in the country and was not restricted by geographical limitations.[1]

The relationship between folk art and "high" American art is interesting to examine. We have been told for years by many art historians that folk art falls outside the "mainstream" of American art and that it is secondary to the great pieces produced by highly-skilled trained artists working in an academic or "school" tradition. One need only to look at the quality of the best folk art to realize that this is inaccurate. Folk art has been and continues to be the mainstream of American art. It is by and for the American people.

A backward look at appreciation for America's folk art provides perspective. The first recorded exhibition of American folk art was presented at the Whitney Studio Club in New York City in 1924. H. E. Schnakenberg, curator of the exhibition, borrowed most of the major pieces from contemporary artists such as Charles Sheeler, Charles Demuth, and Yasuo Kuniyoshi. These professionals were among the first to appreciate the aesthetics of American folk art and to collect it. Juliana Force, Director of the Whitney Studio Club and a serious folk art collector, indicated in the catalogue that she did not view folk art as a minor expression of American art, but an extension of craft traditions into the realm of fine art. A similar attitude has always been a central idea for Jean Lipman, one of America's most adventurous pioneer scholars in the field. In the preface to the catalogue for the 1974 exhibition, "The Flowering of American Folk Art (1776-1876)," she wrote:

. . . In my two books on American folk painting, I expressed the opinion, "radical though this may seem" that a number of gifted folk artists arrived at a power and originality and beauty that were not surpassed by the greatest of the academic painters. I have never changed my mind and am convinced that the entire field of activity of the folk artists was absolutely not, as has often been said, a charming postscript. I believe it was a central contribution to the mainstream of American culture in the formative years of our democracy.[2]

6

The first museum in the United States to mount a major exhibition of American folk art was The Newark Museum, Newark, New Jersey. In 1930 Holger Cahill who then was the Museum's director, assembled and installed an exhibition of folk paintings titled "American Primitives, An Exhibit of the Paintings of Nineteenth Century Folk Artists," which later circulated to the University of Chicago and the University of Rochester. He noted in the show catalogue that most of the artists represented had no doubt seen originals or reproductions of paintings from foreign schools. In its second special presentation of folk art, "American Folk Sculpture—The Work of Eighteenth and Nineteenth Century Craftsmen," held from October 1931 through January 1932, The Newark Museum showed pieces selected by Holger Cahill chiefly from the pioneer collection formed by Abby Aldrich Rockefeller.

Another early and perhaps even more influential exhibition was installed at The Museum of Modern Art in 1932. The distinguished modern art dealer, Edith Gregor Halpert, assisted Holger Cahill, director of the exhibition, in bringing together the 175 objects which composed the show. Again, most of the pieces were from Mrs. Rockefeller's collection. They included oil paintings, watercolors, paintings on velvet, paintings on glass, a special design group of cookie molds, 25 pieces of wood sculpture, and 13 plaster ornaments. Ships' figureheads, toys, small carvings, cigar store Indians, ornamental eagles and roosters, weathervanes and decoys, metal stove-plates and stove-figures, and plaster figures (now commonly referred to as chalk) accounted for the total variety of sculptural forms. Pottery, decorative ironwork, religious carvings, signs, and several other categories were ignored. Perhaps these were simply omitted through oversight, but more likely they were not considered "artistic" enough to be included in the exhibition, despite its title, "American Folk Art—The Art of the Common Man in America 1750-1900." Cahill wrote in the catalogue that American folk art is

...the unconventional side of the American tradition in the fine arts... It is a varied art, influenced from diverse sources, often frankly derivative, often fresh and original, and at its best an honest and straightforward expression of the spirit of a people. This work gives a living quality to the story of American beginnings in the arts, and is a chapter ... in the social history of this country.[3]

The Whitney Studio Club, The Newark Museum, and the Museum of Modern Art led the way, and the rest of the American museum community followed. Folk art became as popular in America in the 1930s as did concern for ecology in the early 1970s.

Several museums have developed major permanent collections of American folk art. Through the years the efforts of the Abby Aldrich Rockefeller Folk Art Center at Colonial Williamsburg, Virginia, have been trailblazing. The center has mounted numerous exhibitions and has produced several significant publications on the subject.

Americans on the eastern seaboard have long been able to view comprehensive collections of their nation's folk art at the Shelburne Museum, Shelburne, Vermont; the New York State Historical Association, Cooperstown, New York; and Old Sturbridge Village, Sturbridge, Massachusetts. A splendid collection of folk sculpture is now being assembled by the newly-founded museum called Heritage Plantation in Sandwich, Massachusetts. Greenfield Village and Henry Ford Museum at Dearborn, Michigan, also boasts impressive holdings. The Denver Art Museum, Denver, Colorado, and the Museum of International Folk Art in Santa Fe, New Mexico, are well known for their collections of Spanish Colonial religious paintings and woodcarvings. One can also find beautiful folk art in the collections at the Smithsonian Institution, Washington, D.C., as well as The Brooklyn (New York) Museum; The New-York Historical Society, New York City; The Metropolitan Museum of Art, New York City; The Philadelphia (Pennsylvania) Museum; and the Henry Francis du Pont Winterthur Museum, Winterthur, Delaware.

The Museum of American Folk Art was established on June 23, 1961, when the New York State Board of Regents granted a provisional charter to a group of founding trustees led by the collector Joseph B. Martinson. A widely acclaimed introductory exhibit at the Time-Life Building in New York City opened on October 5, 1962, and the museum was launched. Later that same year space was rented on 53rd Street in New York City.

Soon after its founding, the Museum of American Folk Art developed an overall plan to mount a substantial series of loan shows, to assemble a permanent collection, to establish a reference library, and to institute important educational programs. Since that time, nearly 100 exhibitions have been presented in its own galleries and at sister institutions throughout the United States and the world. An

energetic publishing program which includes books, catalogues, and America's Folk Art Magazine, *The Clarion*, has brought increased visibility to the Museum's endeavors.

Appreciation for American folk art is not confined to American shores. The American Museum in Britain, Bath, England, founded in 1961 by Dallas Pratt and John Judkyn, features an extensive collection of folk art of great artistic merit. The John Judkyn Memorial is also assembling a study collection on contemporary American folk art which it exhibits and circulates to museums and schools throughout Britain.

Jean Lipman views folk art as *artistic efforts confined within time boundaries.*

The signing of the Declaration of Independence in 1776 also signaled the beginning of a new independence for American art. The seeds of the native folk tradition, planted with the founding of the American colonies in the 17th century, sprouted and throve all along the eastern seaboard from the last quarter of the 18th century through the first three quarters of the 19th. Folk art was a prime product of the new American democracy, strongly representative of the spirit of the country. By the time of the Centennial this art has reached its peak; the machine age marked the start of its decline, despite some reseeding and blossoming through the late 19th and 20th centuries.[4]

Mary Black, former director of the Abby Aldrich Rockefeller Folk Art Collection and later the second director of the Museum of American Folk Art, also views folk art in a specific time frame.

The genesis, rise and disappearance of folk art is closely connected with the events of the 19th century when the dissolution of the old ways left rural folk everywhere with an unused surplus of time and energy. People were free to invent and make simple things for their own pleasure in each household and in each village, until the rise of industrial production toward the end of the 19th century. Folk art occupies the brief interval between court taste and commercial taste.[5]

Mrs. Lipman and Mrs. Black account admirably for the great explosion in all fields of folk art in 19th century America, but it must not be thought that the creation of folk art has ceased. Far from it. Handcrafted weathervanes are rarities now, of course, and whittled playthings for children have been replaced by mass-produced toys; but the basic urge to create remains as strong today as it ever was. Perhaps it is that today the artist reacts to his complex environment in ways different from those of his forebears.

Controversy about modern folk art—"primitive" works made by contemporary, self-taught artists—has raged since the distinguished curator, art historian, and dealer Sidney Janis published *They Taught Themselves: American Primitive Painters of the Twentieth Century*, in 1942. Conservative collectors felt that many of the artists described painted only for monetary advancement and that their works were not valid folk art. These critics chose to forget that the greatest outpouring of folk expression—portraiture—was nearly always created for a fee and that the 18th and 19th century itinerant folk portraitist earned his living from his art.

In part, it is the difficulty of determining what is art that terrifies the traditional folk art collector when he views 20th century material. With historical perspective on his side it is much easier to look at the 18th and 19th century works and develop a consensus about which pieces are of significance. In the 20th century one must rely upon his own instincts. At the same time he must have a broad knowledge of the art world at large to place his opinions about modern-day folk art in historical perspective. Decisions are far more difficult and few, indeed, are brave enough to speak out with conviction.

One thing is certain—the best folk art today, as always, has its roots in the craft traditions. Alice Winchester, in her introduction to the catalogue *The Flowering of American Folk Art 1776-1876* acknowledges the relationship of the crafts to the folk arts:

The artisan tradition discernible in all folk art is perhaps its chief unifying characteristic, but it is the eye of the artist directing the hand of the craftsman that gives it aesthetic validity. The works gathered together here demonstrate the heights American folk art could achieve in all its amazingly varied forms. They represent the "unconventional side of the American tradition in the fine arts," yet they are an integral part of that tradition, as they have always been an integral part of American life.[6]

The legitimacy of 20th century folk or naive art has been greatly aided by the National Endowment for the Arts, one of the three major federal agencies created to perpetuate the cultural life of America. It recently established a Folk Arts Division that provides funds for research, film, and exhibitions often featuring the work of living artists. This agency, however, has been dominated by folklorists and folk culturists who, in their zeal for the folk, occasionally ignore the art part of the term. So few cultural and social artifacts are art that it becomes imperative to separate the cultural

artifact from the folk art object.

Today many of the best naive painters could be classified as memory painters. Artists like Mattie Lou O'Kelly from Georgia, Tella Kitchen from Ohio, and Kathy Jakobsen and Malcah Zeldis (both from Michigan originally), paint vibrant, action-filled scenes of a fast-disappearing life.

There are those naive contemporaries who fit no mold nor category. "Transmitters: The Isolated Artist in America," a major exhibition assembled by Elsa S. Weiner at the Philadelphia College of Art in 1981, featured the work of painters and sculptors with individual vision too strong and too important to be ignored. The general public was indifferent, skeptical, and even outraged. Only those with a thorough understanding of modern art comprehended the aim and the surpassing importance of this presentation.

Another controversy has emerged as scholarship has increased. Are carousel figures, circus carvings, and "factory" weathervanes really folk art? Often they were carved by more than one person or mass-produced in limited numbers in craft shops or studios. Museums tend to sidestep this issue. Few curators would refuse to display a factory weathervane in an exhibition of folk art even though these vanes were produced by hammering thin sheets of copper into a metal mold which resulted in a large number of nearly identical pieces.

With the great rise of interest in folk art, modern artists have begun to search the field for sources of inspiration for their own work. Reginald Case, a highly imaginative artist working in collage; Edward Larson, an inventive sculptor/constructionist who also paints and designs richly textured quilts; and Roger Brown, the modern painter, produce works of art that are inspired by the folk arts of earlier periods. These neo-naive or radical naive artists continue to expand the dimensions of the field. Neil Jenney, a contemporary artist whose paintings are not in the least naive has led many contemporary artists to the folk art field through his "Dumb Art" movement. His pieces in the "artless" tradition enable many to intellectually bridge the folk arts and modern art. The modern-day folk artist, however, is still ignored by the conservative collectors who continue to prefer the yellowed patinas only age can produce.

What is the future for American folk art? Every indication is that it will continue to increase in popularity. As museums acquire major works, what remains in the private sector becomes rare and more difficult to acquire.

Collecting taste will also continue to affect the folk art field. At first antiques collectors acquired folk art as decorative accessories for serious American furniture collections. Later modern art collectors discovered the field and began to make acquisitions on a frequent basis. Today the most important folk art is collected by art collectors who are aggressively preserving their own rich cultural heritage.

The Museum of American Folk Art is the only institution of its kind in New York City. Guided by a deeply interested and thoughtful board of trustees it will continue its role as collector, preserver, and exhibitor of the best of American folk art while it develops its plans for a new museum facility. It is also prepared to assume the leadership role for the field in the area of education. Already its classes for schoolchildren and adults are much respected, and its graduate program leading to a Master's Degree in Arts with a concentration in Folk Art Studies, presented in conjunction with New York University, is one of the finest in the world. In addition, by publishing *The Clarion*, America's Folk Art Magazine, it has become the central clearing house for the entire field of American folk art scholarship.

[1] Abby Aldrich Rockefeller Folk Art Collection, p. xiii.

[2] Lipman, Jean and Winchester, Alice. *The Flowering of American Folk Art 1776-1876*. New York: The Viking Press in cooperation with the Whitney Museum of American Art, 1974, p. 7.

[3] Lipman, Jean and Winchester, Alice. *The Flowering of American Folk Art 1776-1876*. New York: The Viking Press in cooperation with the Whitney Museum of American Art, 1974, p. 13.

[4] Lipman, Jean and Winchester, Alice. *The Flowering of American Folk Art 1776-1876*. New York: The Viking Press in cooperation with the Whitney Museum of American Art, 1974, p. 6.

[5] Bishop, Robert. *American Folk Sculpture*. New York: E. P. Dutton & Co., Inc. 1974, p. 12.

[6] Lipman, Jean and Winchester, Alice. *The Flowering of American Folk Art 1776-1876*. New York: The Viking Press in cooperation with the Whitney Museum of American Art, 1974, p. 14.

FOLK PAINTING **& decorated furniture**

The folk arts were first acknowledged in the 1920s by modern artists returning from Europe after World War I. The academic community and the art historians focused their attention upon pieces created by members of transplanted European cultures who perpetuated social and artistic patterns of the Old World in isolated American settlements.

Portraiture was the most significant artistic expression in the small colonial towns which dotted the East Coast in the 17th century. Two distinct schools of portraiture emerged in the declining years of that century. One style, totally English, was Medieval in nature. Artists generally focused upon that which they considered important in a portrait: the features of the face and the head of the subject. The backgrounds were simplified and stylized. This in part explains some portraits which appear to be poorly drawn even though the sitters exude a remarkable self-satisfaction.

A second attitude toward portraiture was introduced toward the beginning of the 18th century by new waves of immigrant English painters who had become familiar with concepts of painting established during the Renaissance and introduced into England by Italian and Dutch artists traveling and fulfilling commissions there in the late 1600s and early 1700s. Artists working in this mode attempted to recreate accurately realistic spatial relationships within their compositions. The folk painters of the 17th century in both New England and the South were nearly always English, and their technical abilities satisfied a clientele which because of its geographic isolation was perhaps somewhat less demanding than its European counterpart.

In the 18th and 19th centuries many folk painters who were for the most part self-taught developed a competence which earned for them national and international reputations. Benjamin West, John Singleton Copley and other well-known artists began their careers as naive artists whose techniques developed from personal experimentation. In time formal training in varying degrees enabled them to cast aside folkish ways. Thousands upon thousands of folk painters lacked the luxury of training afforded men like West and Copley, and because of economic, cultural, and social considerations failed to attain the impressive stature of these masters. Still they created art—great art which only today are we beginning to fully appreciate. Though much of their work lacks technical competence, it does demonstrate a power of observation, a brilliant sense of design, and a wide range of imaginative vision. The folk art record of America was brushed with penetrating insight. In the 19th century the folk artist caught the many faces of an optimistic, self-confident expanding country.

Although a simple, modest life was lived by most country people, that is not to say that country folk lacked pretensions. Within the folk idiom there were countless manifestations of a quest for the elegant and beautiful, and having one's portrait taken was near the top of the list. In the 19th century there were countless portrait artists who earned their living by traveling from town to town and recording the likenesses of all who could afford their artistry. William Matthew Prior, Erastus Salisbury Field, Sturtevant J. Hamblen, J. A. Davis, and Ruth W. and Samuel A. Shute are but a few of the better known.

Prior began his career in Bath, Maine; later moved to Portland, Maine; and finally settled at 36 Trenton Street in Boston, Massachusetts, where he established his now famous "Painting Garret." Prior adapted his technique to the potential sitter's financial means: a flat likeness "without shade" could be had for about one dollar. For more affluent subjects, he would provide a surprisingly realistic portrait at a price as high as 25 dollars. Prior also practiced the art of reverse painting on glass. His likenesses of favorite American Founding Fathers were exhibited at the Boston Athenaeum, where they were most enthusiastically received.

Many folk landscapes and seascapes were decorative and were executed on purely utilitarian objects such as fireboards, overmantles, and paneled doors. These functional objects were produced in all of colonial America, but were especially popular with the Dutch and the English settlers. The Dutch brought with them a love of genre painting which flourished wherever they settled. Folk landscapes began to appear in small numbers during the last decades of the 17th century in the English colonies. Prints served as a primary design source for the struggling self-taught "landskip" painter. *The Graphice, or The Most Ancient and Excellent Art of Limning*, written by Henry Peachem and published in London in 1612, and *The Artist's Assistant in Drawing, Perspective, Etching, Engraving, Mezzotinto Scraping, Painting on Glass, in Crayons, in Water Colours, and on Silks and Satins, the Art of Japanning*, etc., originally produced by Carrington Bowles, an English publisher and print seller about 1750, provided a visual encyclopedia for the beginning artist who lacked access to formal training.

Though there are many different categories of folk painting, historians and collectors have a special appreciation of the art created by the immigrant who, with paintbrush in hand, celebrated the freedoms both personal and political of his adopted homeland. His song of America was a hymn which resulted in idealized portraits of political heroes such as George Washington and personifications of the ideas of the Goddess of Liberty, Hope, and Virtue. This was the same artist who painted numerous battle scenes depicting the Revolution and the War of 1812, and carved ships' figureheads in the form of Columbia. He was the celebrant of the American experience and its spirit.

Religion has always been a major inspiration for the folk artist. From the first outpost settlements of the Spanish adventurers established in the second half of the 16th century came a rich outpouring of artistic efforts designed to serve and propagate the Catholic Church. Three-dimensional sculptural pieces and wooden panels and animal hides decorated with painted representations of holy figures were used both in the home and in the church. These were initially created by the Franciscans, who taught the native Indian converts to execute religious works depicting Christ and the most important patron saints. Portraiture and landscapes were rarely attempted in Spanish Colonial America.

In the Hudson Valley, Dutch settlers between New York City in the south and Albany in the north produced a body of religious art of vast significance as well. Numerous Dutch immigrants adorned their walls with religious paintings based on illustrations in Bibles brought from Holland. Many of these crude, vital pictures appear to have been executed by the portrait painters of the day.

During the opening years of the 19th century, culture-hungry Americans of financial means took great pride in their success and sent their daughters to academies and finishing schools where the polite arts of music, dancing, writing and painting were major parts of the curriculum. At precisely the same moment in history, the French and English romantic movements reached the American shores. Idealized pictures; moody, moonlit landscapes; and romantic story paintings emanated from these schools in astonishing numbers. Delicate watercolors with incredible detail, romantic landscapes filled with castles, and grisaille and brightly-colored theorems are all part of this manifestation. A renewed interest in "religious" concerns flourished as well and led to the execution of untold numbers of watercolor and needlework pictures depicting Hope, Virtue, and romanticized Biblical scenes.

No discussion of folk painting in America would be complete without an acknowledgment of the contributions made by the furniture decorator. Folk furniture inevitably reflected European tastes of earlier periods. A furniture style would first emerge at an English or Continental court and almost immediately be adapted by those associated with the ruling classes. Finally it would filter down to the lesser nobles and ultimately to the lower classes. Immigrants to America brought with them these styles which first enjoyed popularity in colonial cities where they were incorporated into the designs of the leading cabinetmakers. Once established in America's cosmopolitan centers, they were adopted and adapted by rural craftsmen who with great imagination created unique forms. Folk furniture was almost always painted and very frequently decorated as well.

Though many would deny it, much of the folk painting of the 20th century has been inspired by the same motivations as those of earlier periods. Portraiture has continued to flourish and naive artists still thrill the viewer with their attempts to record the world which surrounds them. The creation of utilitarian, functional objects which could be embellished and made more beautiful with decoration, have certainly been primary concerns of the modern day folk artist. Immigrants and descendants of immigrants are still utilizing transplanted exotic designs and motifs to infuse America's artistic heritage with a unique blend of the old and the new.

1
**Portrait of a Gentleman
 Seated Between Two Tables**
Jane A. Davis (active 1827-55)
New England; c. 1840
Watercolor, bodycolor and pencil on wove paper,
 $7\frac{7}{8} \times 7\frac{7}{8}''$ (20 × 20 cm)
*Eva and Morris Feld Folk Art Acquisition Fund.
 1981.12.14*

J. A. Davis was one of a large number of watercolor
artists working in New England in the second
quarter of the 19th century. This is one of her most
complex and beautiful compositions.

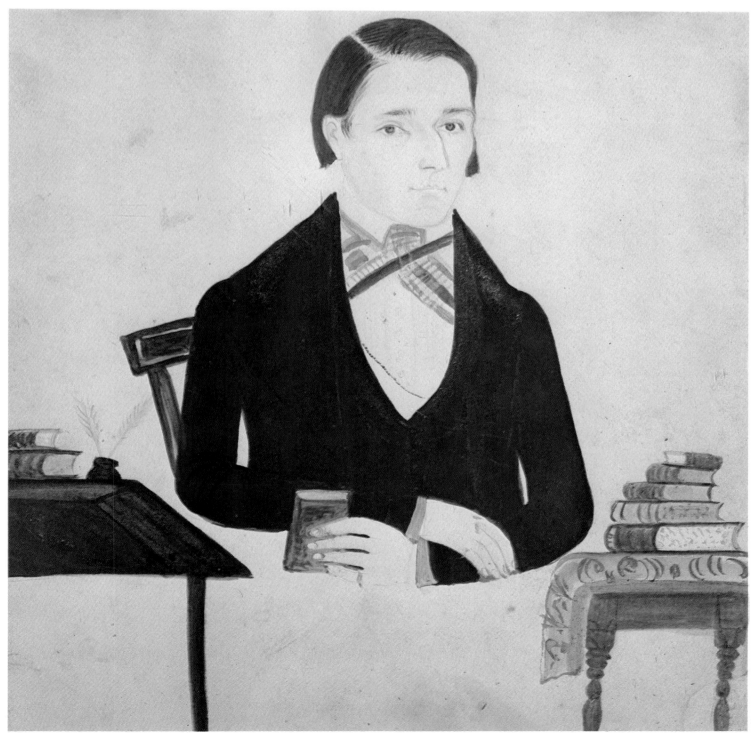

2
Portrait of Eliza Gordon
 (Mrs. Zophar Willard Brooks)
Ruth Whittier Shute (1803- ?) and
 Dr. Samuel A. Shute (1803-36)
Peterboro, New Hampshire; 1832-33
Watercolor and bodycolor over pencil on wove paper,
 gilt paper, 25 × 19½″
 (63.4 × 49.5 cm)
Museum of American Folk Art purchase. 1981.12.24

Ruth and Samuel Shute painted separately but their
best works are the beautiful watercolors which
they created together as husband and wife.
The Shutes' portrait of Eliza Gordon, with its
colorful diagonal streaking, bold abstraction and
sensitive pencil delineation of the features,
represents the couple's watercolor style at its
most mature. An inscription on the back reads:
 Eliza (Gordon) Brooks
 Born in Henniker
 Oct. 25th 1813
 N.H.
 Taken when she worked in the Phinny (?) mill
 Peterboro, N.H.

3
Portrait of a Woman in a Mulberry Dress
Isaac Sheffield
New England; 1835
Oil on canvas, 33⅛ × 27″ (84.1 × 68.5 cm)
Gift of Ann R. Coste. 1970.1.1

The subject is set against a red curtain pulled aside
to reveal the outdoors. The pelerine, an embroidered
lace-like, double-tiered cape, creates a decorative
design against the abstract form of the body.

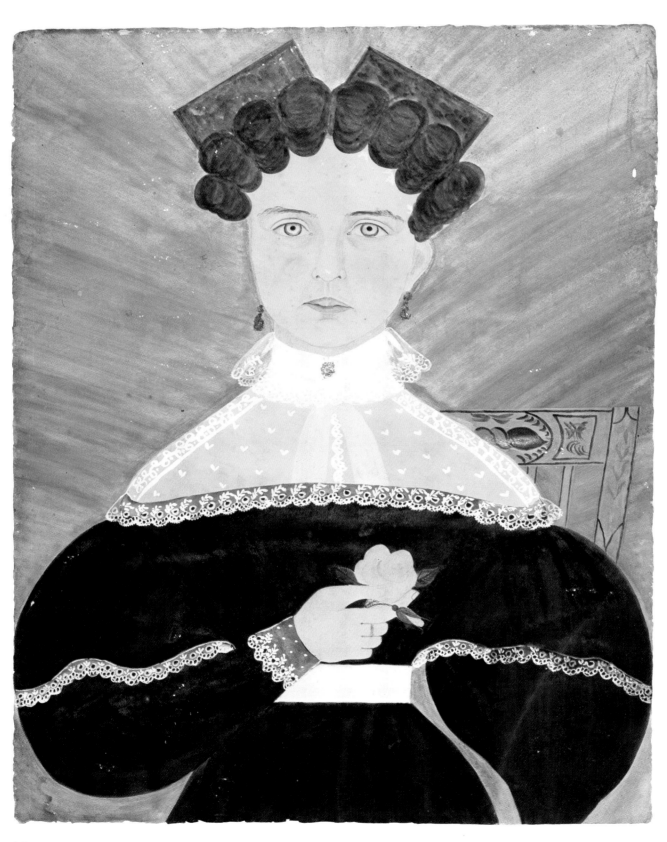

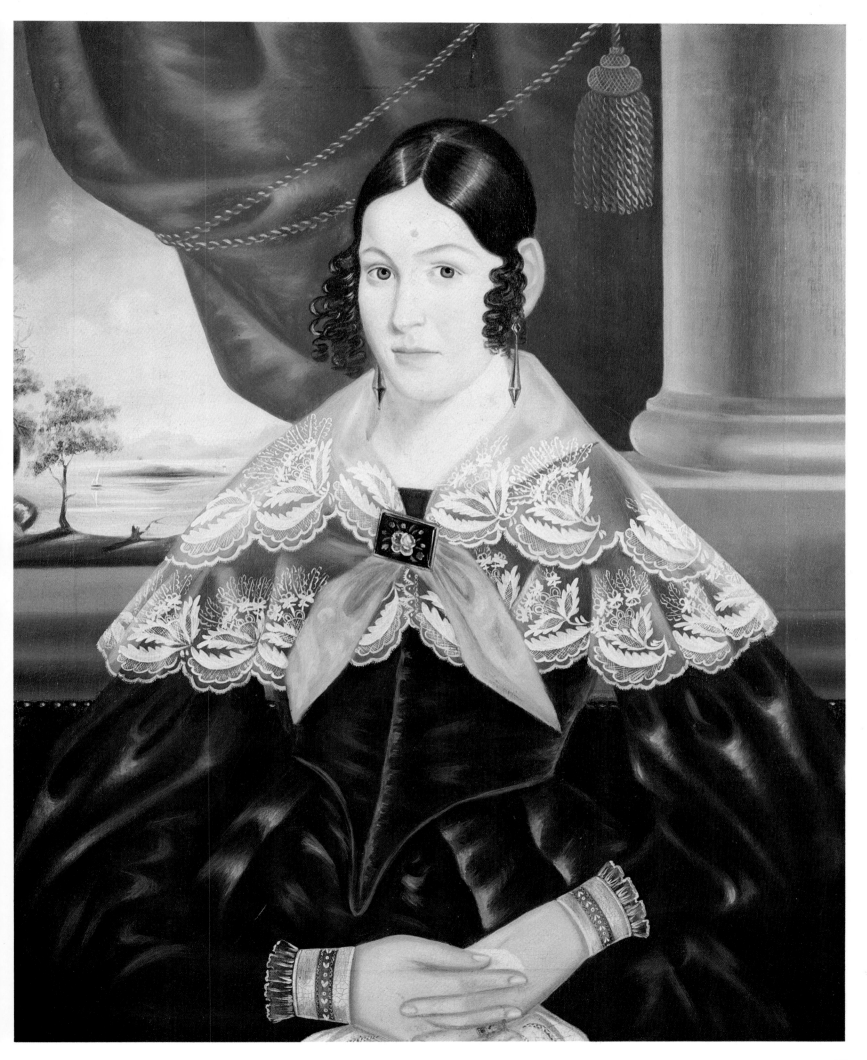

4
Unidentified Child
William Matthew Prior (1806-73)
 Boston, Massachusetts; 1830-55
Oil on canvas, $26\frac{3}{4} \times 21\frac{3}{4}''$ (67.9 × 55.2 cm)
Promised gift of Robert Bishop. P78.101.1

This painting is a monumental version of Prior's
inexpensive "without shade" portraits. Although
this self-taught artist earned his living from
portraiture, he preferred to paint landscapes and
reverse paintings on glass which he considered
"fine" art. Prior eventually developed a technical
proficiency which led him to execute a large number
of well-conceived landscapes and fully developed
portraits not unlike the work of Gilbert Stuart
(1755-1828), an artist he much admired.

5
Portrait of Child with Basket
 (an unidentified member of the
 Webber family)
Artist unknown
Mt. Vernon, Maine; c.1835
Oil on wood panel, $34 \times 18\frac{1}{4}''$ (86.3 × 46.3 cm)
Gift of Mrs. Jacob M. Kaplan. 1977.13.1

As an art form the folk portrait reached a high
degree of development in America during the late
18th century and flourished until the mid-19th
century although folk artists often lacked the
painterly techniques associated with European
art schools. In this charming portrait the typical
characteristic of a flat spatial arrangement results
in a static pose.

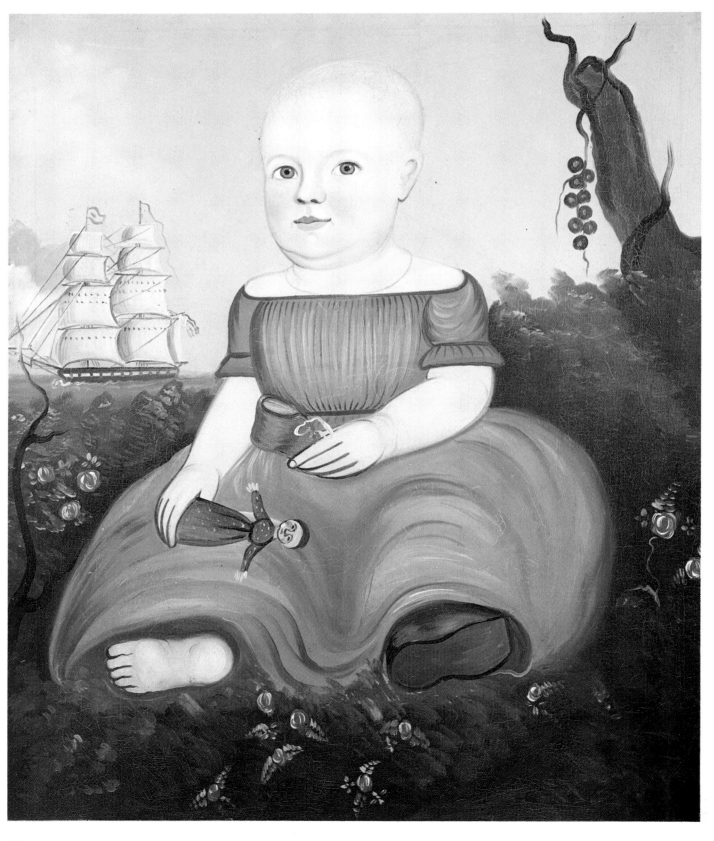

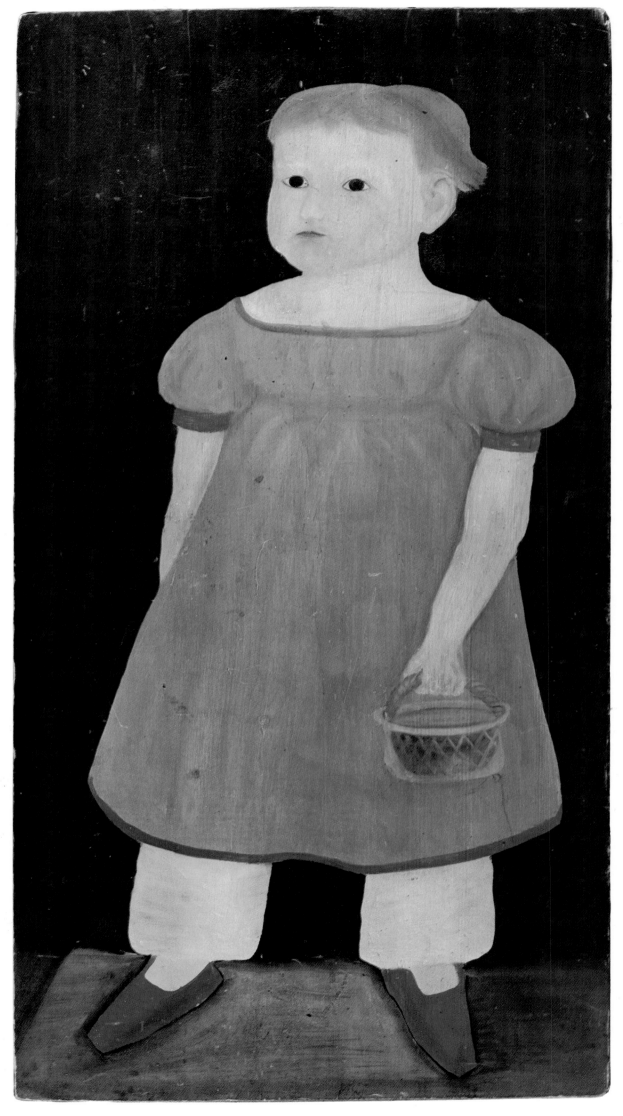

6

Unidentified Sea Captain
Attributed to Sturtevant J. Hamblen
 (active 1837-56)
Massachusetts; c. 1830
Oil on canvas 27⅛ × 22¼″ (68.9 × 56.5 cm)
Promised gift of Robert Bishop. P78.101.2

Folk painters often included personal objects belonging to the sitters in their portraits. The unidentified ship's captain holds a telescope, while a ship, perhaps the one he commanded, may be seen in the background. The work of Hamblen is difficult to distinguish from that of his more famous brother-in-law, William Matthew Prior. A nearly identical portrait is in the collection of the Colby College Museum at Waterville, Maine.

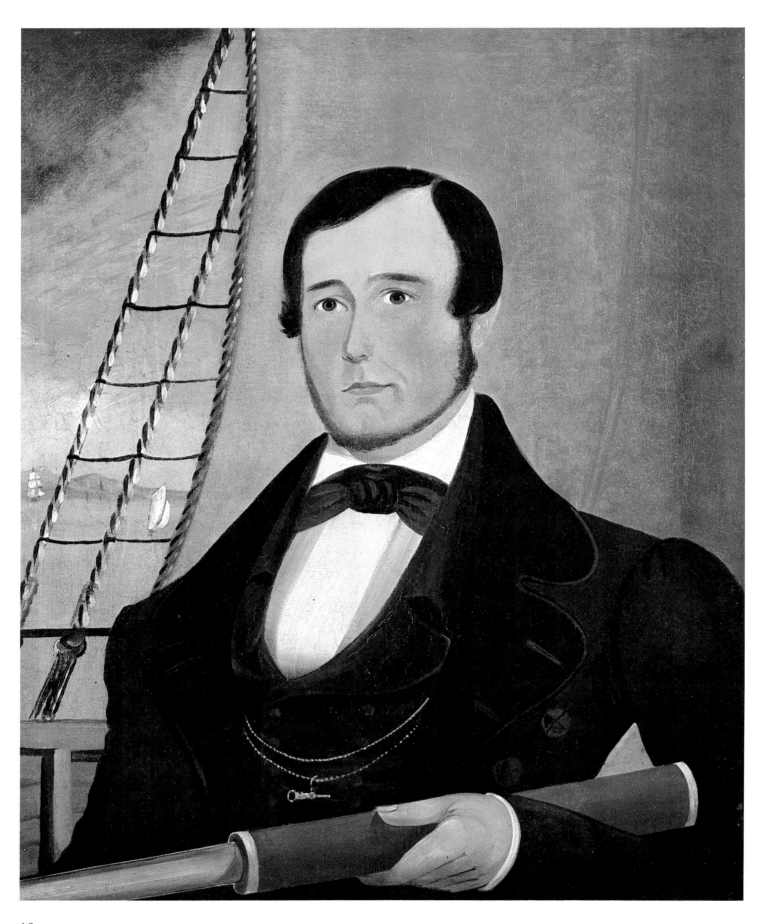

7
Portrait of a Miller
Erastus Salisbury Field (1805-1900)
New England; 1830-40
Oil on canvas, 30½ × 25¼" (77.5 × 64.1 cm)
Gift of Cyril I. Nelson in honor of
Howard and Jean Lipman. 1981.13.1

Erastus Salisbury Field, who studied with
Samuel F. B. Morse (1791-1872) in 1824, was
itinerant for much of his long career, traveling
through Massachusetts, Connecticut and much
of the New England countryside in search of new

clients. Like many other folk artists, he was forced
from his trade with the advent of the daguerreotype.
In later years Field executed numerous allegorical,
religious and genre pictures.

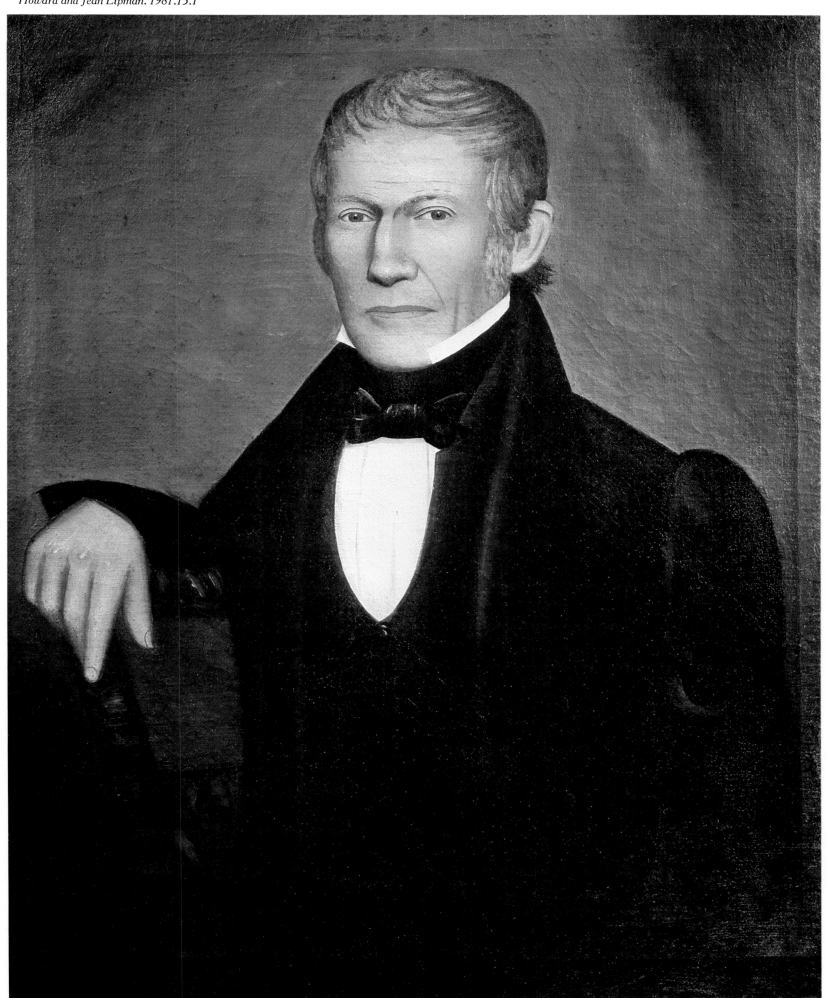

Masonic Memorial Picture for the Rev. Mr. Ambrose Todd

Eunice Pinney (1770-1849)
Windsor or Simsbury, Connecticut; 1809
Watercolor on laid paper, pen and ink inscription,
 sight: 14 × 11⅞" (35.6 × 30.2 cm)
Museum of American Folk Art purchase. 1981.12.7

The Masonic associations of the Rev. Mr. Todd,
rector of the Episcopal Church in Simsbury,
Connecticut, are apparent in this mourning picture
by Eunice Pinney. The artist has included a large
number of Masonic symbols in her abstract
representation of the tomb.

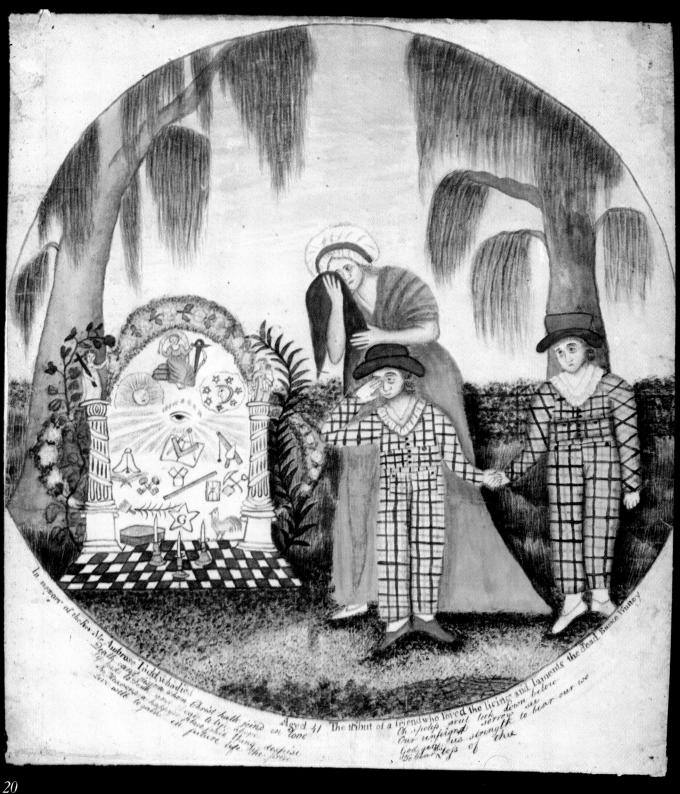

Mourning Picture for Mrs. Ebenezer Collins
Artist unknown
South Hadley, Massachusetts; Dated July 15, 1807
Watercolor, bodycolor, silk and metal threads on
 silk, velvet, sight, circular: 16⅞″ (42.8 cm) diam.
Eva and Morris Feld Folk Art Acquisition Fund.
 1981.12.8

Most mourning pictures were executed by young
women; they served not only as a tangible expression
of grief but as a means of recording the vital
statistics of the deceased. This mourning picture
has all the elements typical of the art form: the urn
set upon a tomb, weeping willows, evergreens, a
village in the distance and mourning relatives.
Each object in the picture has symbolic value:
weeping willows symbolized mourning;
evergreens, resurrection; the town or village,
temporary environment.

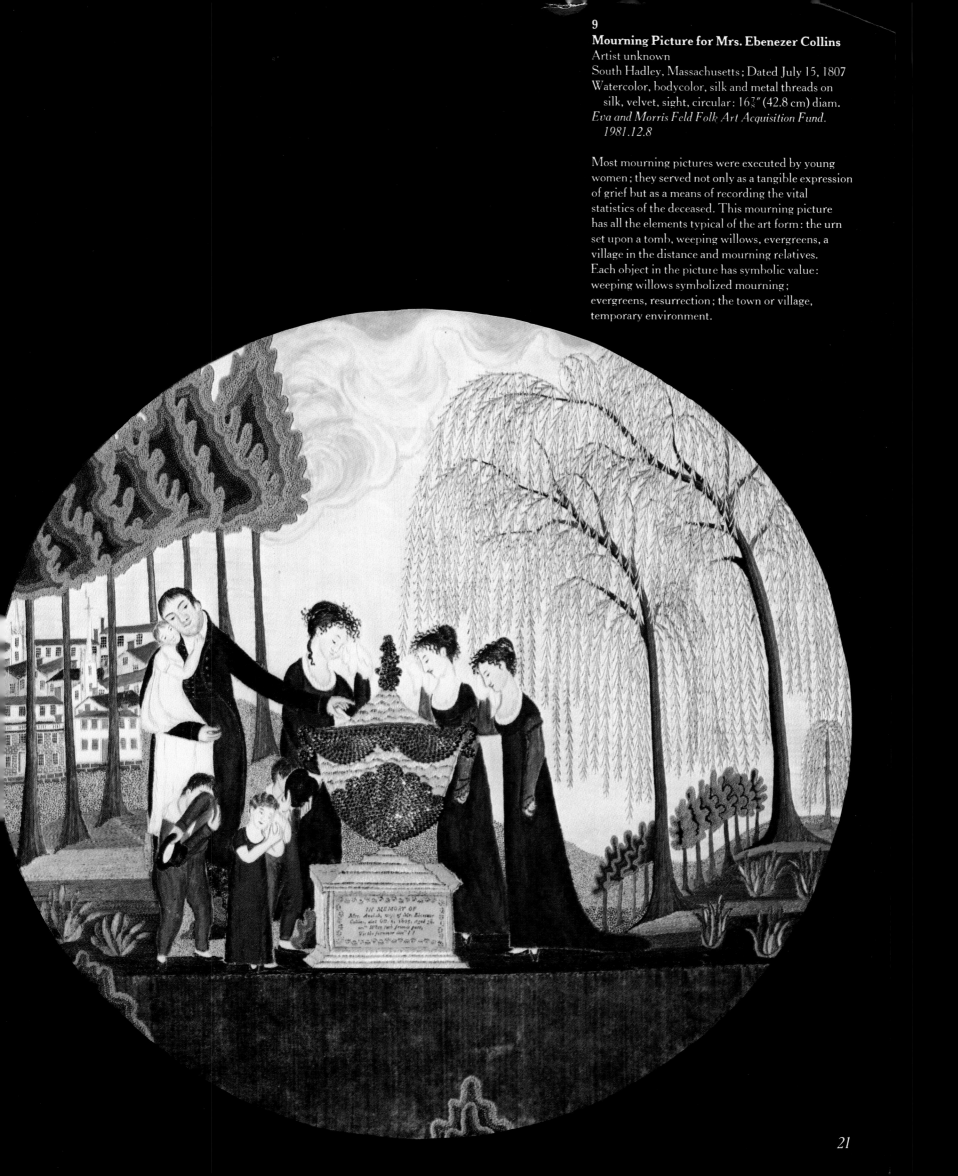

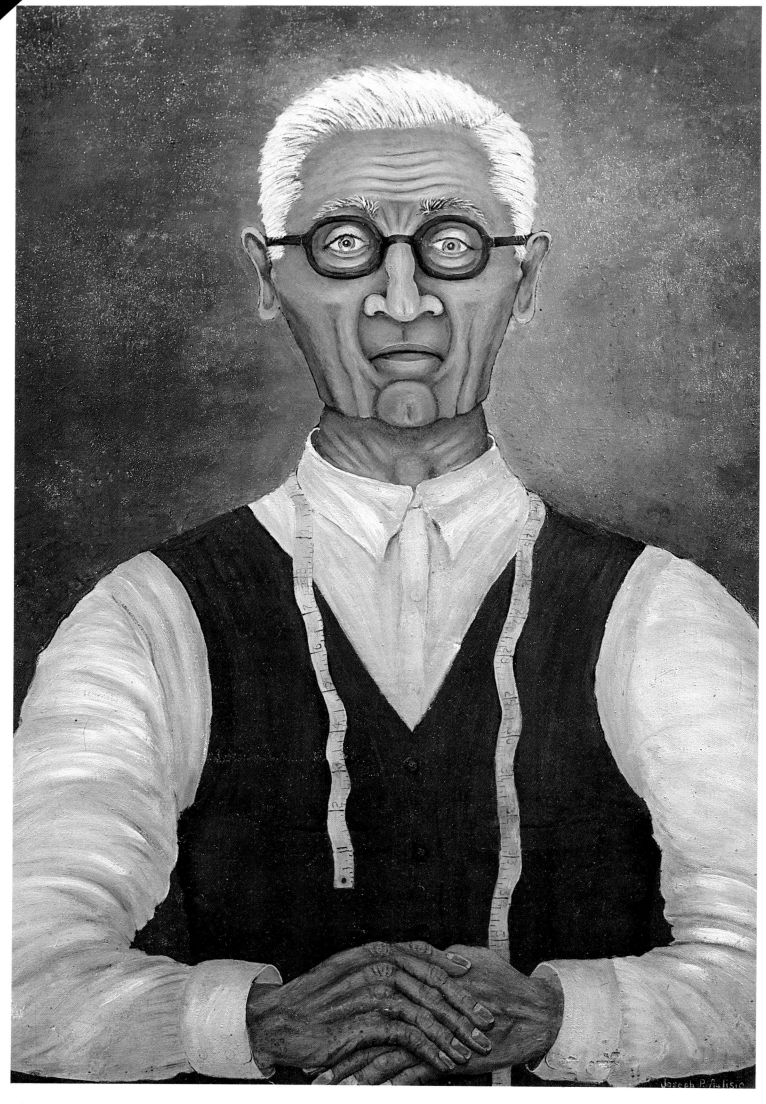

10
Portrait of Frank Peters
Joseph Aulisio (1910-74)
Pennsylvania; 1965
Oil on masonite, 28 × 20″ (71.1 × 50.8 cm)
Gift of Arnold B. Fuchs. 1978.8.1

This contemporary portrait which realistically
details the sitter Frank Peters is remarkable for
its perceptive characterization. Joseph Aulisio
of Stroudsburg, Pennsylvania, worked in a dry
cleaning store while harboring a desire to be
an artist.

11
The White House
Artist unknown
Pennsylvania; 1855
Oil on canvas, 12¾ × 17¾″ (32.3 × 45 cm)
Promised gift of Robert Bishop and Cyril I. Nelson.
P77.101.1

The romantic theme of the simple, white house on
a gently flowing stream is charmingly exemplified
in this picture. With the rise of middle class ideals
in the 19th century came a longing to own one's
own home which helped establish a man's position
in society. Nearly every American felt that his
dwelling was his "castle."

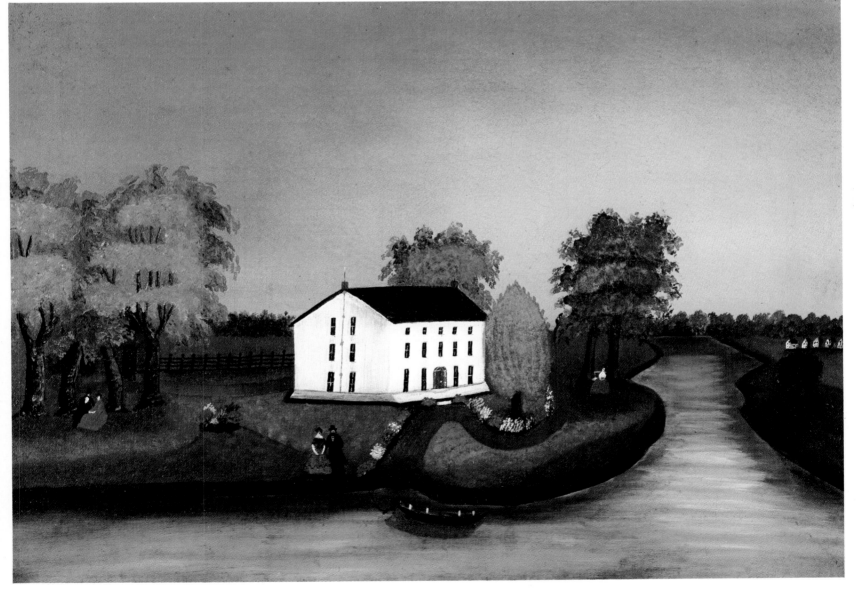

12
**Sailing Ship "Sarah" of Portland
 passing Flushing, New York**
Artist unknown
Probably New York; 1849
Reverse painting on glass, $22\frac{1}{4} \times 28\frac{3}{4}''$
 (56.5 × 73 cm)
Gift of Toby and Martin Landey. 1980.36.3

By mid-19th century, New England was noted for
its sturdy masted ships. Many of the finest vessels
were built in Maine shipyards located at Portland,
Bath and Brunswick. Portland was home port for
the sailing ship "Sarah."

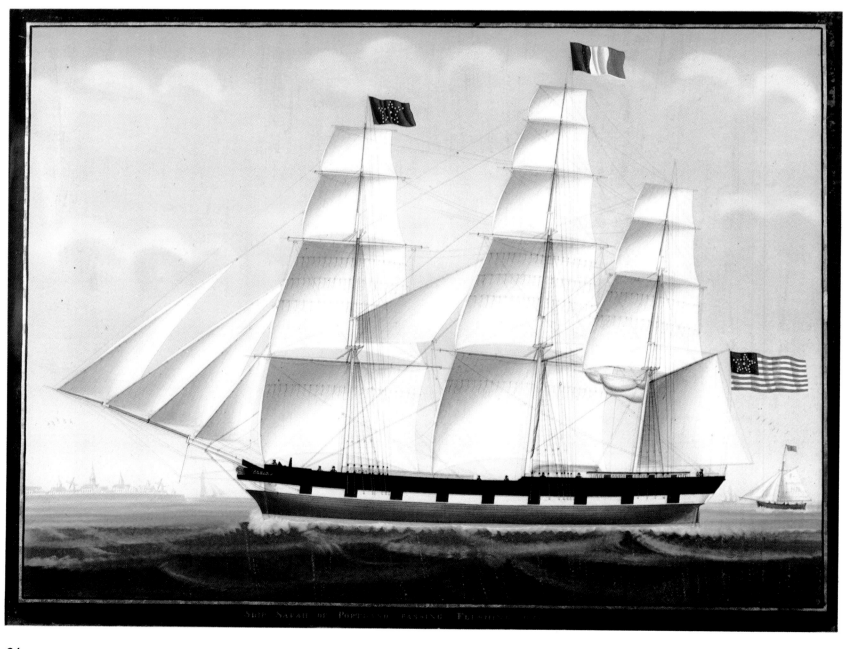

13
Harbor Scene on Cape Cod
Artist unknown
Massachusetts; late 19th century
Oil on canvas, 23 × 31¾″ (58.4 × 80.6 cm)
Promised gift of Robert Bishop. P78.101.5

Though the artist responsible for this vibrant
harbor view lacked technical proficiency his sense
of design and color was remarkable. A sail and
steam powered vessel is visible on the open seas.

14
Oswego Starch Factory (overleaf)
Artist unknown
Oswego, New York; mid-19th century.
Watercolor, pen and ink on wove paper
36⅛ × 53¼″ (91.7 × 135.3 cm)
Museum of American Folk Art purchase. 1981.12.16

During the 19th century it was not uncommon
for commercial and industrial enterprises to
commission folk artists to record their prosperity by
executing large watercolors depicting their facilities.
This painting may have been a trade sign, or perhaps
a decorative piece hung in the factory offices.

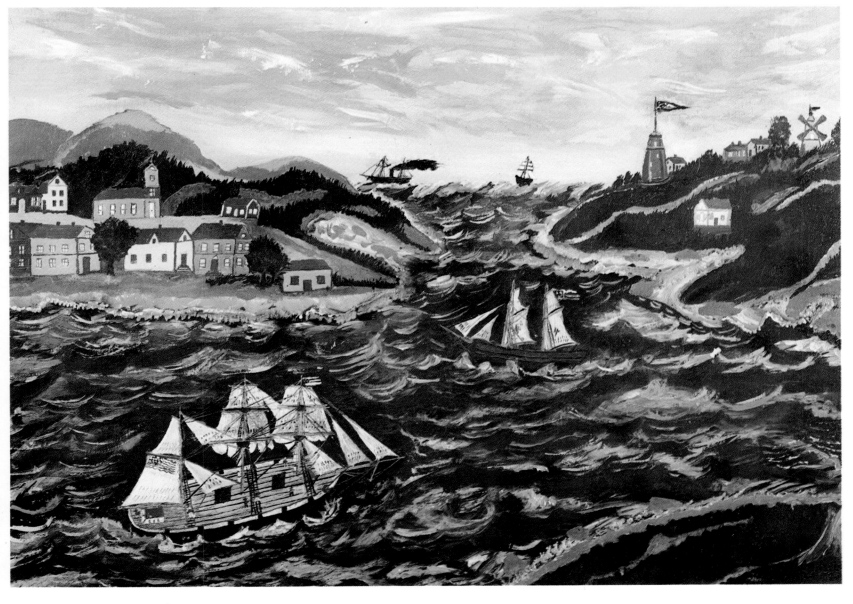

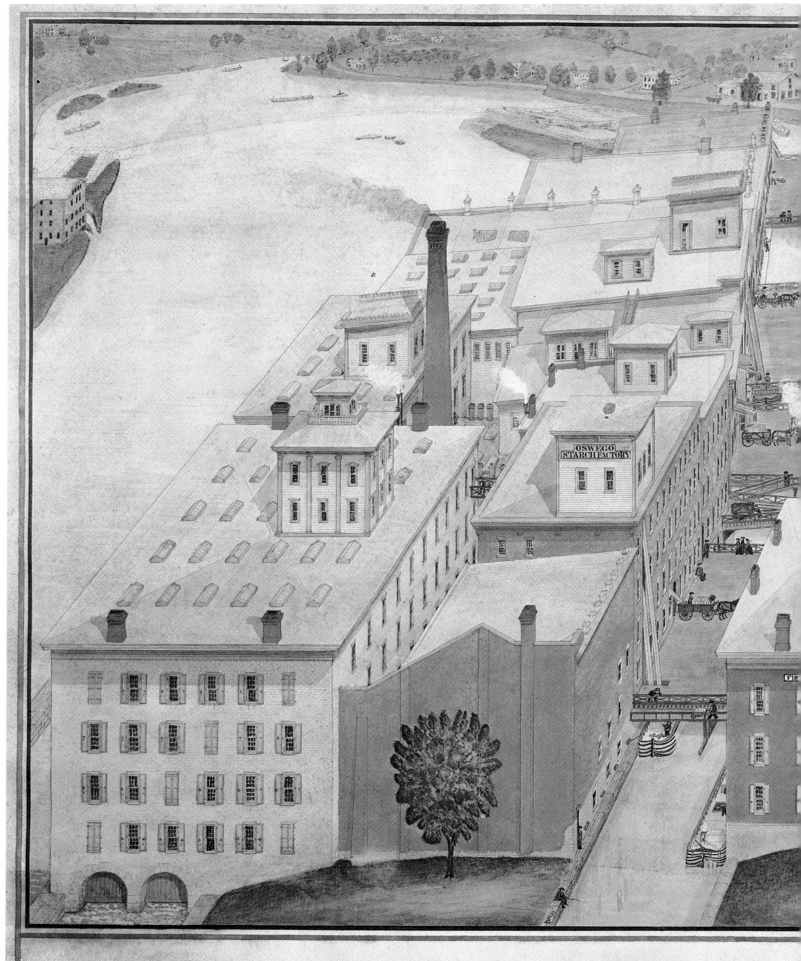

OSWEGO STA

INCORPORATED 1848 OSW

CARPENTER SHOP.

STABLES.

BARREL FACTORY.

FIRE PROOF STORE-HOUSE.

IRON FACTORY.

OFFICE.

FAMILY SUPPLY STORE.

KINGSFORD
FOUNDRY AND MACHINE WORKS.

CH FACTORY.

NY. T. KINGSFORD & SON Manufacturers.

15
Residence of Lemuel Cooper at Plain, Wisconsin

Paul A. Seifert, 1879
Plain, Wisconsin
Watercolor, oil and tempera over pencil on wove paper, 21⅞ × 28" (55.5 × 71.1 cm)
Museum of American Folk Art purchase. 1981.12.26

Seifert recorded with precise detail many of the farmsteads which surrounded his residence in Wisconsin in the last quarter of the 19th century. He preferred to work on cardboard rather than canvas for it enabled him to use metallic paints for details such as the sun and clouds, giving them a wonderful glow. His combination of watercolor and oil added dimension and texture to his paintings.

16
Circus Parade

Kathy Jakobsen (born 1952)
New York; 1979
Acrylic on canvas, 24 × 36" (61 × 91.4 cm)
Gift of Robert Bishop. 1979.11.1

During the 19th and much of the early 20th century, the circus parade was an important event in almost every town across America. This colorful and whimsical painting filled with detail reflects the artist's interest in calligraphy and illuminations. Kathy Jakobsen was born in Michigan and her early paintings depict the mining towns and rural areas of the Upper Peninsula.

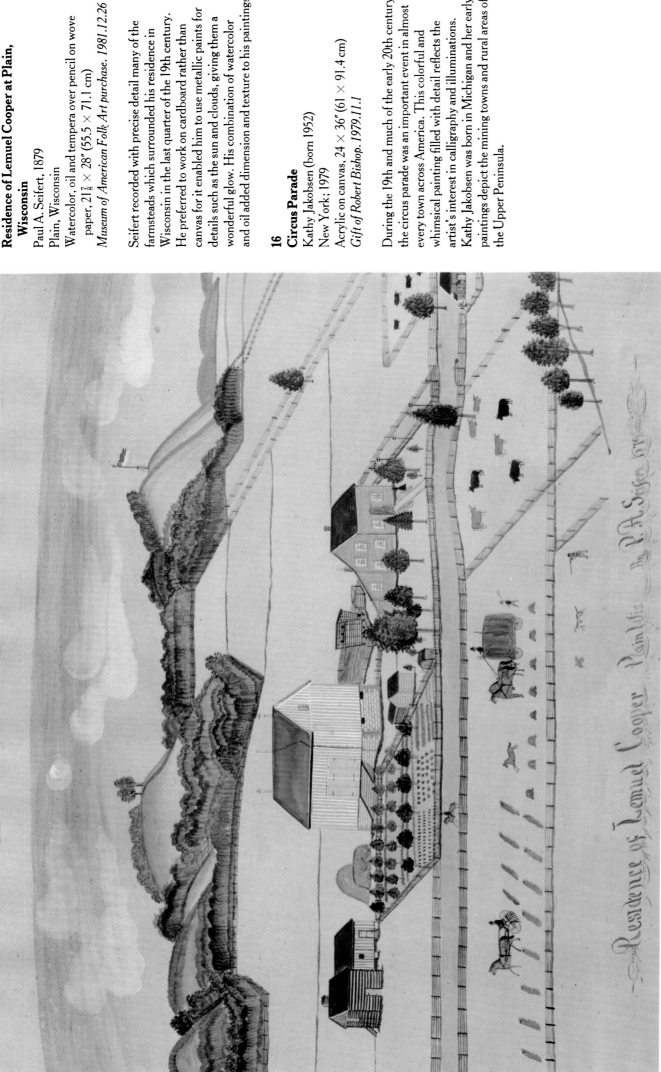

Residence of Lemuel Cooper Plain Wis — By P.A. Seifert 1879

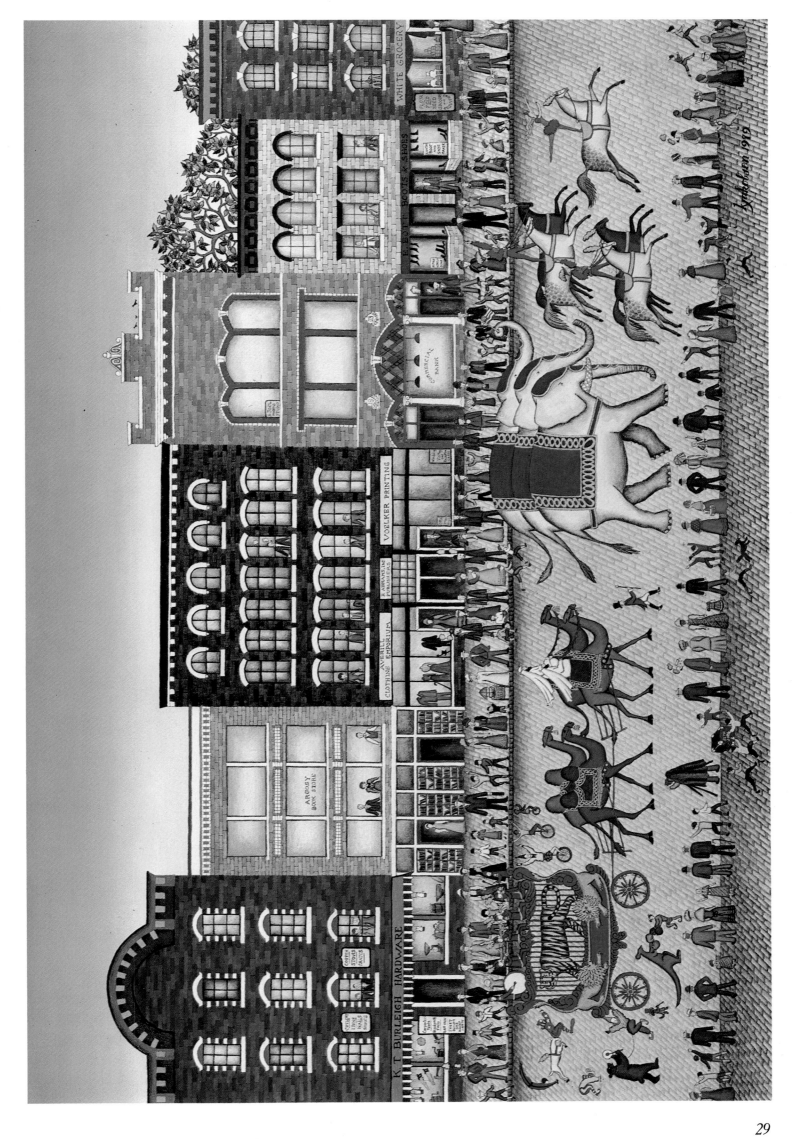

17, 18, 19, 20
Pages from a sketchbook
Betsey Lewis (1786-1818)
Massachusetts; book dated January 8, 1801
Pen and ink and watercolor on laid paper,
$7\frac{1}{2} \times 6\frac{1}{4}$" (19.1 × 15.9 cm)
Promised anonymous gift.
P79.303.5, P79.303.4, P79.303.3, P79.303.2

Miss Lewis was born in Dorchester, Massachusetts and attended the Ladies Academy where she probably executed these pages in a personal book which also contained poetry and odes on the death of General George Washington.

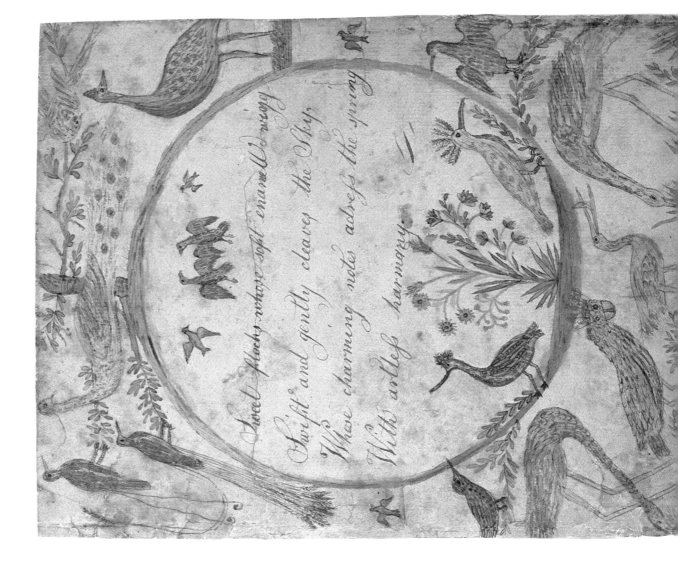

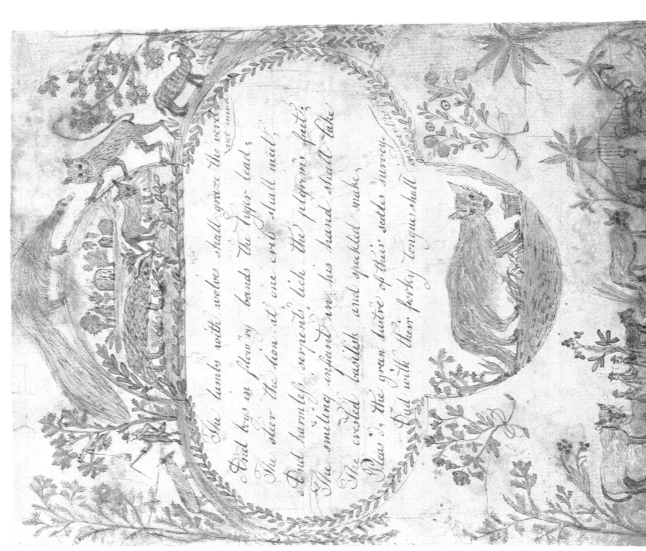

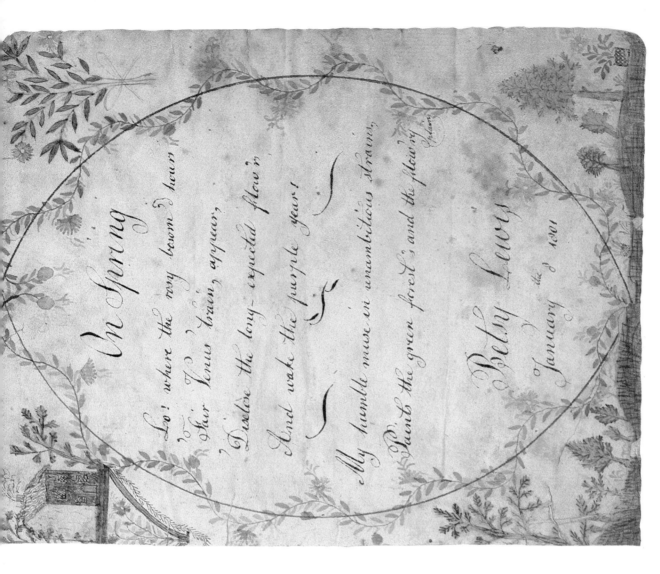

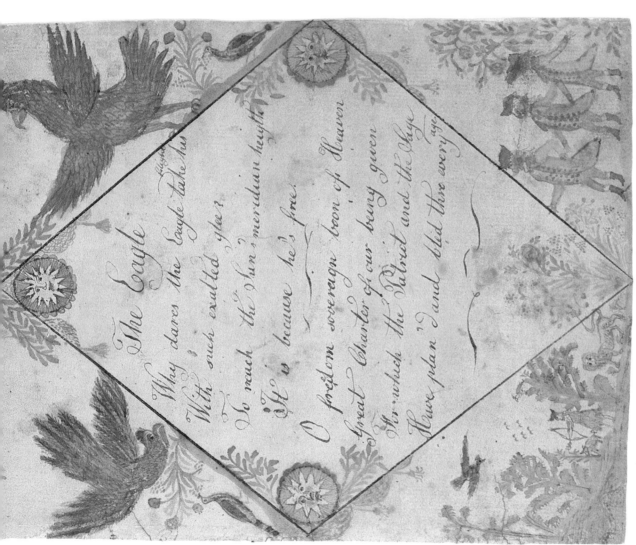

21
General George Washington on Horseback
Artist unknown
American; 1830-50
Pen and ink, pencil and watercolor on wove paper,
 13⅝ × 9¾″ (34.5 × 24.7 cm)
Promised anonymous gift. P79.102.1

The image of George Washington fascinated
countless folk painters and folk sculptors because
he personified the American dream and its ideals of
freedom and democracy. No American national hero
has captured the popular imagination more widely
than the nation's first president, a fact which is well
reflected in American folk art.

22
The Big Farm in the Spring
Mattie Lou O'Kelley
Georgia: 1976
Oil on canvas, 36 × 24″
Gift of the artist

Mattie Lou O'Kelley, a contemporary naive painter,
records her childhood experiences in rural Georgia.
Many modern-day folk artists execute 'memory'
pictures illustrating lifestyles that are fast
disappearing.

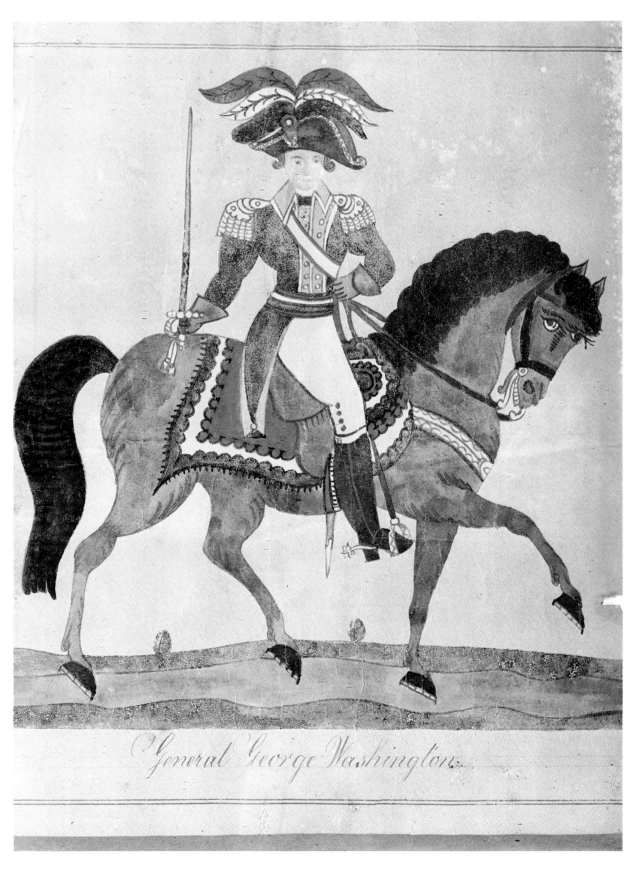

General George Washington

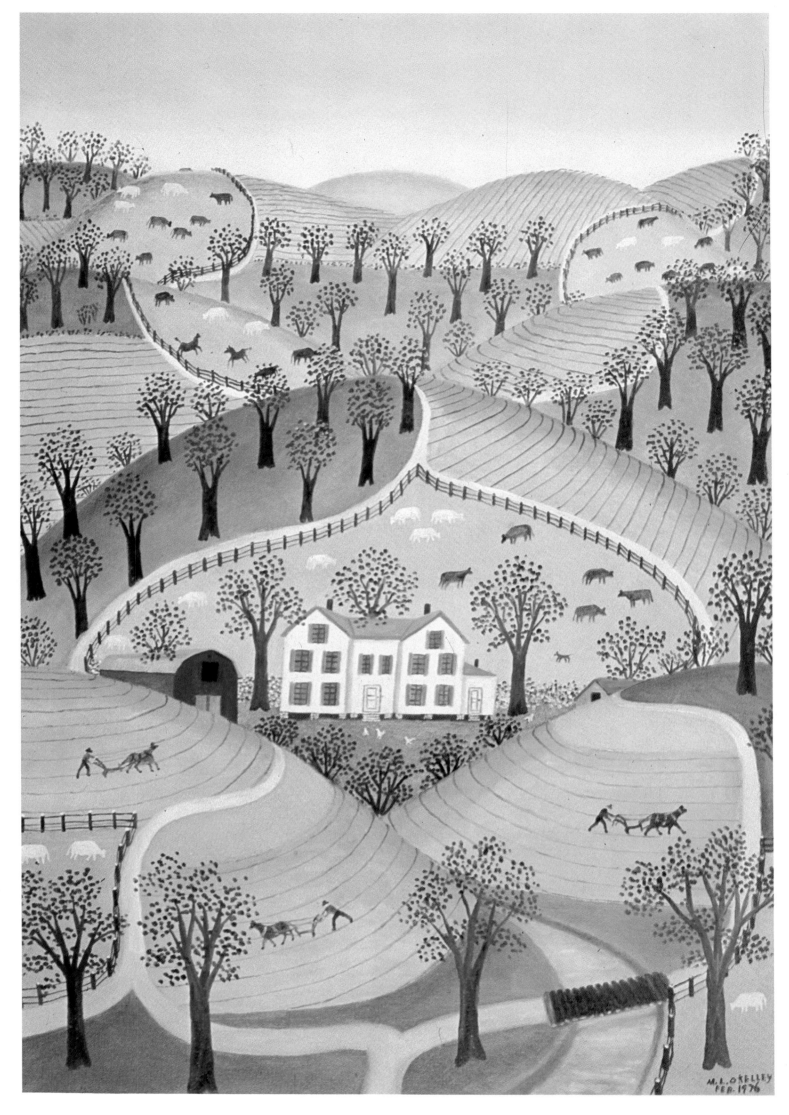

23
Theorem: Fruit, Bird and Butterfly
Artist unknown
New England; late 19th century
Watercolor on velvet, sight: $15\frac{3}{8} \times 18\frac{3}{4}''$
 (39 × 47.6 cm)
Promised anonymous gift. P78.102.1

Baskets of fruit and flowers were frequently painted
by young ladies in academies or finishing schools
or by housewives. Executed in pastels on paper
or watercolor on paper or velvet, these still life
paintings were created with the aid of stencils or
"theorems." The stencils were cut from heavy paper
which had been shellacked and oiled to create a
stiff, strong surface. Some of these pieces were
sketched free hand as well.

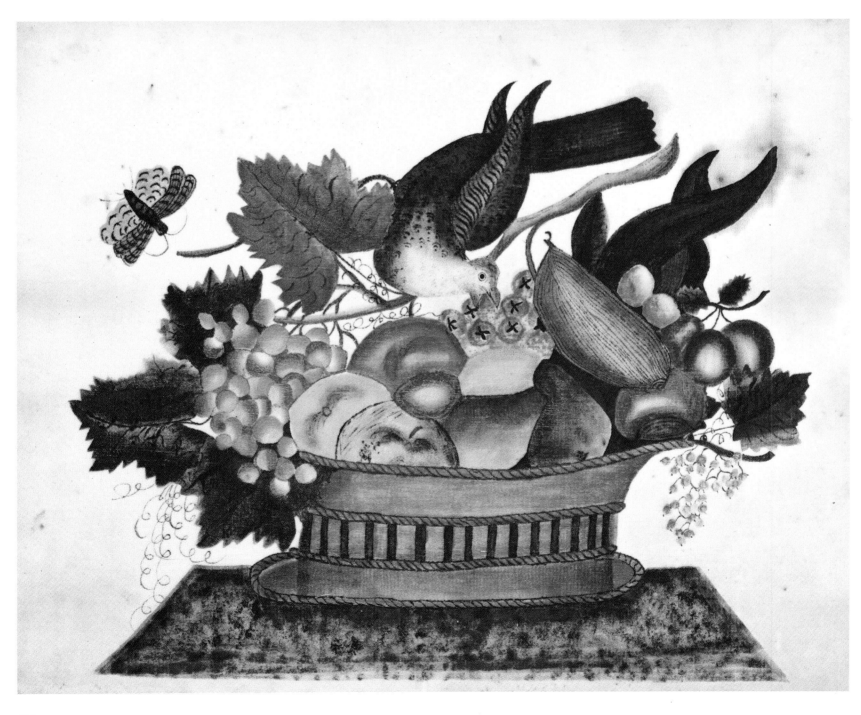

24
Romantic Landscape
Unknown seminary student
Sturbridge, Massachusetts area; 1830-50
Watercolor on paper $15\frac{7}{8} \times 20''$ (40.3 × 50.8 cm)
Promised gift of Cyril I. Nelson. P77.102.1

The female seminary flourished after the American
Revolution. In these educational institutions
students were trained to execute needlepoint and
watercolor pictures and to become accomplished in
the other pursuits thought suitable for young
women. Additional paintings, similar in design and
execution to this landscape but obviously created by
different artists have been discovered in the same
region, substantiating the belief that they were
created by young girls attending a local finishing
school or seminary.

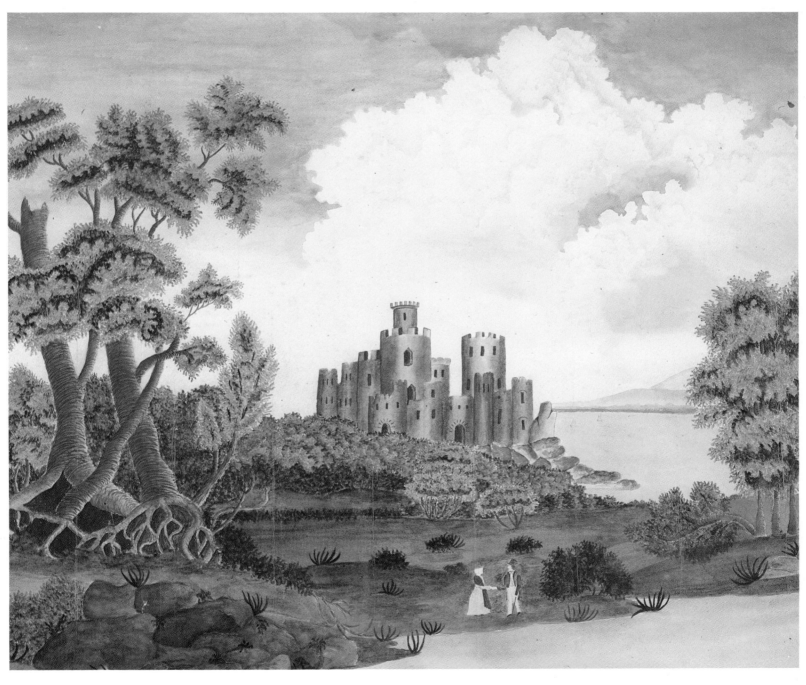

25
Fraktur; Simon H. Mayberry–Mary M. Hall
 Family Record
Heart and Hand artist
Saccarrappa (Westbrook), Maine
Sept 2, 1850
Watercolor and ink on wove paper
 sight: 13½ × 9¼" (34.2 × 24.1 cm)
Gift of Mr. and Mrs. Philip M. Isaacson. 1981.21.3

26
Fraktur; Andrew Mayberry–Margaret Trott
 Family Record
Heart and Hand artist
Windham, Maine
Sept 11, 1850
Watercolor and ink on wove paper
 sight: 13⅜ × 9⅜" (34 × 23.8 cm)
Gift of Mr. and Mrs. Philip M. Isaacson. 1981.21.1

27
Fraktur; Stephen Hall–Catherine Mayberry
 Family Record
Heart and Hand artist
Casco, Maine
Sept 11, 1850
Watercolor and ink on wove paper
 sight: 13½ × 9⅜" (34.2 × 23.8 cm)
Gift of Mr. and Mrs. Philip M. Isaacson. 1981.21.2

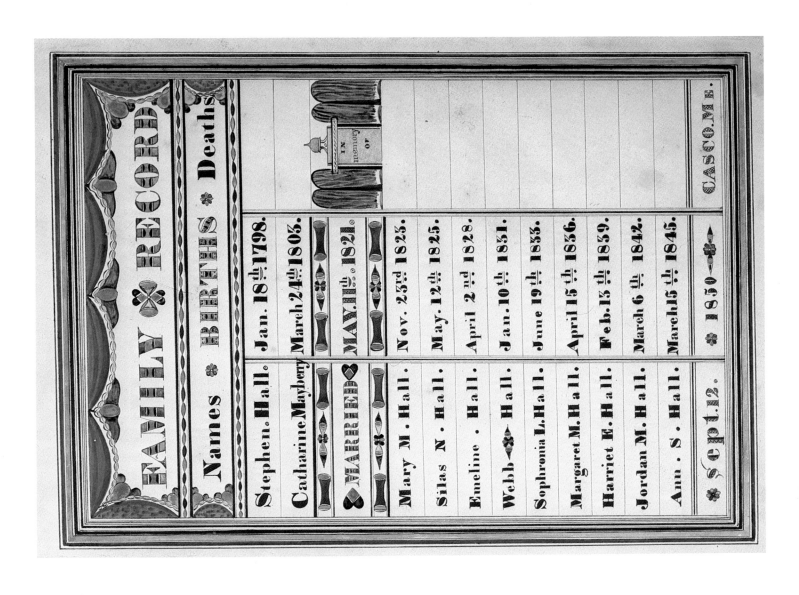

FAMILY RECORD

Names	BIRTHS	Deaths
Stephen. Hall.	Jan. 18th 1798.	IN memory OF
Catharine Mayberry	March 24th 1805.	
MARRIED	MAY. 1st 1821.	
Mary M. Hall.	Nov. 23rd 1823.	
Silas N . Hall.	May. 12th 1825.	
Emeline . Hall.	April 2nd 1828.	
Webb Hall.	Jan. 10th 1831.	
Sophronia L. Hall.	June 19th 1833.	
Margaret M. Hall.	April 15th 1836.	
Harriet E. Hall.	Feb. 13th 1839.	
Jordan M. Hall.	March 6 th 1842.	
Ann. S . Hall.	March 15 th 1845.	
Sept. 12.	1850.	CASCO. ME.

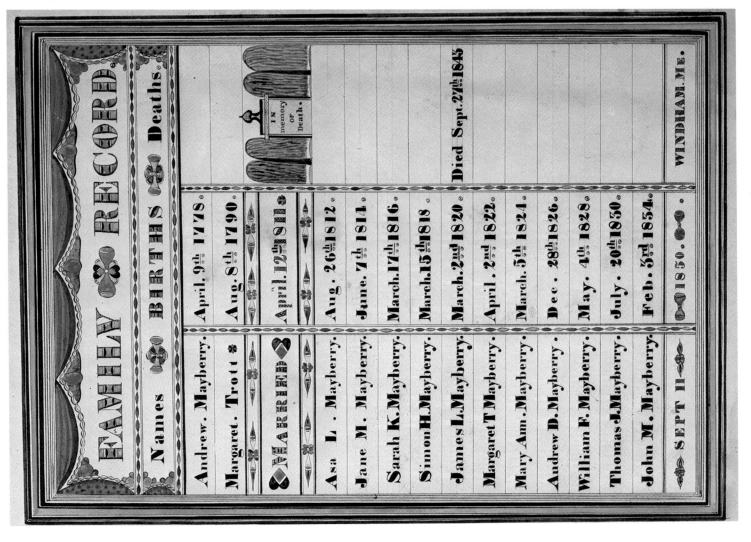

FAMILY RECORD

Names	BIRTHS	Deaths
Andrew. Mayberry.	April. 9th 1778.	IN memory OF Death.
Margaret. Trott	Aug. 8th 1790.	
MARRIED	April. 12th 1811.	
Asa L . Mayberry.	Aug . 26th 1812.	
Jane M. Mayberry.	June 7th 1814.	
Sarah K. Mayberry.	March. 17th 1816.	
Simon H. Mayberry.	March. 15th 1818.	
James L. Mayberry.	March. 2nd 1820.	
Margaret T Mayberry.	April. 2nd 1822.	
Mary Ann. Mayberry.	March. 5th 1824.	
Andrew D. Mayberry.	Dec . 28th 1826.	
William F. Mayberry.	May. 4th 1828.	
Thomas J. Mayberry.	July. 20th 1850.	
John M. Mayberry.	Feb. 5rd 1854.	Died Sept. 27th 1845
SEPT 11	1850.	WINDHAM. ME.

28
Fraktur: The Messiah's Crown
Franklin Wilder
Hingham or Leominster, Massachusetts; c. 1865
Pen and ink, pencil and watercolor on wove paper,
 sight: 15½ × 17″ (39.4 × 43.2 cm)
Gift of Mr. and Mrs. Philip M. Isaacson. 1979.28.1

The Klu Klux Klan, a secret society with a racist
philosophy, grew substantially in numbers
immediately following the American Civil War.
This fraktur, representing the artist's reaction to
the movement, is one of several known to have been
executed by Wilder.
It is inscribed,
Judgement
Conscience
 The Twelfth
 Commandment
 A new Commandment give I unto
 you as it E-I-O-U forms a Unity: and
 as I-O-U and U-O-Me forms a Government
 in Perfect Unity.
 That is to say that:
 'Thou shalt not pledge theyself
 to Any
 Pledged Secret Lodge Whatever'
 For that Pledge Supersedes the Laws of both
 God and Man, as it binds the taker of the Pledge,
 Under the penalty of Death and Hell, to not
 regard the Equitable Laws of the Land,
 'nor any unseen God.'
 Therefore it is the 'Great Sin against the
 Holy Ghost' that dooms the taker down
 to an Eternal Hell.
 Amen.
 Compiled and written and
 issued by his Servant
 'The Son of Man'
 the P. of P.
 The Messiah's Crown
 Anti Klu Klux Klan
 The All Saints Banner
 The Prince of Peace.

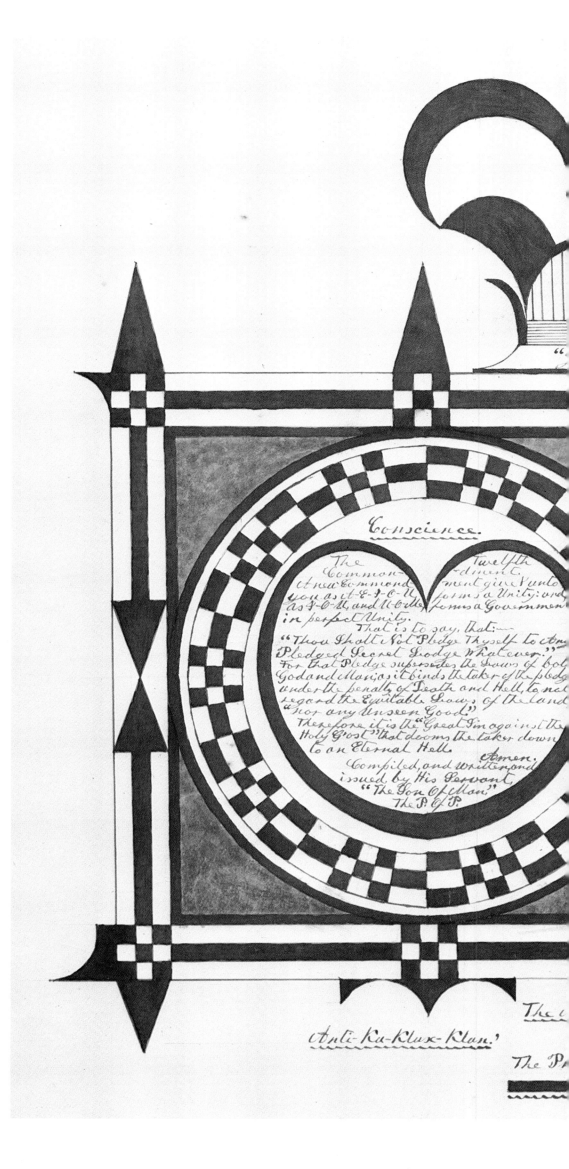

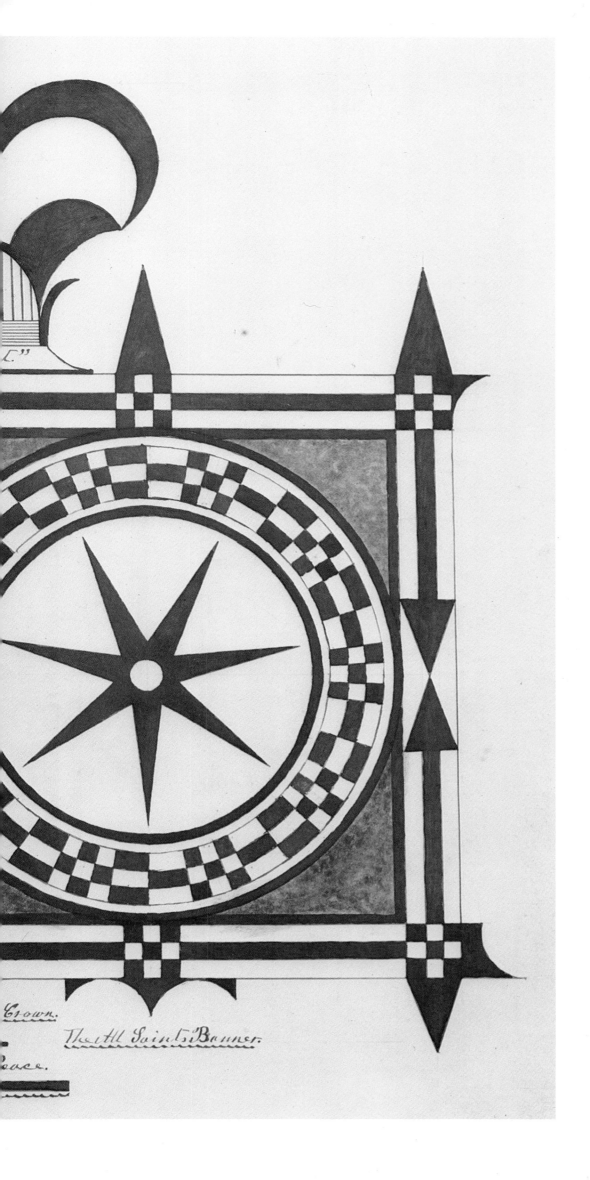

Crown.

The All Saints Banner.

Peace.

29
Calligraphic Drawing: Spencerian Birds
Miss Lillian Hamm and her students
American; c. 1850
Pen and ink, and watercolor on wove paper,
 sight: 18¾ × 17¾″ (47.6 × 45 cm)
Promised gift of Cyril I. Nelson. P77.304.1

The term calligraphic is defined as "the art of fine handwriting." The word has been used to describe 18th, 19th, and 20th century quill and steel pen drawings made with repeated cursive flourishes and strokes resembling the strokes used to form letters. These Spencerian birds on small cards were executed by students in the handwriting class instructed by Miss Lillian Hamm. They were then pasted onto a larger Spencerian drawing and presented to their teacher. A series of handwriting and drawing copybooks were turned out by Platt Rodgers Spencer during the mid-19th century.

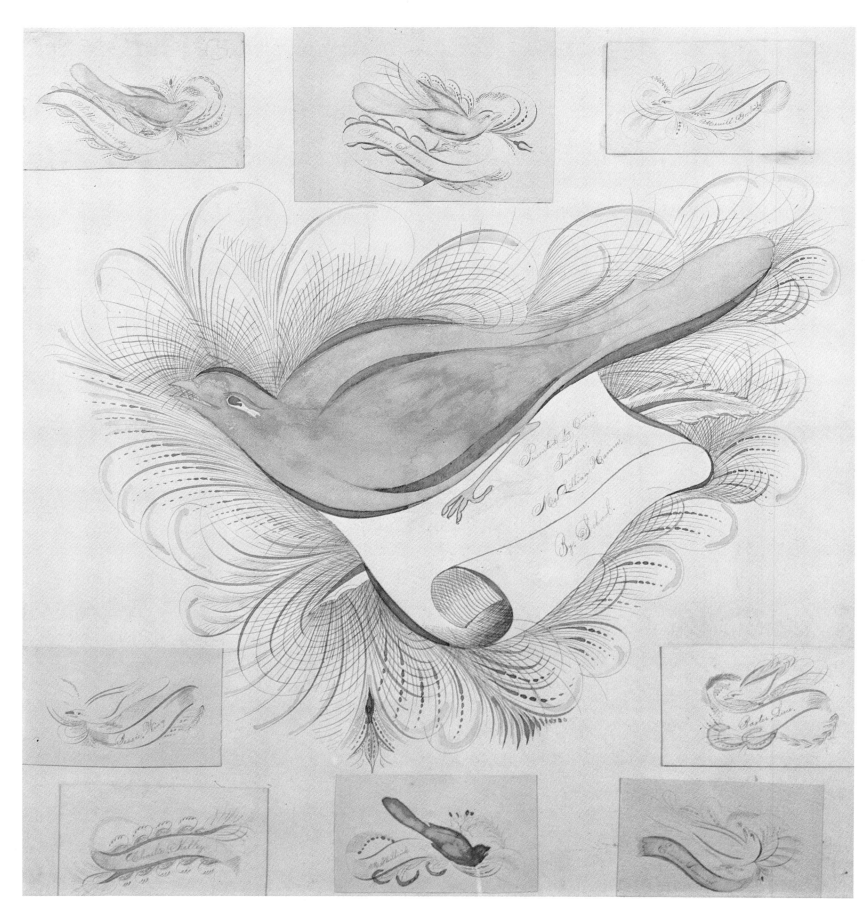

30
Heart and Hand Valentine
Artist unknown, c. 1850
Probably Connecticut.
Pen and ink on cut paper mounted on tissue on card,
$14\frac{1}{8} \times 12''$ (35.8 × 30.5 cm)
Museum of American Folk Art purchase. 1981.12.15

This strikingly fresh graphic bears the inscription
Hand in heart will never part
When it you see remember me.

31
Tinsel Picture: Vase of Flowers
Artist unknown
New England; 1850-80
Ink and reverse glass painting, tinsel, 15 × 13⅛"
 (38.1 × 33.3 cm)
Gift of Mr. and Mrs. Day Krolik. 1979.3.4

Tinsel pictures were created predominantly in
New England and Pennsylvania during the last half
of the 19th century. The reverse painting on glass
is backed with crinkled foil which provides a
shimmery effect through the translucent paint.

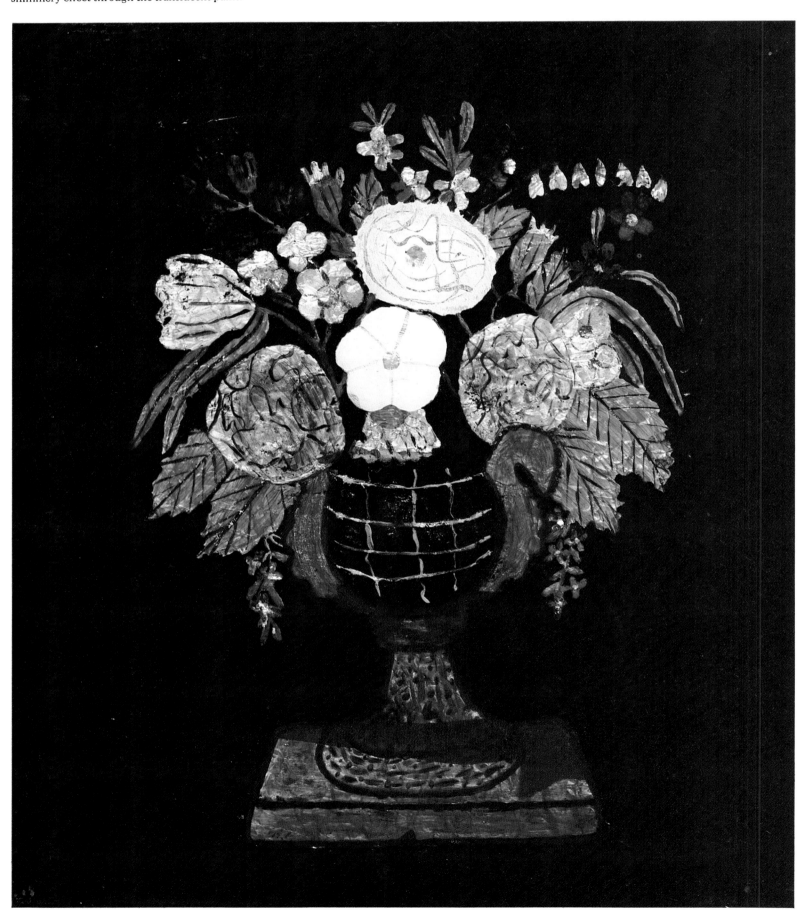

Tinsel Picture: Birds, Flowers and Child
Artist unknown
Pennsylvania; 1850-80
Ink and reverse glass painting, tinsel and framed
　　hand-colored photograph, 12 × 14⅛″
　　(30.5 × 35.8 cm)
Gift of Mr. and Mrs. Day Krolik. 1979.3.1

Some folk portrait painters, forced from the
profession by the advent of photography, learned
the process and became "folk photographers,"
enabling them to offer their services as painter or
photographer. Here the forms are combined.

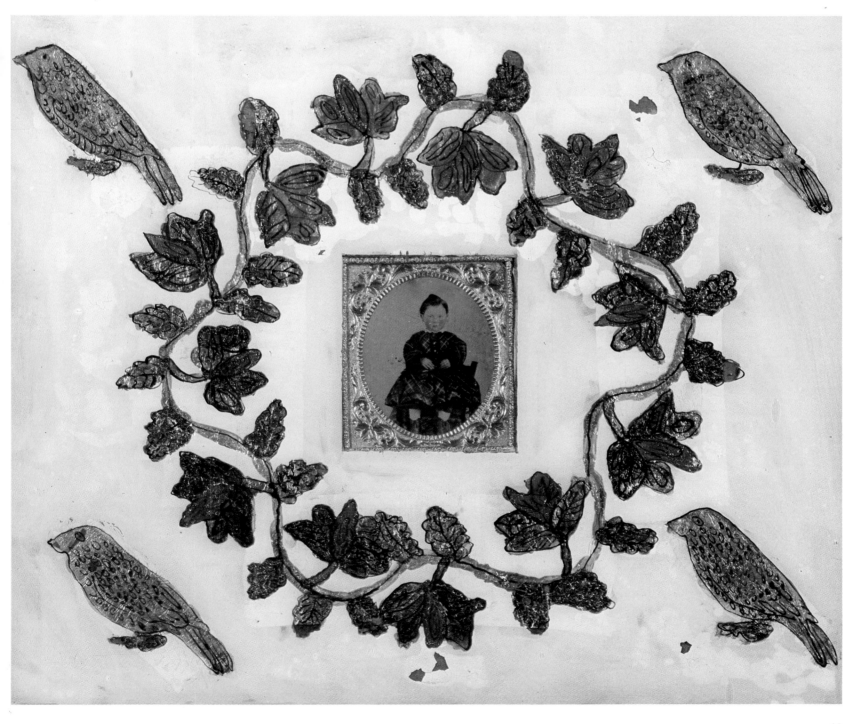

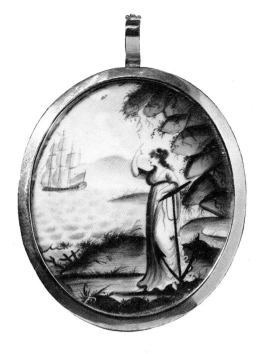

33

Miniature: Mourning Locket (Woman & Ship)
Artist unknown
American; late 18th century
Watercolor on ivory,
 sight, oval: $2\frac{1}{8} \times 1\frac{3}{4}''$ (5.4 × 4.5 cm)
Museum of American Folk Art purchase. 1981.12.27

Mourning art, including needlework, watercolor
memorial pictures and memorial jewelry, was
practiced by school girls and young ladies who
romanticized the otherwise harsh realities of life.
The painting in this locket appears to have been
the work of a semi-professional artist.
The back of the locket is initialed
 "M.R."

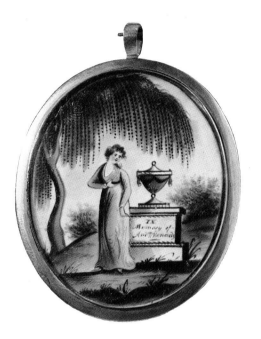

34

Miniature: Mourning Locket (Woman & Urn)
Artist unknown
American; late 18th century
Watercolor on ivory, human hair and rose gold
 frame, oval: $2\frac{1}{2} \times 1\frac{3}{4}''$ (6.3 × 4.5 cm)
Museum of American Folk Art purchase. 1981.12.28

Before the advent of modern medicine, the death
rate was extremely high, and many Americans
experienced the early loss of family members and
friends. Memorial jewelry was one way of expressing
bereavement. In most mourning art the classical urn
and the weeping willow were familiar motifs.
The back of the locket is initialed
 "M.R."

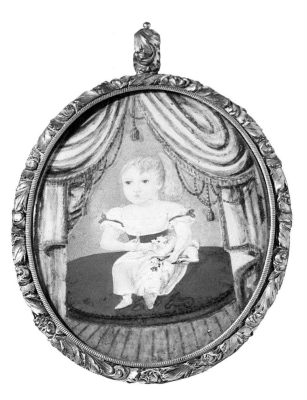

35

Miniature: Memorial Locket (Girl with Dog)
Artist unknown
New England; 1820-30
Oil on ivory, hair, oval: $2\frac{3}{4} \times 2\frac{1}{8}''$ (6.9 × 5.4 cm)
Promised gift of Howard and Jean Lipman.
 P3.1981.1

This memorial miniature was probably executed
by a young schoolgirl who wished to memorialize
a sister or other relative. The young child is shown
with her pet.

36
Miniature: Political Pin (Log Cabin)

Artist unknown

American; c. 1840

Watercolor on ivory, pen and ink inscription,
$\frac{5}{8} \times \frac{3}{4}''$ (1.5 × 1.9 cm)

*Eva and Morris Feld Folk Art Acquisition Fund.
1981.12.30*

It is unusual for fine decorative jewelry to have
political connotations. This political pin supports
the candidacy of William Henry Harrison (1773-
1841) for president and is inscribed "*Harrison &
Reform*." The "Log Cabin and Hard Cider"
campaign of 1840 presented Harrison as a simple
frontiersman, the candidate of the people.

38
**Miniature: Mourning Fob with
 Portrait of a Cow**

Artist unknown

American; 19th century

Watercolor on horn, hair, silver, sight: $1 \times 1\frac{1}{4}''$
(2.5 × 3.1 cm); oa: $10\frac{1}{2} \times 1\frac{5}{8} \times \frac{3}{8}''$ deep
(26.6 × 4.2 × .9 cm)

Museum of American Folk Art purchase. 1981.12.32

This unusual mourning fob memorializes someone's
favorite cow.

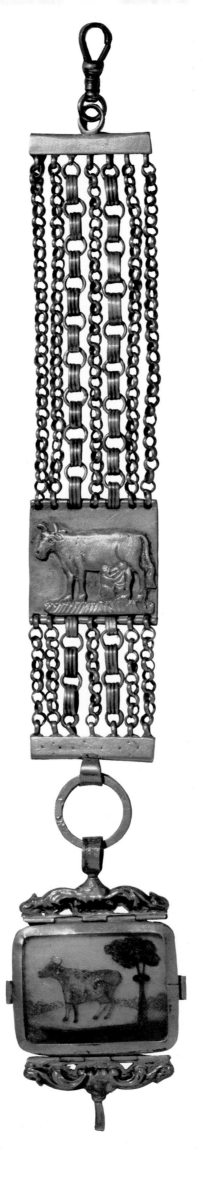

37
Miniature: Mourning Pin (Soldiers)

Artist unknown

American; 19th century

Watercolor on ivory, $1\frac{1}{4} \times 1''$ (3.1 × 2.5 cm)

*Joseph Martinson Memorial Fund,
Frances and Paul Martinson. 1981.12.29*

This pin probably was given to a young woman
by her husband or betrothed in celebration of his
return from War.

39
Miniature: Friendship Pin (Clasped Hands)

Artist unknown

American; 19th century

Watercolor on ivory, brush inscription, $\frac{7}{8} \times 1\frac{1}{8}''$
(2.2 × 2.8 cm)

*Joseph Martinson Memorial Fund, Frances and
Paul Martinson. 1981.12.31*

This pin is inscribed
"*Friendship the fountain of love.*"

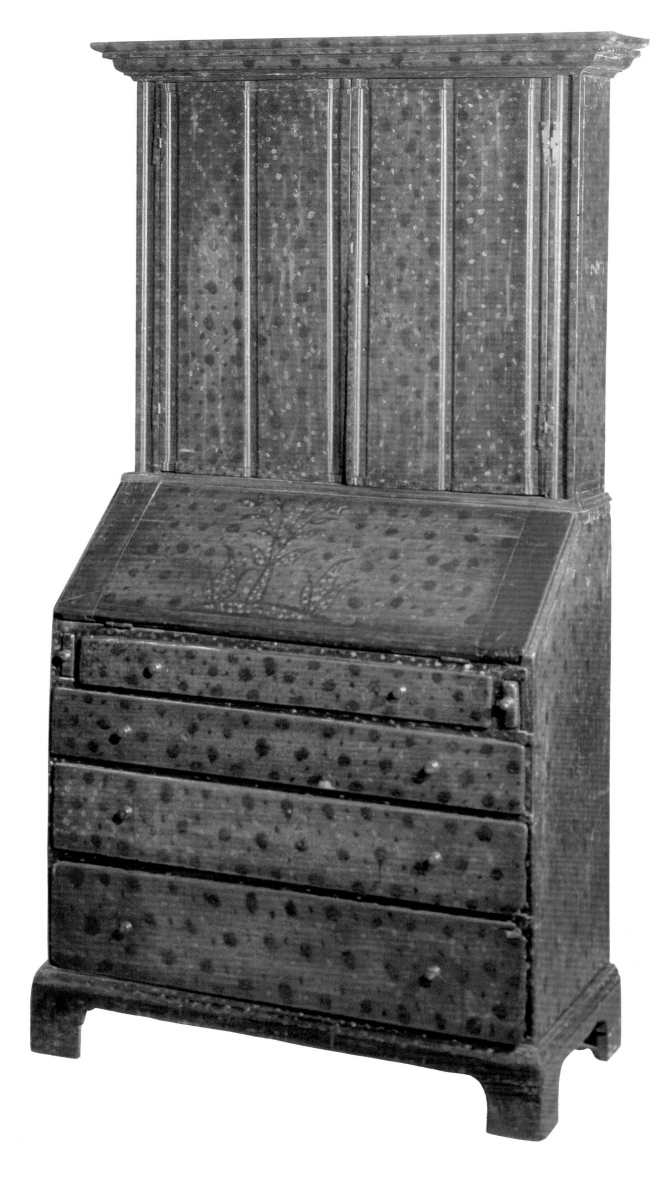

40
Queen Anne Secretary Bookcase
Artist unknown
New England; 1720-50
Carved, painted and decorated maple and pine,
 $67\frac{3}{4} \times 37 \times 16\frac{3}{4}''$ deep (172 × 94 × 42.5 cm)
Eva and Morris Feld Folk Art Acquisiton Fund.
 1981.12.1

The mottled finish makes this extremely
rare piece of early American furniture even
more distinctive.

41
Dower Chest with mermaid decoration
Artist unknown
Pennsylvania; c. 1790
Painted and decorated pine, iron,
 $24\frac{3}{4} \times 50\frac{1}{2} \times 23\frac{3}{4}''$ deep
 (62.8 × 128.3 × 60.3 cm)
Museum of American Folk Art purchase. 1981.12.4

Dower chests were made as gifts for young brides
and frequently were inscribed with the young girl's
name and the date on which it was presented.
An early German folk art motif, the mermaid
symbolizes the duality of Christ; the flower designs
were brought from Germany and Holland.

Mirror with carved hearts decorated frame
Artist unknown
Probably New England; mid-18th century
Carved and painted pine, mirror glass,
 20 × 9⅜ × 1⅛″ deep (50.8 × 23.8 × 2.8 cm)
Gift of Amicus Foundation Inc. 1981.12.18

The whimsical design of this unusual piece
demonstrates how New England yankees
embellished European motifs. Similar forms were
also produced in Pennsylvania at this time.

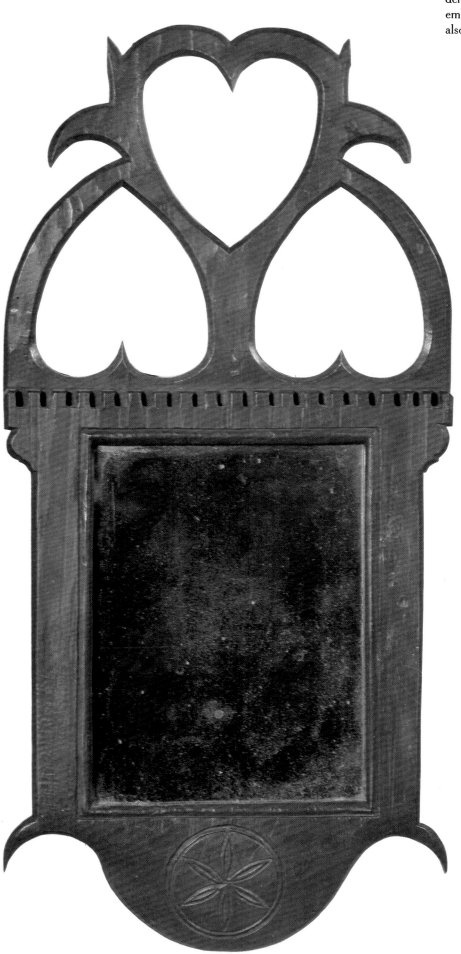

43
Hanging Candle Box
Artist unknown
Connecticut River Valley; c. 1800
Carved and painted pine, tallow,
$24\frac{5}{8} \times 12\frac{3}{4} \times 5\frac{3}{8}''$ deep ($62.5 \times 32.3 \times 13.7$ cm)
Museum of American Folk Art purchase. 1981.12.11

This piece was found with 19th century candles
still in it.

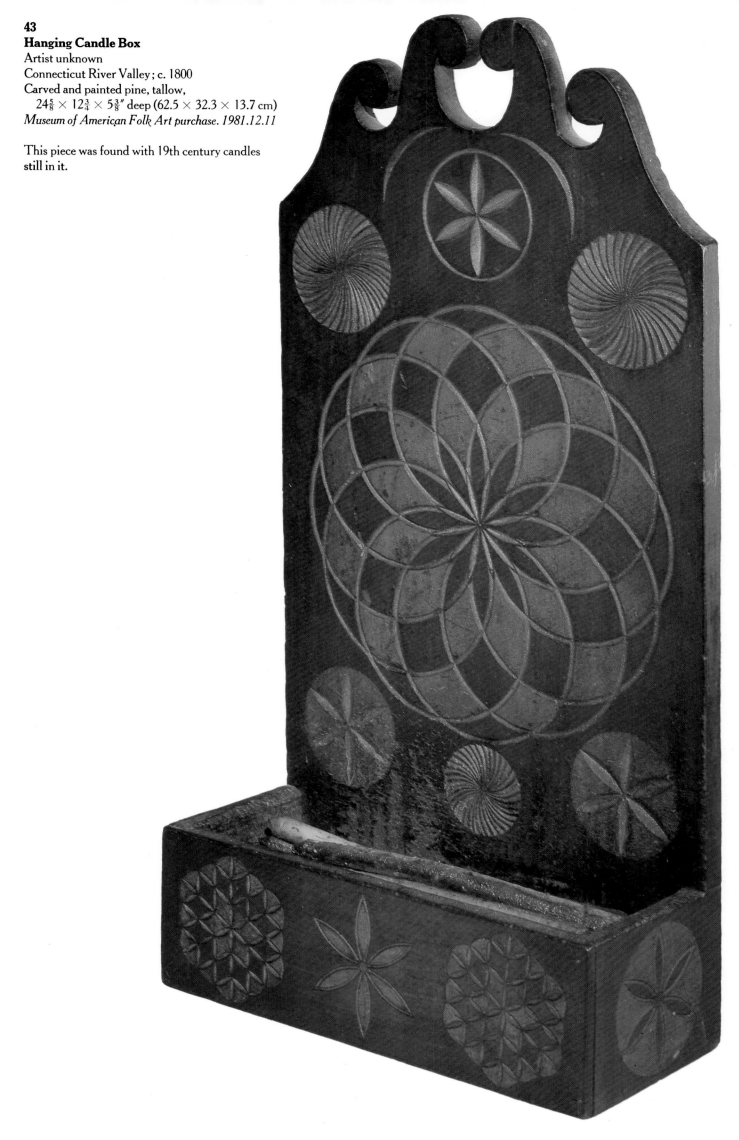

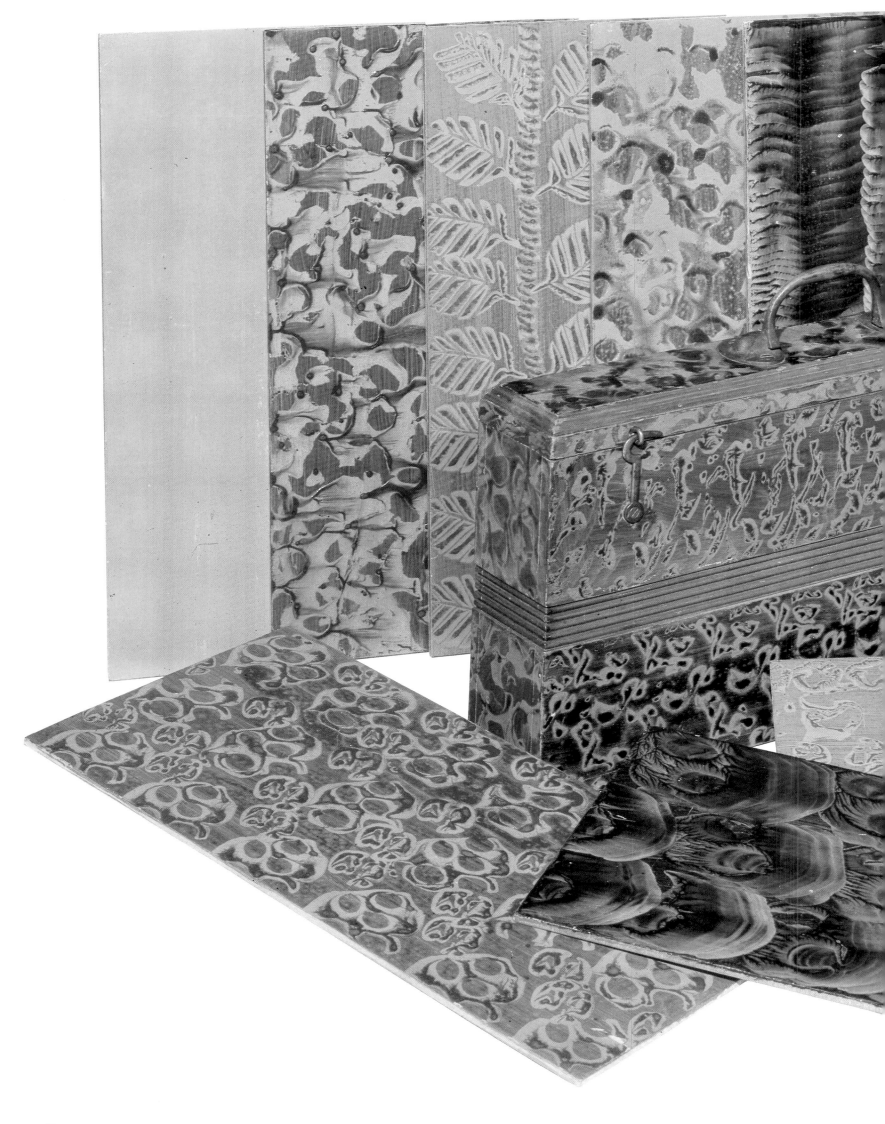

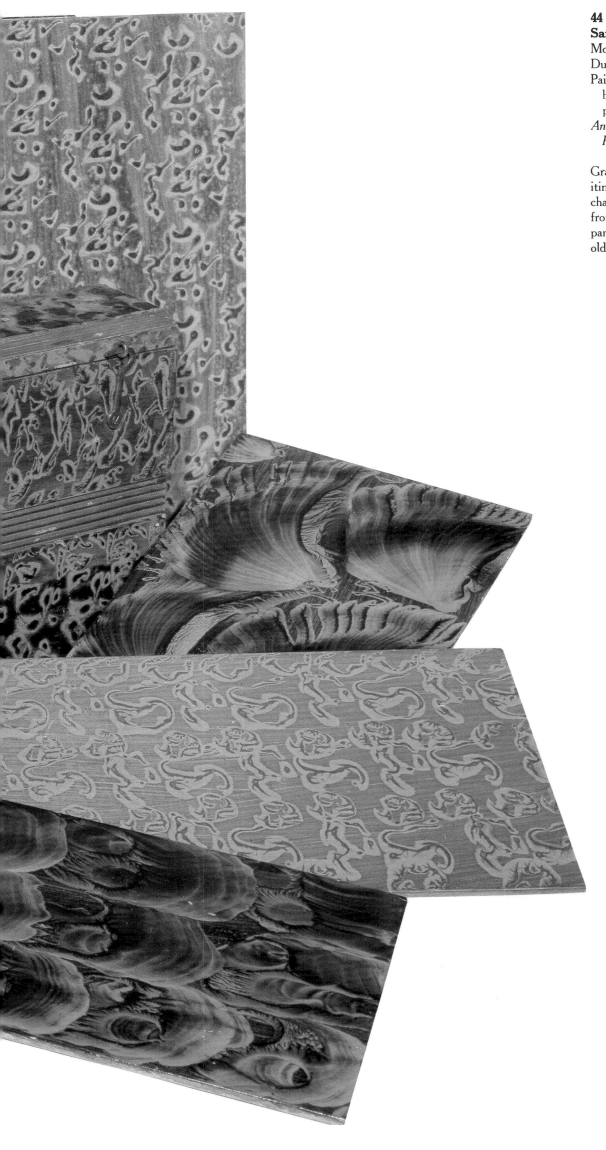

44
Sample Box Containing 10 Panels
Moses Eaton (1753-1833)
Dublin, New Hampshire; 1800-30
Painted and decorated pine, brass,
 box: $8\frac{3}{4} \times 15\frac{1}{16} \times 2\frac{5}{8}''$ (22.2 \times 38.2 \times 6.6 cm);
 panels: $6\frac{7}{8} \times 14 \times \frac{1}{8}''$ (17.5 \times 35.5 \times .2 cm)
Anonymous gift and gift of the Richard Coyle Lilly
 Foundation. 1980.28.1a-k

Graining, which was part of the repertoire of many
itinerant painters, was used to embellish doors,
chairs, chests or other wooden objects fashioned
from less desirable wood. The box containing the
panels is grained on all sides. It was found on the
old Moses Eaton farmstead in New Hampshire.

45
Trinket Box with Eagle Decoration
Artist unknown
New England; 1820-40
Painted and decorated wood with grained interior,
 $6\frac{3}{8} \times 14\frac{7}{8} \times 8\frac{1}{8}''$ deep (16.2 × 37.8 × 20.6 cm)
Eva and Morris Feld Folk Art Acquisition Fund.
 1981.12.21

This trinket box displays on its cover an eagle,
the symbol of the new republic. The interior of
the box is sponge-decorated and contains nine
small drawers.

46
Storage Box, initialed "D.B."
Artist unknown
New England; 1820-40
Painted and decorated wood, iron, lined with
 newspaper, $11\frac{3}{4} \times 23\frac{3}{4} \times 11\frac{7}{8}''$ deep
 (29.8 × 60.3 × 30.1 cm)
Gift of Howard and Jean Lipman. 1977.7.1

American painted furniture at its best is bright,
bold and beautiful, all characteristics of this piece.

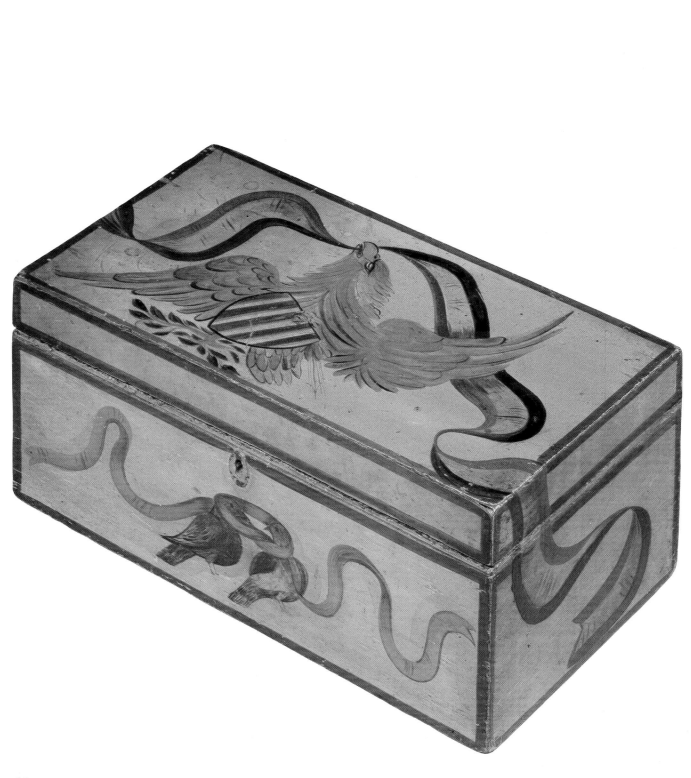

47
Trinket Box with Portraits
Artist unknown
New England; c. 1825
Watercolor, pencil, pen and ink on paper panels
under glass, wood, brass, $4\frac{1}{2} \times 8 \times 5\frac{1}{8}''$ deep
($11.4 \times 20.3 \times 13$ cm)
Museum of American Folk Art purchase. 1981.12.17

Several small watercolor portraits have been
incorporated into the design of this unusual box.
They probably depict members of the artist's family.

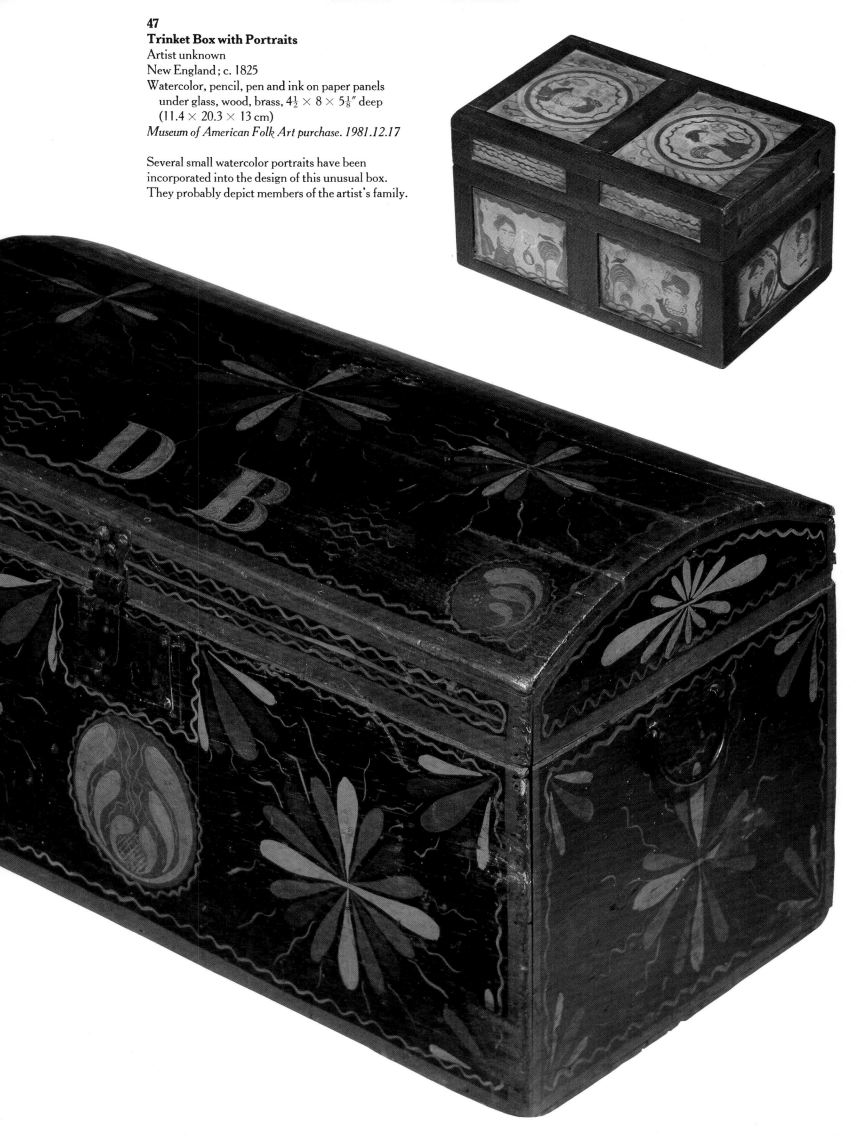

48
Sideboard Table
Artist unknown
Found in Connecticut; 1835
Painted and grained wood, brass,
 $34\frac{1}{2} \times 26 \times 20''$ deep (87.6 × 66 × 50.8 cm)
Eva and Morris Feld Folk Art Acquisition Fund.
 1981.12.6

An exuberant and inventive piece. The sponge and
feather decoration on this country sideboard was
intended to imitate the finely grained wood used
in the construction of costly city furniture.

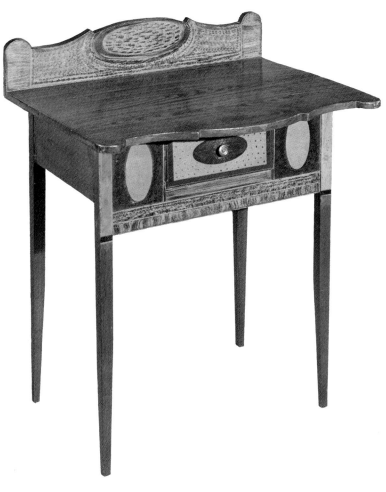

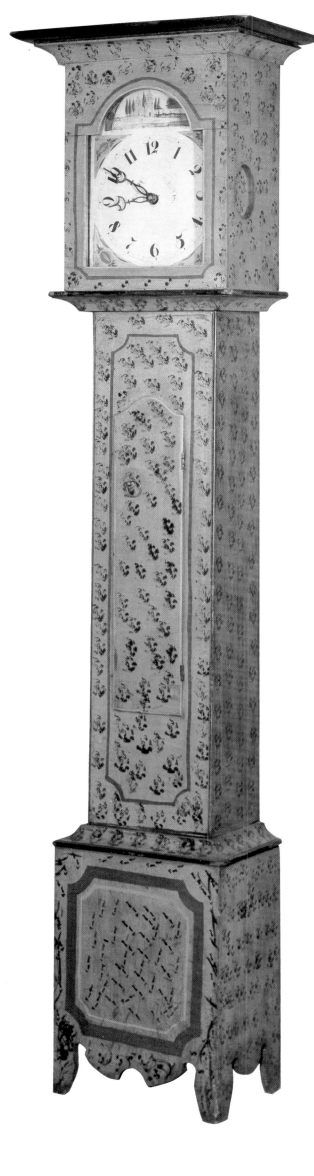

49
Tall-case Clock
Artist unknown
Probably New Jersey; c. 1840
Painted and decorated pine case, with iron works,
 87 × 21½ × 12¾″ deep (220.8 × 54.6 × 32.3 cm)
Eva and Morris Feld Folk Art Acquisition Fund.
 1981.12.22

The decorative pattern on this clock has been called
"paw printed;" it was probably created with a bit of
sponge, crumpled paper or cloth.

50
Chest of Drawers
Attributed to Jacob Mazur (active 1820's and 30's)
Mahantango Valley, Pennsylvania; dated 1830
Painted and decorated pine, brass,
 47½ × 43⅜ × 22″ deep
 (120.6 × 110.1 × 55.9 cm)
Museum of American Folk Art purchase. 1981.12.3

Mahantango Valley craftsmen painted small highly
stylized motifs on a flat background color. Many
of these designs are similar to traditional fraktur
motifs used by artists executing illuminated
manuscripts.

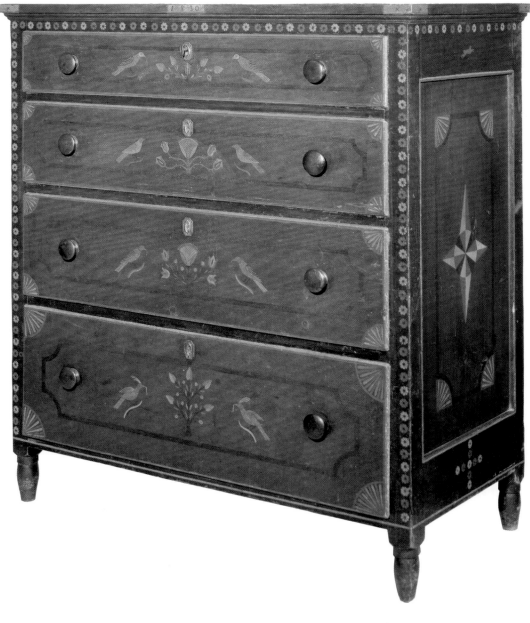

FOLK SCULPTURE & three-dimensional works

Almost as soon as permanent settlements were established in the New World, the folk sculptor found a substantial demand for his efforts. Carved religious figures were important in church and domestic life in the southwestern Spanish Colonial settlements. In the east, carved stone monuments and gravemarkers are the earliest dated examples of American folk sculpture. Groups of gravemarkers with stylistic similarities indicate that stonecutters working in close proximity in the 18th century borrowed design concepts from one another and developed a common type of embellishment. This stonecutting tradition changed with popular taste as new ideas about design were transported to America by immigrants throughout the Colonial and Federal periods. By the mid-19th century most stonecutters were forced from their profession when machine technology began to replace handcraftsmanship.

Woodcarvings for ship decorations are nearly as old as the shipping industry itself. Throughout the 17th century and the first half of the 18th century, Colonial figureheads generally followed English prototypes and were in the form of "lions and other beasts." By the mid-18th century representations of human figures symbolizing a vessel's name became popular. In the 19th century wooden sailing vessels constructed in burgeoning seaboard cities on both the Atlantic and Pacific coasts were decorated with elaborately carved wooden figureheads, matching sternboards, pilot-house carvings and other three-dimensional embellishments. The art of the sea also encompassed scrimshaw—carved and decorated pieces of whalebone and ivory generally fashioned by sailors on long sea journeys aboard ship.

The trade sign took many forms in early America. When education was a privilege and literacy rare, the ideal trade sign immediately caught the attention of a passerby and because of its design was totally self-explanatory. The popular life-sized three-dimensional figures in the forms of Indians and blackamoors for the tobacconists shops, and Orientals for tea stores, enjoyed a great popularity in the second half of the 19th and early 20th centuries. These marvelous examples of carved Americana are among the most treasured artifacts of a society which respected mercantile success.

During the second half of the 19th century and the early 20th century immigrant German woodcarvers employed in woodworking shops located primarily in New York and Philadelphia produced carousel horses, circus wagons, cigar store Indians and other decorative, utilitarian carvings.

Pieces created in the shop tradition were generally worked on by more than one carver. They do not possess the single vision of an individual artist. Mail-order catalogues offered these pieces to a substantial middle-class audience. In order to meet the increasing demand for objects of this type, technology was once again harnessed and white metal castings produced in great quantities signaled the death knell of this branch of the woodcarving profession.

The weathervane represents the second great American sculptural tradition. There are several basic types – handcrafted silhouette and three-dimensional wooden vanes, handcrafted silhouette and three-dimensional metal vanes, and factory produced vanes. The factory vanes were made by carving a wooden pattern and then fashioning a metal mold from it. A craftsman would hammer thin sheets of copper into the metal mold and create various parts of the body of a vane. These were then soldered together to form a finished piece. In time, technology developed to the point that it became possible to stamp out weathervane parts and handcraftsmanship disappeared from the process.

Certainly no one can be sure when the first American whirligig or windtoy was constructed. One of the earliest references to such a device was made by Washington Irving in his 1819 story, "The Legend of Sleepy Hollow":

Thus while the busy dame bustled about the house, or plied her spinning-wheel at one end of the piazza, honest Balt would sit smoking his evening pipe at the other, watching the achievements of a little wooden warrior, who, armed with a sword in each hand, was most valiantly fighting the wind on the pinnacle of the barn.[7]

Because of their fragility, few whirligigs fashioned before the second half of the 19th century have survived. Most were created by untrained carvers and were quite rudely executed. Despite this crudeness, which often adds to its appeal, the whirligig many times conveys a whimsical point of view or makes a comment about American society that is characteristic of the best American folk sculpture.

Archeologists have determined that waterfowl decoys were probably first used by American Indians in the southwest. Combining tightly-bound reeds with feathers, tribesmen of the Tule Eaters created a remarkable imitation of a canvasback duck well over 1,000 years ago. Indians in eastern North America at the same time stacked small stones on top of larger ones to form visual imitations of resting ducks, which would lure waterfowl within striking range of the bow

and arrow. Early American colonists quickly recognized the value of the decoy and began to use it.

During the last half of the 19th century the demand for food, improved firearms and a seemingly inexhaustible supply of wild birds gave rise to the sport of duck-hunting. Regional types of decoys developed because of local hunting conditions. It became financially profitable to manufacture, in specialized factories, wooden decoys that could be marketed at a price between $9 and $12 per dozen. The Mason's Decoy Factory at Detroit, Michigan, competed favorably in a nationwide marketplace. Factory production introduced innovations that a single carver could not achieve. Rubber decoys appeared in 1867; honking decoys that operated by water current were factory-produced; and by 1873 numerous patents had been granted for metal duck bodies that floated on wooden bases and tin shore bird decoys that could be folded and transported easily.

In the midwest, around the Great Lakes area, fish decoys were used for fishing through the ice. These hand-carved lures range in size from a few inches to several feet long and were often sculptural in form.

Until the time of the Industrial Revolution, probably no other type of folk art was created in such prodigious numbers as utilitarian objects made of clay. The potter was an important part of every community, and while not every craftsman was an artist, his products met the undemanding aesthetic requirements of the clientele he served. Some artisans fashioned delightful and even frivolous pieces to fit the country woman's craving for imported Staffordshire ornaments which she could not afford. As long as household and utilitarian pieces were fashioned by hand, they continued to be original and beautiful. Once factory production made it economically impossible for handcrafted objects to be competitively marketed, they all but disappeared.

Chalkware is another sculptural form that enjoyed immense popularity in rural America. These cast plaster decorative ornaments were individually decorated and provided an inexpensive alternative to imported European ceramics. Chalkware is rich in color and whimsical in design. At its best, it is a vibrant indication of 19th century American taste.

Some of the most beautiful pieces of utilitarian folk sculpture came from the highly-talented hands of the members of America's communal settlements. From the early days of the New World, thousands of men and women entered into a bewildering variety of communal ventures. Most often motivated by a commitment to sectarian religion or to the burning call for social reform, they built villages which dotted the rural landscape.

They frequently served as models of self-sufficiency, efficient community organization and human social consciousness, and often preserved Old World cultural patterns and folk traditions. By its very nature the communal society generally tended to limit the view of the world and existed within self-erected boundaries. Many of these communities were places of spiritual life and art for art's sake was ignored or of little concern.

Of the many communal societies, none was as important, lasted as long, or contributed so much to the American experience as the Shakers, or the United Society of Believers in Christ's Second Appearing, who built more than 20 villages scattered from New England to Indiana in the late 18th and early 19th centuries. Members of the Shaker Society were drawn from numerous cultural and socioeconomic backgrounds. In this mix of peoples there emerged a surprisingly progressive and life-affirming system which produced a creative spirit among the faithful.

The impact of the Shaker aesthetic led to the elimination of "superfluities" in life and in craftsmanship. Celibacy, the equality of men and women in communal life, and the strong sense of living close to the "other world" had their effect on Shaker artistic expression and artisanship. The paradox of simplicity in Shaker architecture and furniture and of extravagance in inspirational drawings establishes two opposite poles of creativity between which an extraordinary outpouring of fine handcraftsmanship existed. The superb design inherent in the Shaker experience has made a lasting imprint on American folk art.

[7] Bishop, Robert. *American Folk Sculpture*. New York: E. P. Dutton & Co., Inc. 1974, p. 12.

51
Flag Gate
Artist unknown
Jefferson County, New York; c. 1876
Polychromed wood, iron, brass,
 $39\frac{1}{2} \times 57 \times 3\frac{3}{4}''$ deep (100.3 × 144.6 × 9.5 cm)
Gift of Herbert Waide Hemphill, Jr. 1962.1.1

The celebration of the centennial of American independence and the great Centennial Exhibition held at Philadelphia in 1876 heightened the national consciousness of Americans, and folk artists increasingly turned to patriotic themes. This extraordinary evocation of the American spirit, a gate patterned after Old Glory, graced the Darling Farm, Jefferson County, New York.

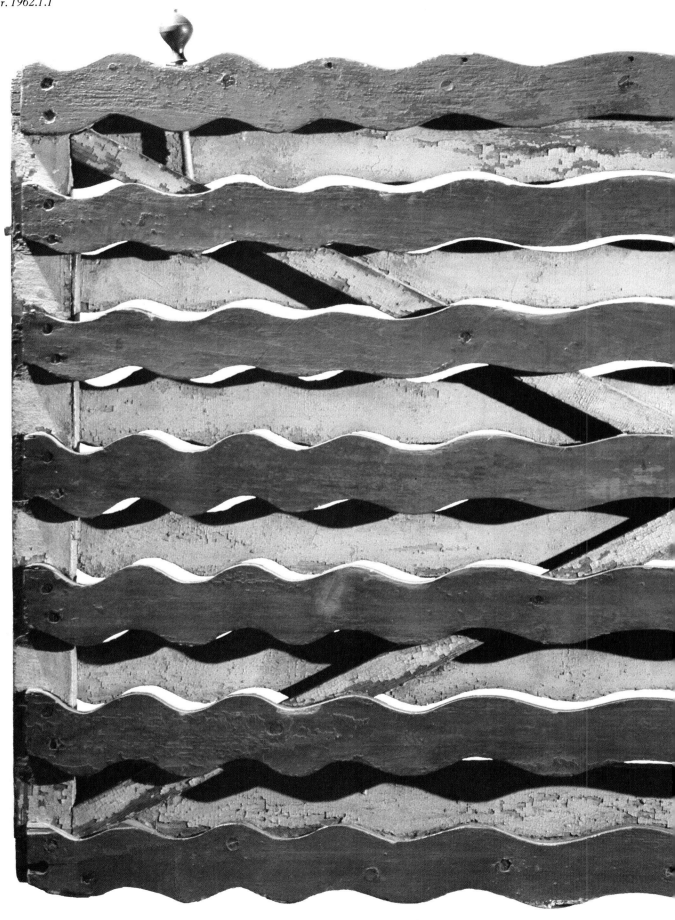

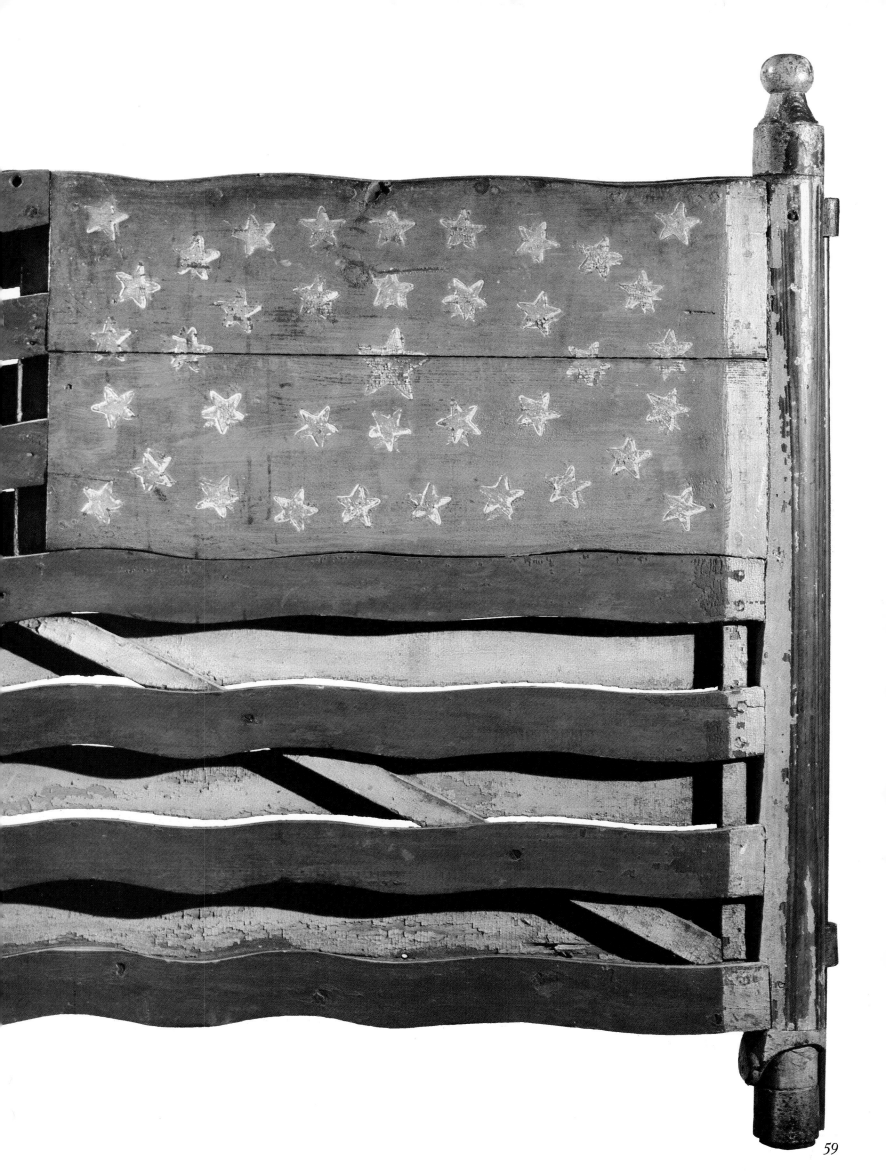

52

Trade and Inn Sign: inscribed on one side—
 "E. Fitts, Jrs. Store"—on the reverse side
 "E. Fitts, Jr. Coffeehouse 1832"
Artist unknown
vicinity of Shelburne, Massachusetts
Polychromed wood, wrought iron, image, oval:
 $22\frac{3}{8} \times 34\frac{1}{2}''$ (56.8 × 87.6 cm); oa: $46\frac{7}{8} \times 46\frac{3}{8}''$
 (119.1 × 117.8 cm)
Gift of Margery and Harry Kahn. 1981.12.9

The shop sign was one of the earliest forms of
advertising. This one probably was painted by
an itinerant artist. It has been embellished with
an ornate wrought iron frame.

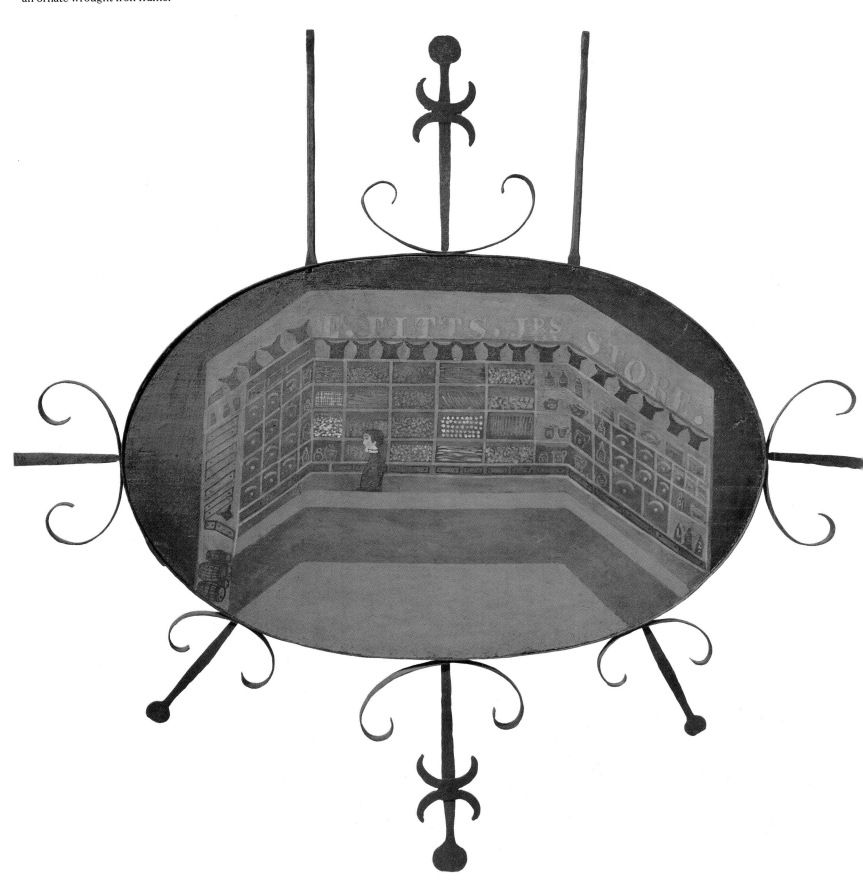

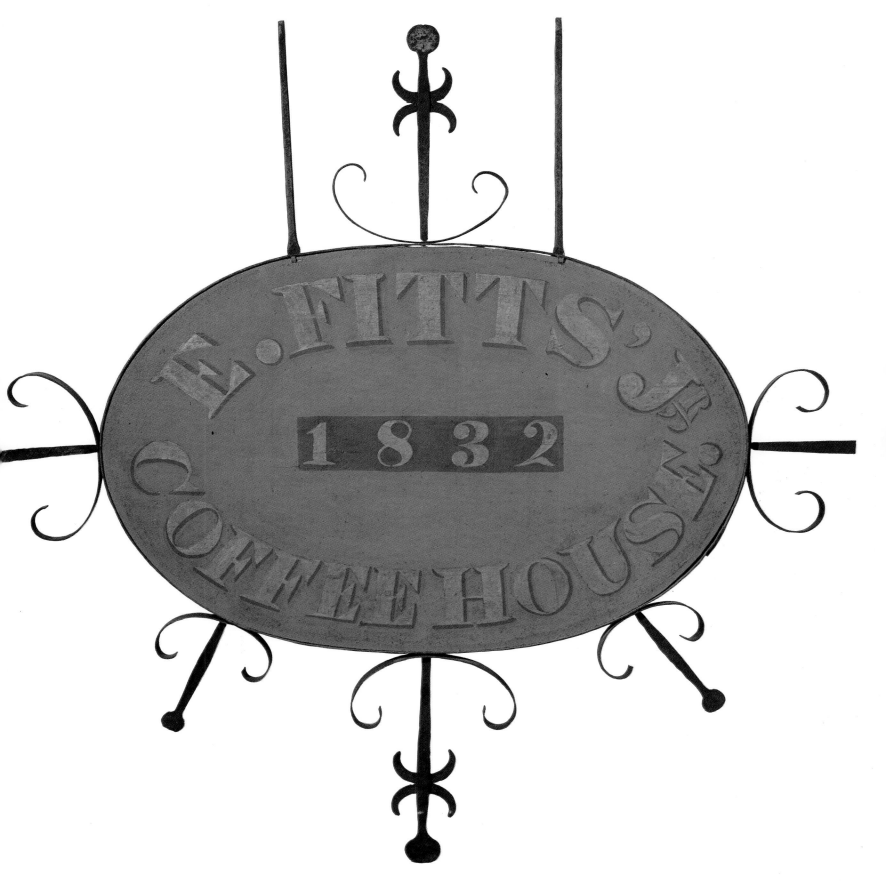

53
Fireboard
Artist unknown
Connecticut; c.1840
Carved and polychromed pine,
$43\frac{1}{4} \times 47\frac{1}{8} \times 7''$ deep (109.8 × 119.7 × 17.8 cm)
Museum of American Folk Art purchase. 1981.12.12

This architectonic fireboard was probably inspired
by the spires of a church. Constructed of wide
boards held together with battens on the back, it
was either attached to the fireplace frame, or stood
on a wooden base. Fireboards sealed off the
fireplace during the summer months.
The same artist who painted the interior of the
home frequently designed a scene especially for
the fireboard.

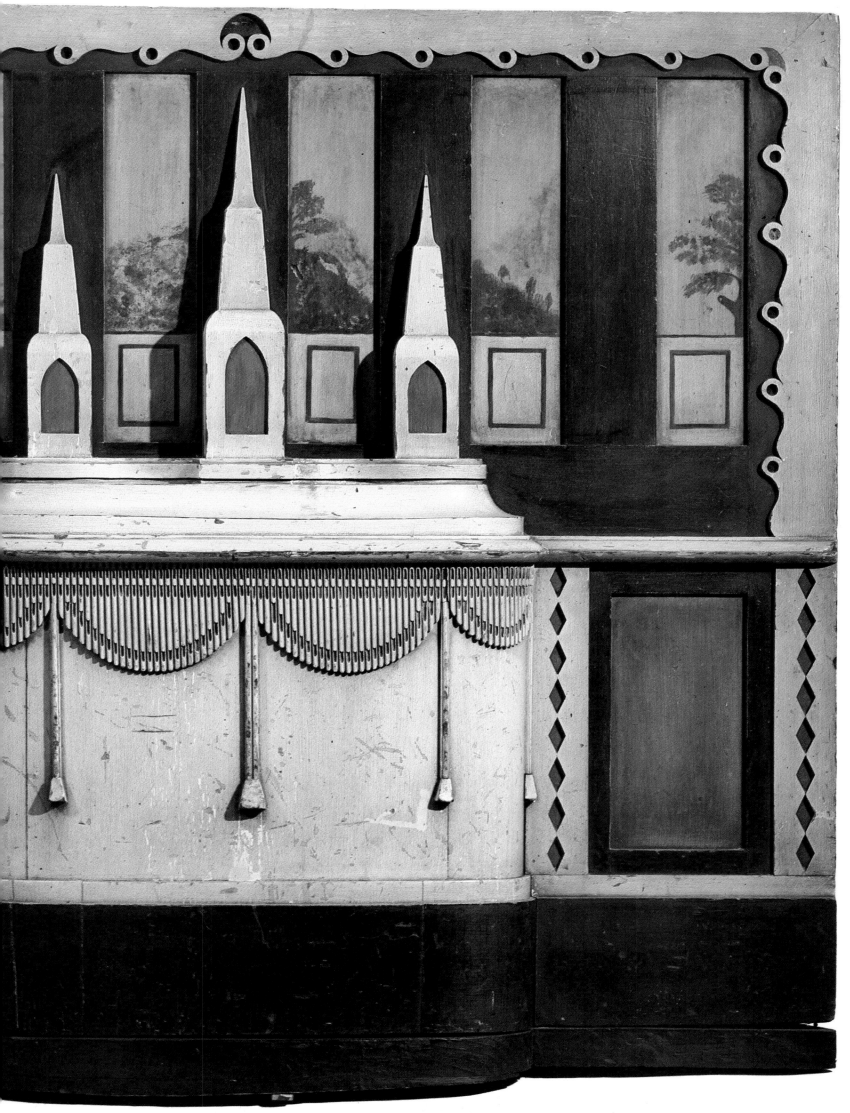

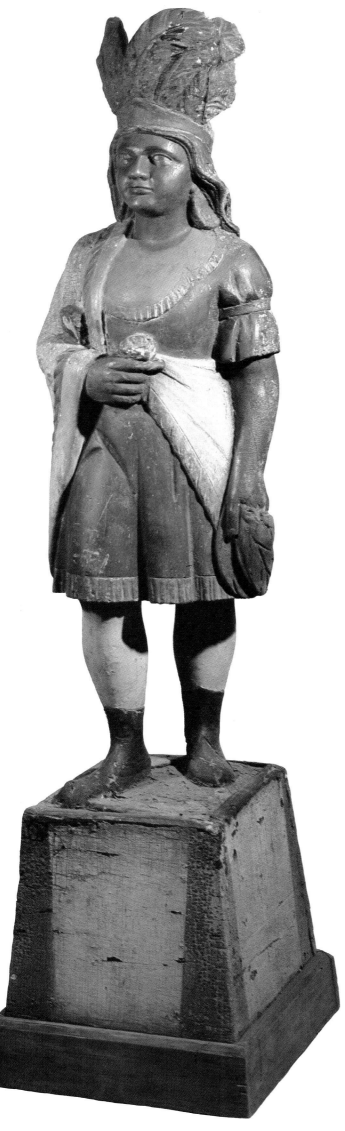

54
Cigar Store Indian Rose Squaw
Samuel Robb (1851-1928)
New York; late 19th century
Polychromed wood, $66\frac{1}{2} \times 17 \times 19\frac{1}{4}''$
 (168.8 × 43.2 × 48.9 cm)
Gift of Sanford and Patricia Smith. 1981.15.1

The Robb carving shop in New York City
employed many carvers who fashioned a virtual
tribe of advertising and trade figures. In the
1890s the cigar store indian began to disappear
from the fronts of shops as local ordinances required
that they be moved inside to relieve sidewalk
congestion.

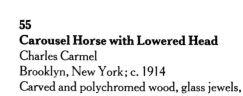

55
Carousel Horse with Lowered Head
Charles Carmel
Brooklyn, New York; c. 1914
Carved and polychromed wood, glass jewels,
 horsehair, $58\frac{5}{8} \times 63 \times 14\frac{7}{8}''$ deep
 ($148.9 \times 160 \times 37.8$ cm)
Gift of Laura Harding. 1978.18.1

Carousel horses were carved in many of the same
shops that created tobacco shop figures and trade
signs. The wood most frequently used was white
pine. Generally, more than one person worked on a
piece, which was cut from one large section of wood.
The first American carousel horses were fashioned
in the 19th century. At the close of the Victorian era
they were manufactured in specialty shops utilizing
assemblyline production techniques.

56
Wool Winder
Artist unknown
Connecticut; c. 1875
Carved, turned and polychromed wood,
 39¼ × 16 × 26⅛" deep (99.7 × 40.6 × 66.3 cm)
Eva and Morris Feld Folk Art Acquisition Fund.
 1981.12.10

Carved in the form of a standing woman, this wool
winder has the simplicity and boldness of modern
sculpture.

57
Man in a Top Hat with a Cane
Artist unknown
probably New York; c. 1870
Carved and painted wood figure, painted and
 smoke-decorated base, 23½ × 7½ × 7½" deep
 (59.7 × 19.1 × 19.1 cm)
Joseph Martinson Memorial Fund,
 Frances and Paul Martinson. 1981.12.5

Although many 19th century carved figures were
intended as trade or shop signs, this humorous
figure probably was simply a decorative piece.

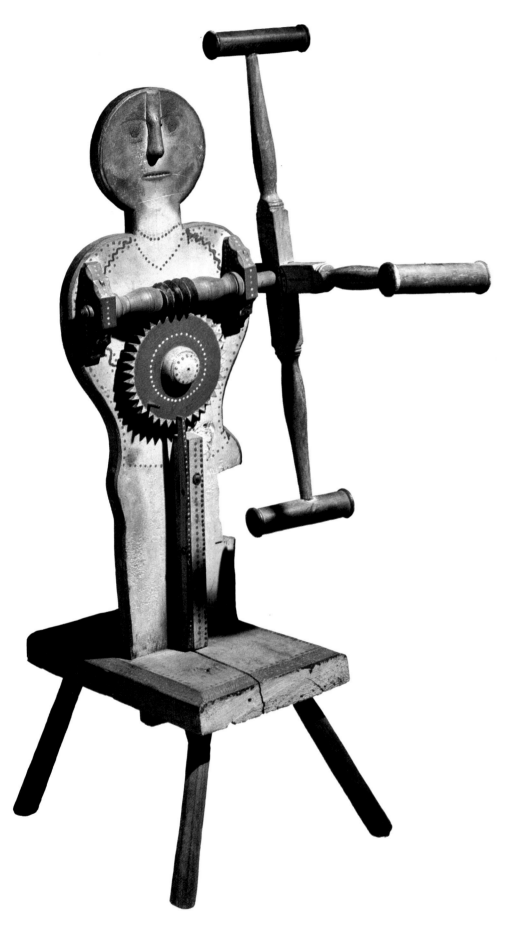

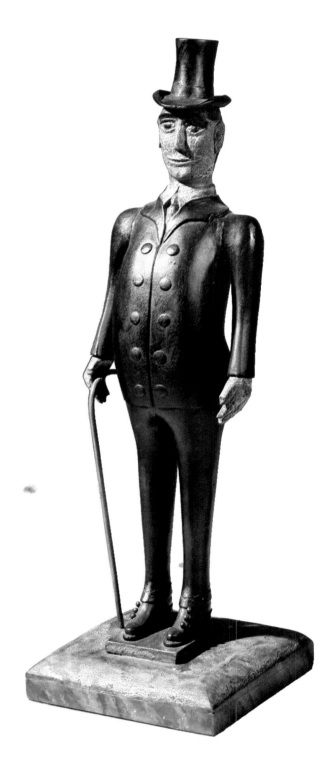

58
Father Time
Artist unknown
Mohawk Valley, New York; c. 1910
Carved and polychromed wood, metal, hair,
 $52\frac{1}{8} \times 13\frac{7}{8} \times 14\frac{1}{2}''$ deep
 (132.3 × 35.2 × 36.8 cm)
Gift of Mrs. John H. Heminway. 1964.2.1

This striking *tour de force* of American folk
sculpture was once articulated so that the right arm
moved and the sickle hit the suspended bell.
The original purpose of this remarkable figure
is uncertain.

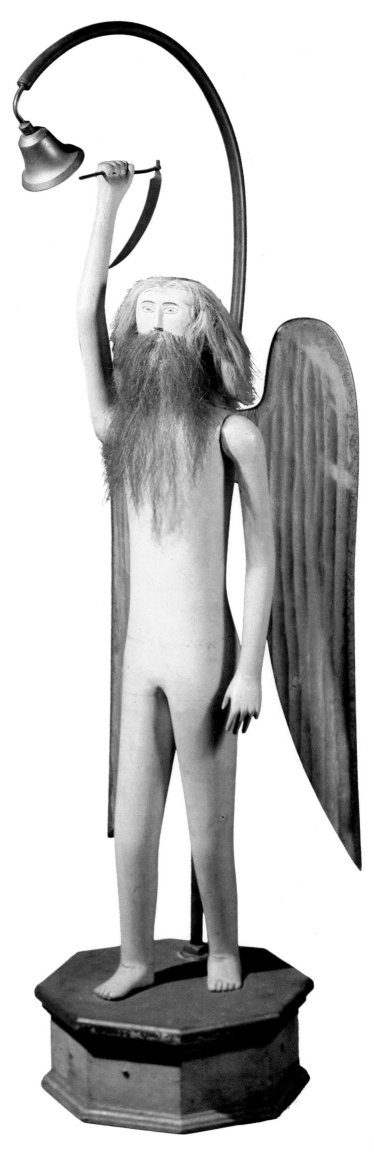

59
Rooster
Wilhelm Schimmel (1817-90)
Carlisle, Pennsylvania; mid-19th century
Carved and polychromed wood $8 \times 5\frac{1}{8} \times 2\frac{5}{8}''$ deep
 (20.3 × 13 × 6.6 cm)
Promised anonymous gift. P79.201.3

Whittled by a Pennsylvania German itinerant
wood carver known as "Old Schimmel," this
rooster is one of approximately 500 pieces he
crafted in the final years of his life. Although
Schimmel was the most talented of the carvers who
wandered through the Cumberland Valley trading
wooden likenesses of birds and animals for a meal,
a bed, or a tote of rum, he died in a poorhouse and
was buried in potter's field. In spite of its diminutive
size this piece has monumental dramatic qualities.

60 & 61
Pair of Bird Trees
Artist unknown
probably Pennsylvania; c. 1875
Carved and polychromed wood, wire,
 $15\frac{7}{8} \times 6\frac{3}{4}''$ diam. (40.3 × 17.1 cm);
 $16\frac{5}{8} \times 6\frac{7}{8}''$ diam. (42.2 × 17.5 cm)
Gift of Mr. and Mrs. Austin Fine.
 1981.12.19, 1981.12.20

Whimsical bird trees were popular among the
Pennsylvania Germans. These examples which
probably served as mantle decorations, retain
their original paint.

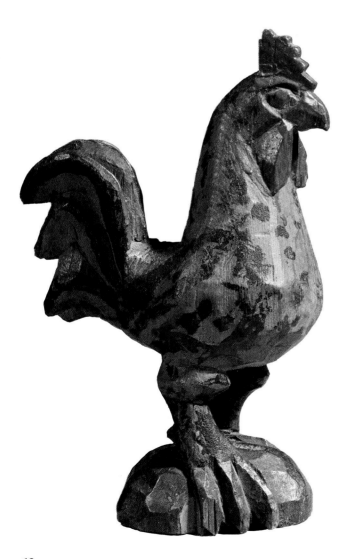

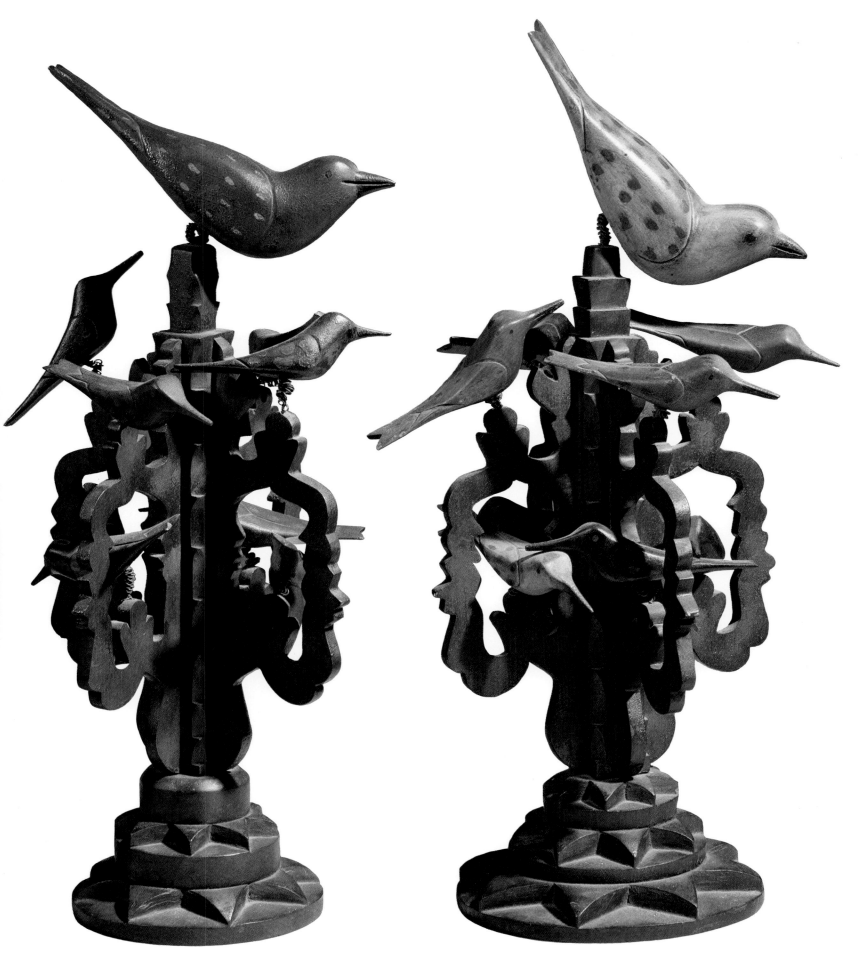

62
Turtle
Artist unknown
American; 19th century
Carved and painted wood $7\frac{1}{4} \times 20\frac{5}{8} \times 7\frac{5}{8}''$ deep
 ($18.4 \times 52.4 \times 19.4$ cm).
Gift of Herbert Waide Hemphill, Jr. 1964.1.2

American folk art is often whimsical. This spotted
turtle with a root neck and head appears to be
smiling.

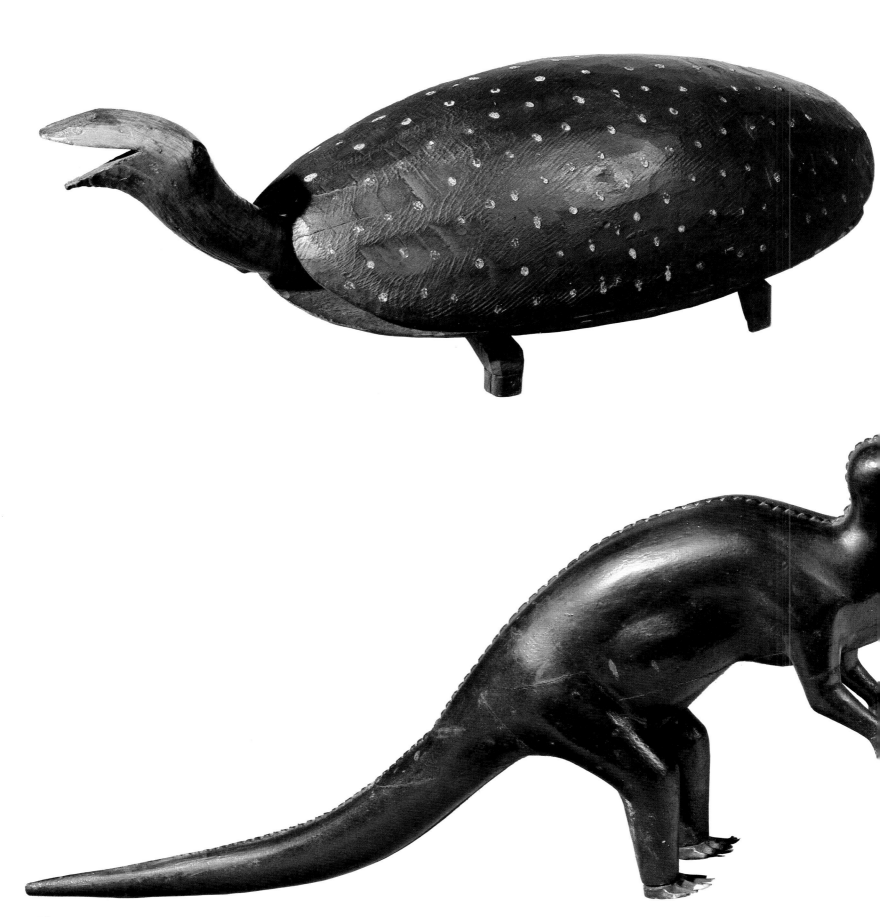

63
Dinosaur
Fred Alten (died 1945)
Wyandotte, Michigan; early 20th century
Carved and painted wood, 9⅜ × 24⅝ × 3½″ deep
 (23.8 × 62.5 × 8.9 cm)
Gift of Mr. and Mrs. Joseph A. Dumas. 1977.2.1

Fred Alten, who spent his early years in Ohio,
moved to Michigan around 1912 and remained
there until his death in 1945. An introverted man,
he spent his leisure hours carving animals in a
woodshed. Alten borrowed many of his ideas from
the book, *Johnson's Household Book of Nature*,
which contained descriptions and illustrations of
modern and prehistoric animals based on the
works of Audubon, Wallace, Wood and other well
known naturalists.

64
Cat Bootscraper
Artist unknown
American; late 19th century
Cast iron, 11⅜ × 17½ × 3″ deep
 (28.9 × 44.5 × 7.6 cm)
*Gift of the Friends Committee of the Museum of
 American Folk Art. 1979.22.1*

During the 19th century cast iron became a
popular and relatively inexpensive material for the
manufacture of a wide variety of utilitarian
objects, including bootscrapers and door stops.
Generally a carver would fashion a wooden pattern,
which in turn would be used to produce a metal
mold. The mold made possible the multiple
production of identical objects.

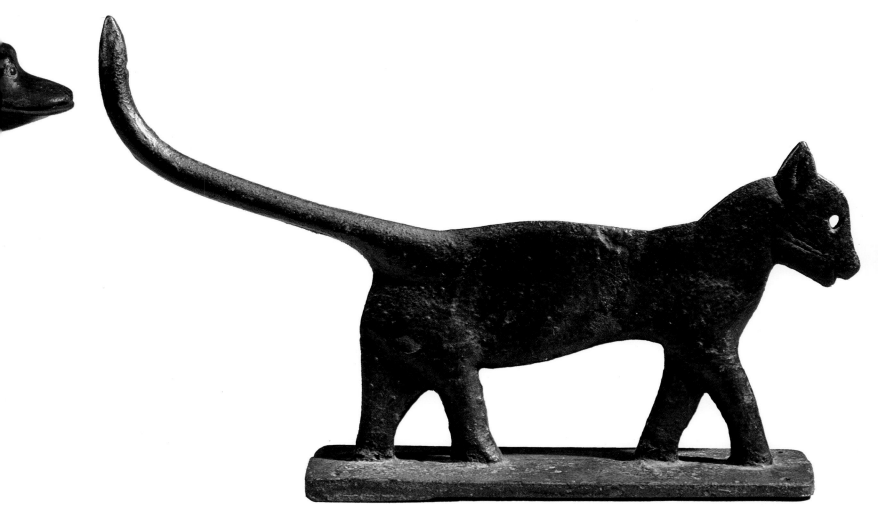

71

65
Bulto Figure
Attributed to Jose Ortega
New Mexico; 1870-1900
Gessoed and polychromed wood, iron, leather,
 45 × 27⅜ × 4¾″ deep (114.3 × 69.5 × 12 cm)
Anonymous gift. 1976.2.1

The religious folk art of New Mexico is distinctive
in its combination of traditional Spanish Baroque
concepts of design with the deep interest in
abstraction of American Indians. In spite of
Ortega's indifference to realism and his deliberate
stylization of form and detail, many of his *bultos*
resemble living New Mexicans of Spanish descent.
This suggests that he may have used relatives or
neighbors as models.

66
Saint Matthew
John W. Perates (1894-1970)
Portland, Maine; c.1930
Carved, polychromed and varnished wood,
 49 × 27⅜ × 6″ deep (124.5 × 69.5 × 15.3 cm)
Promised gift of Robert Bishop. P1.1981.1

John W. Perates, a cabinetmaker, combined his
knowledge of the Bible with his woodcarving skill
to produce a Byzantine-style pulpit and related
icons that were intended to be used in a Greek
Orthodox church in Portland, Maine. Perates,
who came to America from his native town of
Amphikleia, Greece, began carving in 1938, and
his monumental icons are a significant contribution
to the field of American folk sculpture.

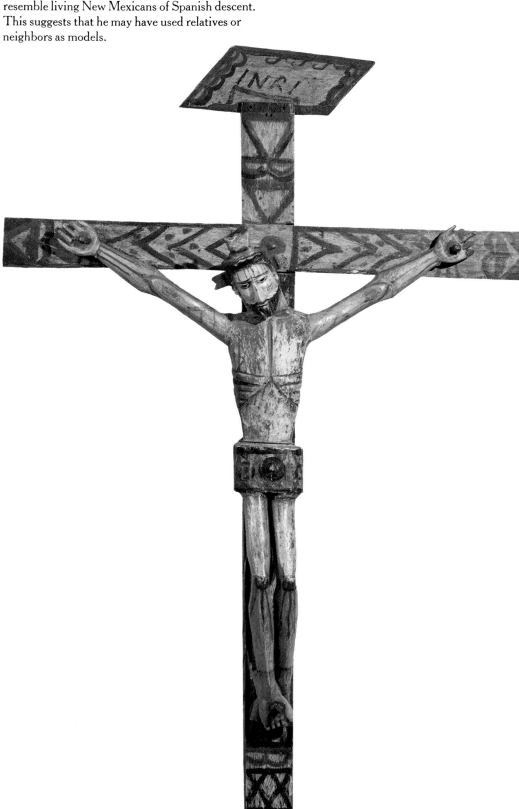

67

Zocobra, Old Man Gloom
Poppsy Schaeffer
New Mexico; c. 1935
Polychromed wood, paper, tacks, celluloid,
59 × 14 × 13⅝" deep (149.8 × 35.5 × 34.5cm)
Promised bequest of Dorothy and Leo Rabkin. P4.1980.41

Poppsy Schaeffer is one of many 20th century naive
artists whose work reflects cultural and social isolation.
He is best known for monumental environmental
works of great complexity and beauty.

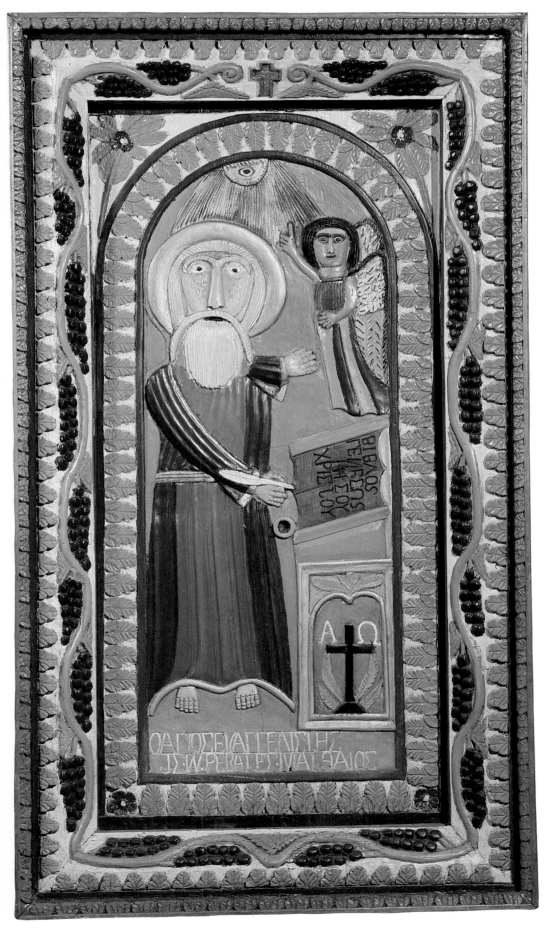

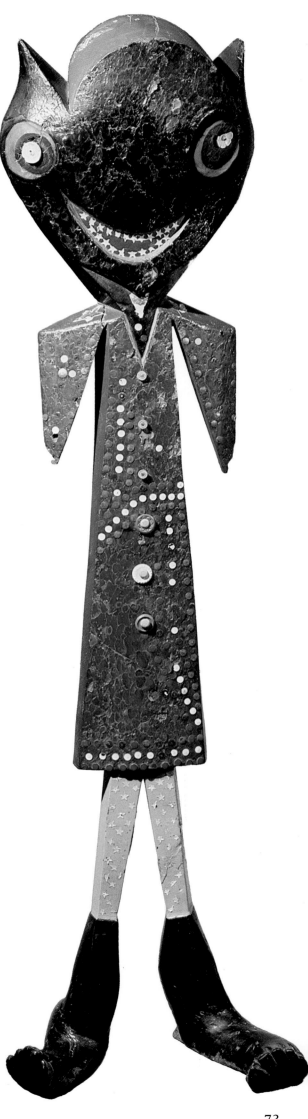

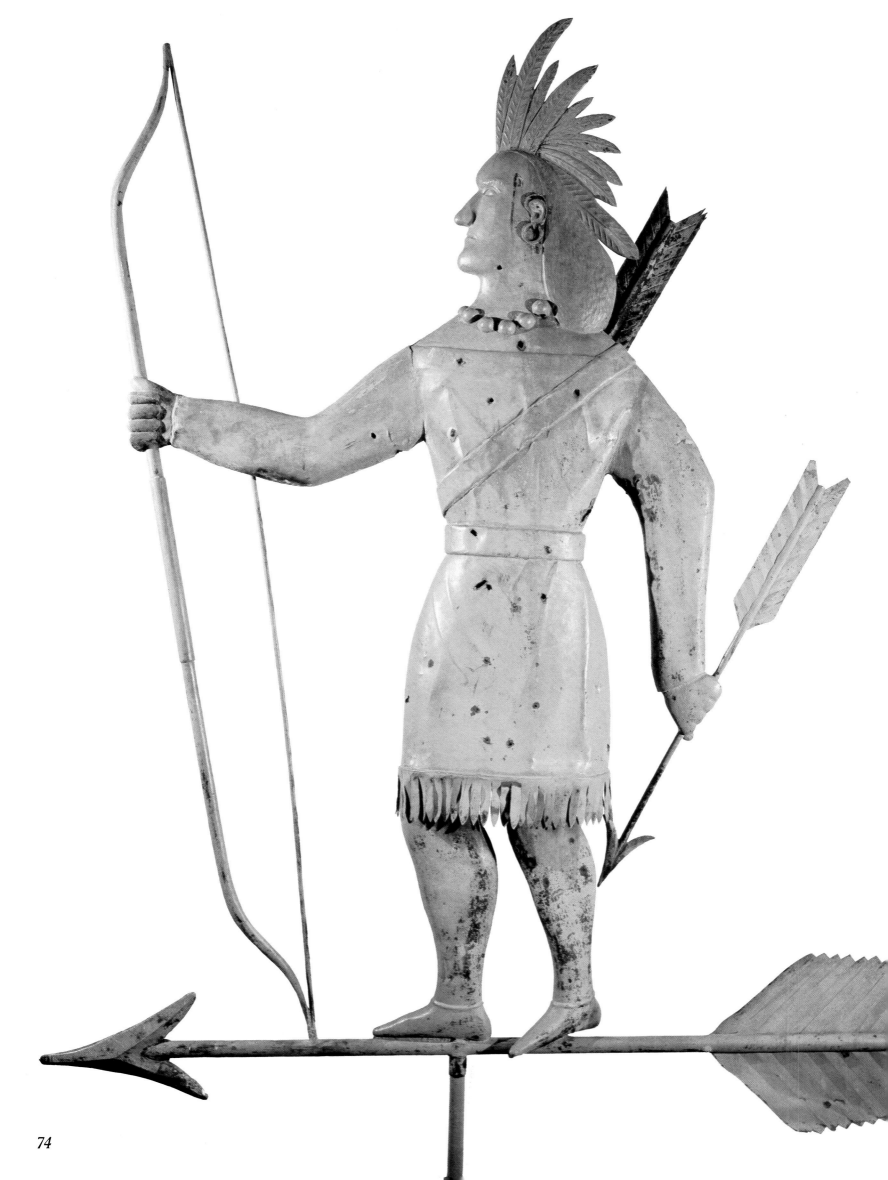

68
Weathervane—St. Tammany
Artist unknown
East Branch, New York; mid-19th century
Molded and painted copper,
$102\frac{1}{2} \times 103 \times 12''$ deep
($260.3 \times 261.5 \times 30.4$ cm)
Museum of American Folk Art purchase. 1963.2.1

This figure of Saint Tammany is unique; no other American vane of such size and workmanship is known. Bullet holes indicate that even this treasure served as a target for prankish marksmen. The vane originally stood on a lodge building in East Branch, New York, where the arrow pointed to the direction of the wind while the figure functioned as a symbol of the organization known as "The Improved Order of Redmen." Numerous fraternal societies adopted Indian customs and dress and pledged allegiance to the ideals of Tammany, Chief of the Delaware Indians, a semi-mythical personage revered in Colonial America for his eloquence and courage. Colonial soldiers who fought against British Sons of St. George or Sons of St. Andrew frequently dubbed themselves Sons of St. Tammany.

69
Weathervane: Archangel Gabriel
Artist unknown
American; 1840
Painted sheet metal, $35 \times 32\frac{1}{2} \times 1\frac{1}{4}$" deep
 (88.8 × 82.5 × 3.1 cm)
Gift of Mrs. Adele Earnest. 1963.1.1

Weathervanes were not only functional pieces
which indicated the direction of the wind; they
were works of art as well. The figure of Gabriel
was used time and again during the 18th and
19th centuries for weathervanes.

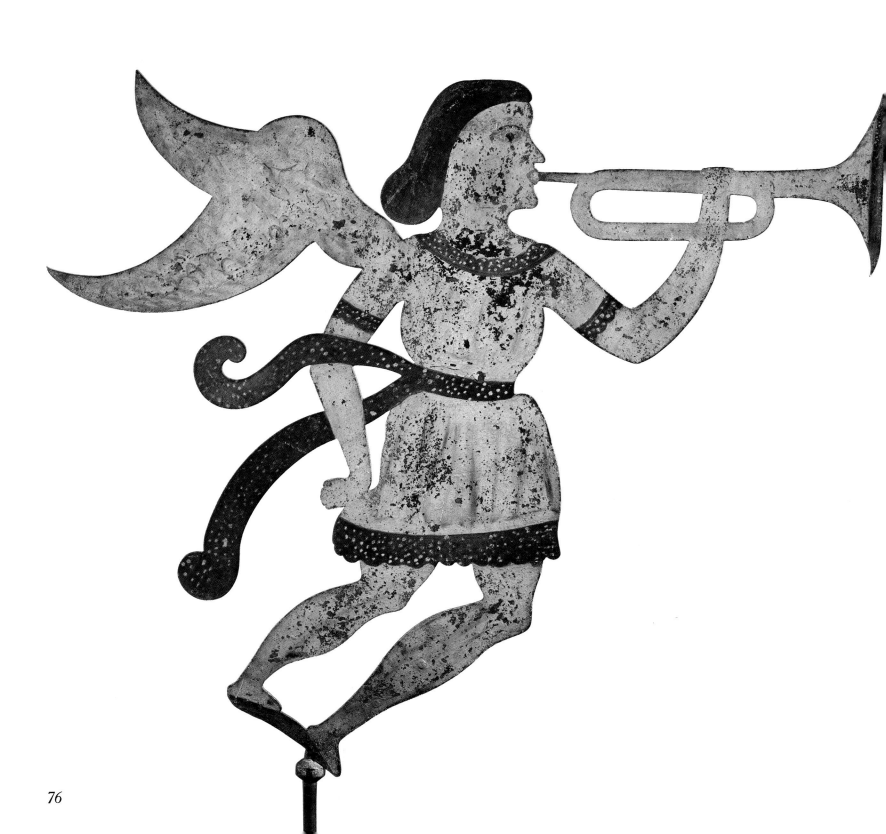

70
Weathervane: Sea Serpent
Artist unknown
Massachusetts; c. 1850
Painted wood, iron, $16\frac{1}{2} \times 23\frac{1}{4} \times 1''$ deep
 $(41.9 \times 59.1 \times 2.5$ cm)
Museum of American Folk Art purchase. 1981.12.13

Early weathervanes were cut from wood with a
chisel or small saw and painted for protection from
the weather. This serpent was probably made for
monitoring the wind in a seaside village.

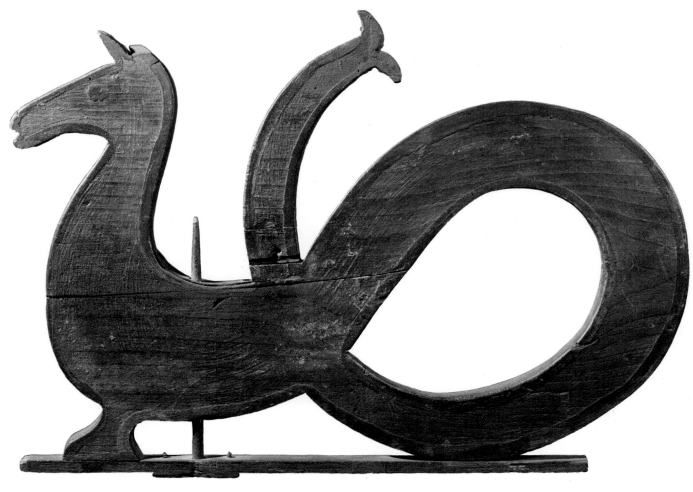

71
Whirligig: Uncle Sam Riding a Bicycle
Artist unknown
New England; 1850-1900
Carved and polychromed wood, metal,
 37 × 55½ × 11″ deep (94 × 141 × 27.9 cm)
Promised bequest of Dorothy and Leo Rabkin.
 P2.1981.6

This handsome whirligig is unusual in that the
Canadian flag is carved and painted on one side
of the tail and the United States flag is on the
reverse side.

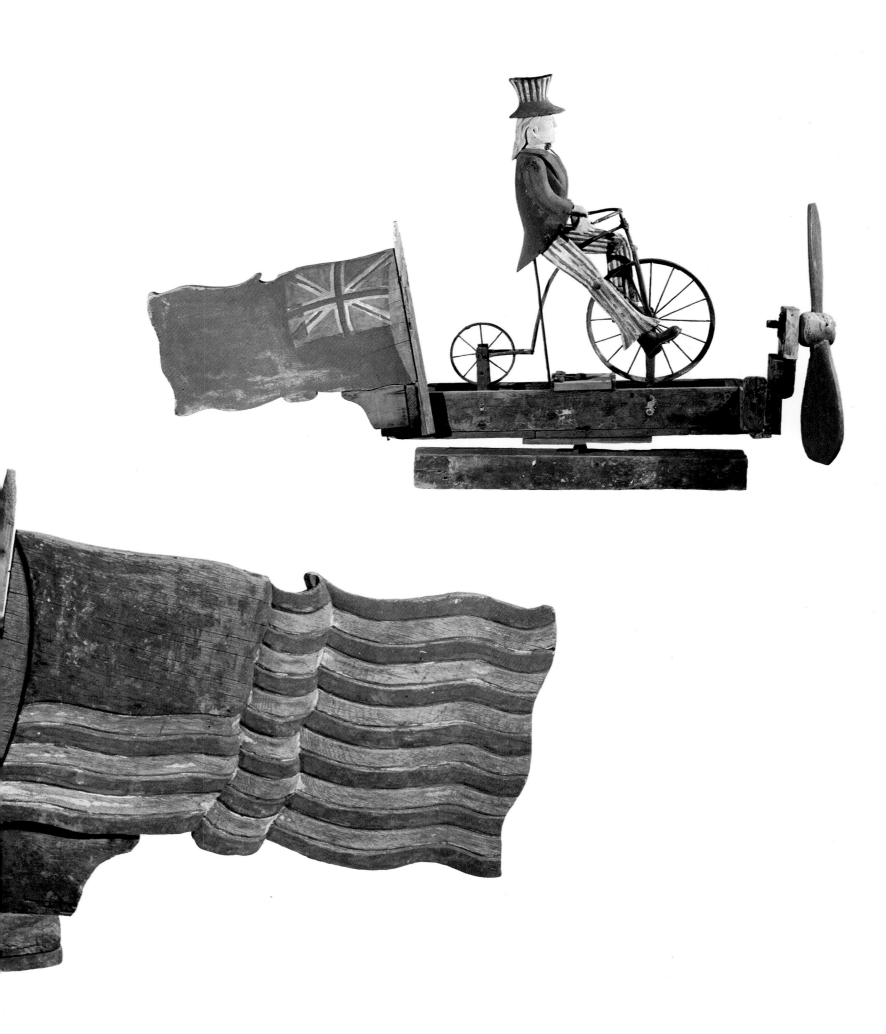

72
Whirligig: Witch on a Broomstick
Artist unknown
New England; 19th century
Polychromed wood, twigs, metal,
 12¼ × 12¼ × 5¼″ deep (31.1 × 31.1 × 13.2 cm)
Promised bequest of Dorothy and Leo Rabkin.
 P2.1981.1

Whirligigs or windtoys are eye catching sculpture
that were made simply for pleasure. They were
used out-of-doors where the wind would catch and
rotate their paddles. This gaily painted and
decorated whirligig is fitted with a broomstick that
is topped by a propeller.

73
Whirligig: Early Bird Gets the Worm
Artist unknown
American; late 19th century
Carved and polychromed wood, wire,
 42½ × 36⅝ × 16¼″ deep (108 × 93 × 41.2 cm)
Promised bequest of Dorothy and Leo Rabkin.
 P2.1981.5

Each section of this whirligig moves. The platform
supporting the cardplayers revolves; two men play
on a seesaw; workers operate a two-man saw;
three men jump industriously on the upper
platform and all the while the early bird chases
the worm.

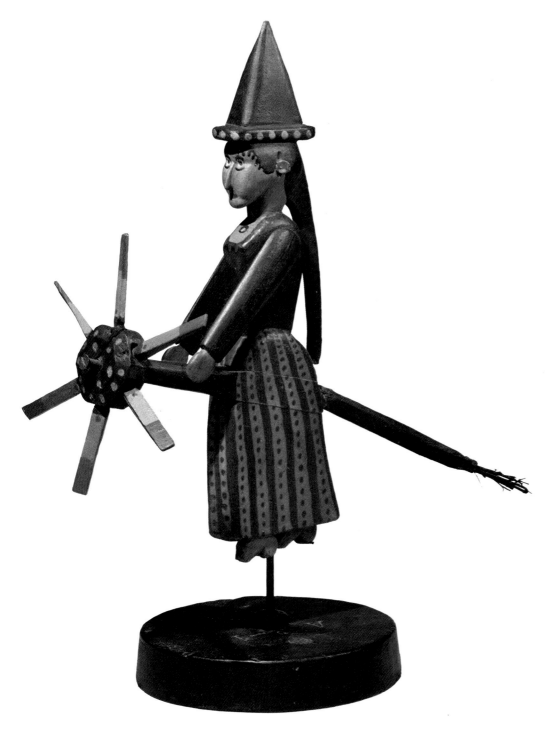

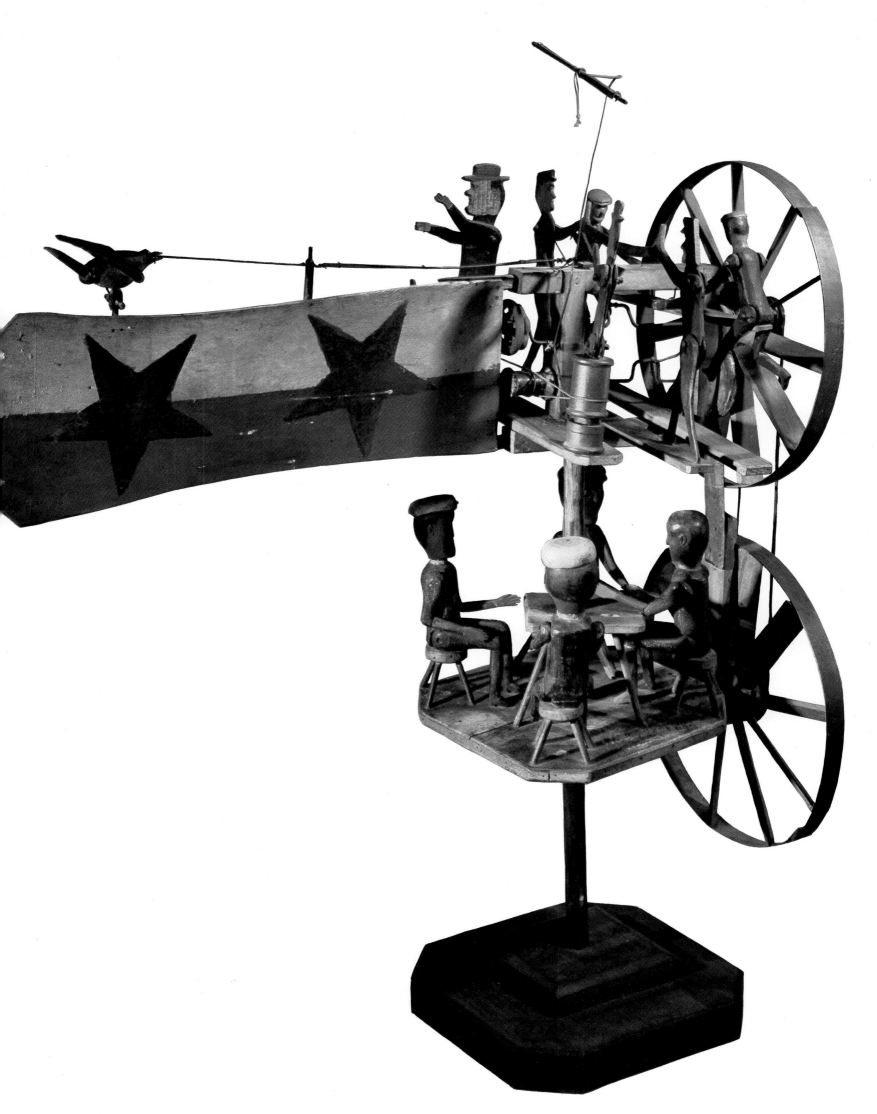

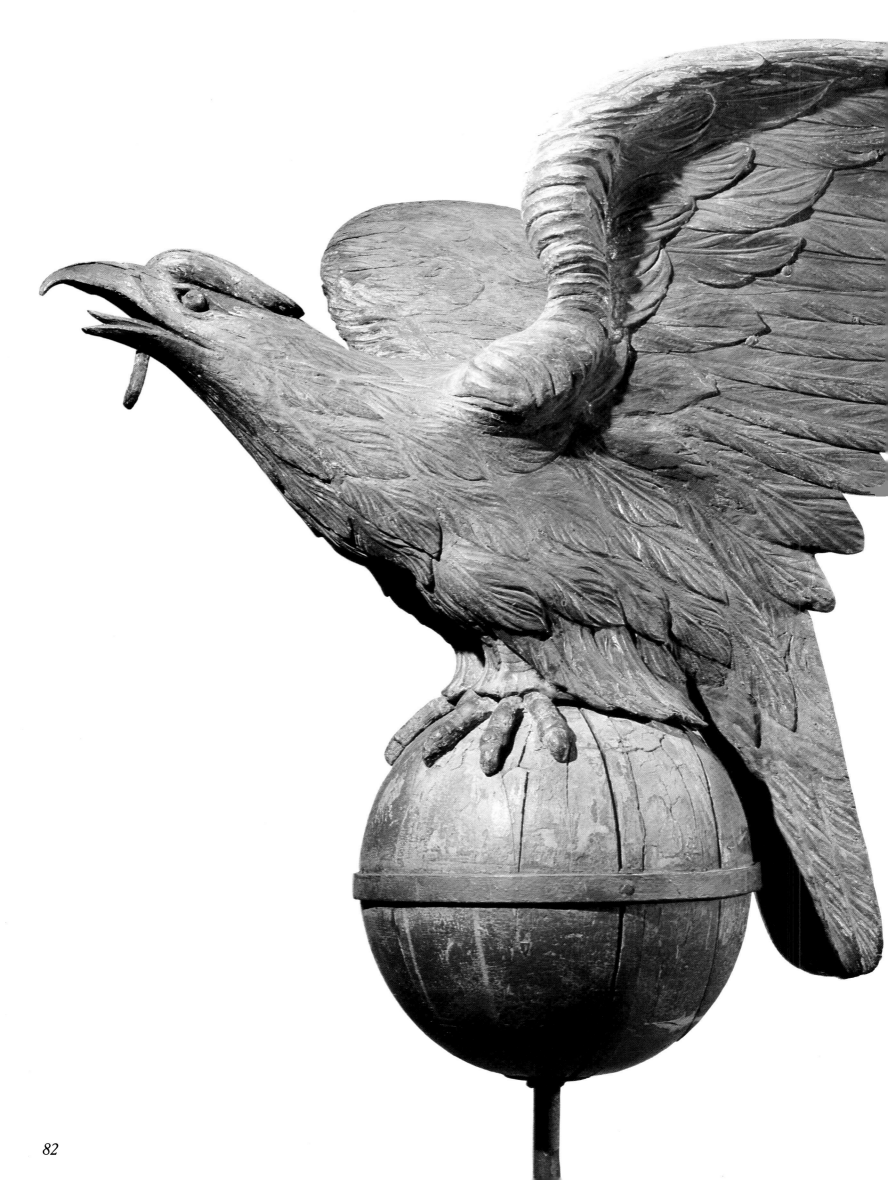

74
Architectural Ornament: Eagle
Artist unknown
Pennsylvania; c. 1905
Carved wood, iron, $69\frac{7}{8} \times 44 \times 50''$ deep
 (177.4 × 111.7 × 126.9 cm)
Gift of William Engvick. 1966.2.1a & b

The patriotic symbol of the eagle was a major
theme in all forms of American folk art. This eagle
stood on top of the Fraternal Order of Eagles Lodge
in Columbia, Pennsylvania.

75
Game of Chance: Auctioneer and Slaves
Artist unknown
Maine; mid-19th century
Painted wood, metal, cotton, paper,
 27 × 24⅝ × 22⅝″ deep (68.5 × 62.5 × 57.5 cm)
Promised bequest of Dorothy and Leo Rabkin.
 P2.1981.2

A growing concern for slaves and an abhorrence of
the institution of slavery ran high in New England
as the 19th century progressed. Each individual
representation of a slave on this game of chance is a
compelling portrait in itself.

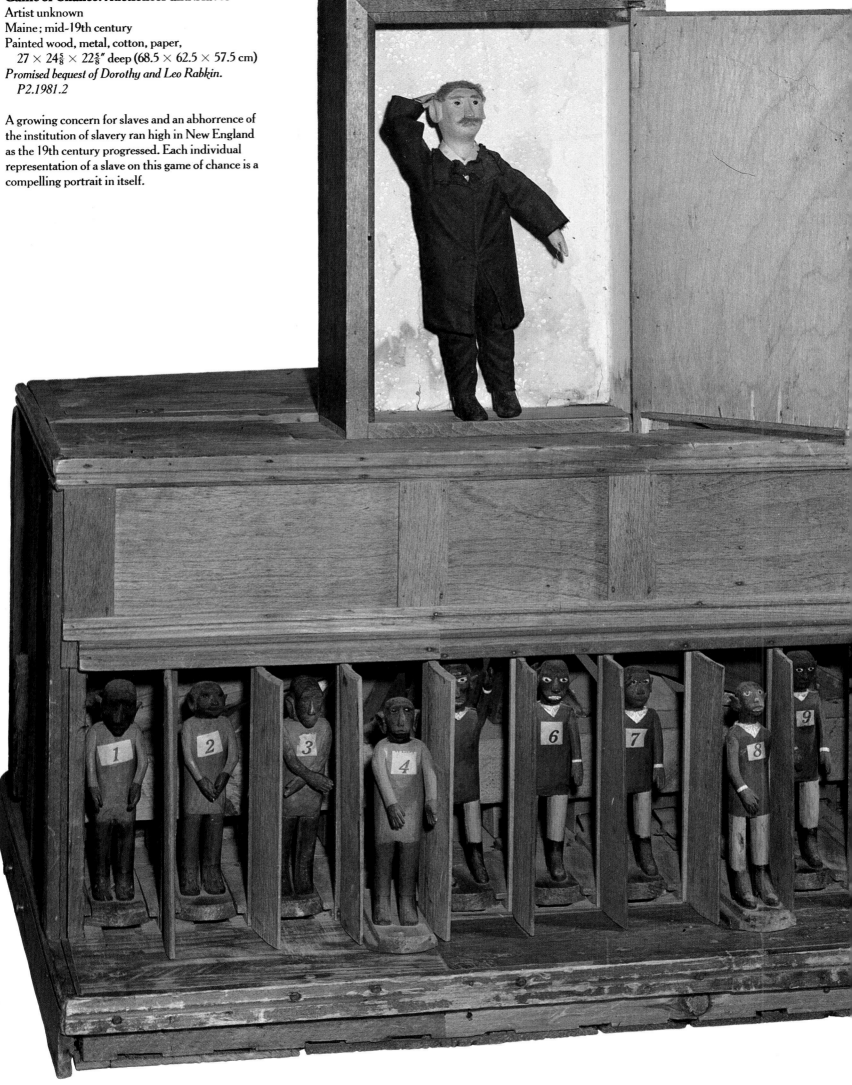

76
Scrimshaw Doll
Artist unknown
American; 19th century
Carved bone, hair, shell, $7\frac{3}{4} \times 2\frac{1}{2} \times 1''$ deep
 $(19.7 \times 6.3 \times 2.5 \text{ cm})$
Promised bequest of Dorothy and Leo Rabkin.
 P2.1981.3

Men aboard American whaling ships used materials
on hand to carve and decorate homecoming gifts.
This dancing doll was probably created by a sailor
for a member of his family.

77
Doll: Part of a Toy
Artist unknown
American; 19th century
Carved bone, $10\frac{5}{8} \times 3 \times 1''$ deep
 $(27 \times 7.6 \times 2.5 \text{ cm})$
Promised bequest of Dorothy and Leo Rabkin.
 P2.1981.4

Scrimshaw, the whalemen's art, provided a link
for the sailor with his home. The scrimshander
(the scrimshaw-maker) produced articles that were
both decorative and utilitarian. Nearly every piece
was intended as a homecoming gift. There is little
doubt that the creation of these fancifully decorated
objects served a therapeutic purpose by providing
a useful means of whiling away idle hours on board
ship. As one "salt" indicated:
 nothing in sight and no signs of ever seeing any
 spirm (sic) *whales around here the old man and the*
 mate devote their time a Scrimshorning. That is all
 they think about. Another observed, *nothing to do*
 but make canes to support our dignity when we
 are home.

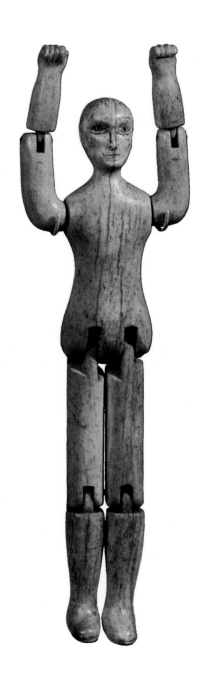

78
Phrenological Head
Alexander Ames (active 1847-50)
Buffalo, New York area
Mid 19th century
Polychromed pine
$16\frac{3}{8} \times 13 \times 7\frac{1}{8}''$ (41.6 × 33.2 × 18.2 cm)
Bequest of Jeanette Virgin. 1981.24.1

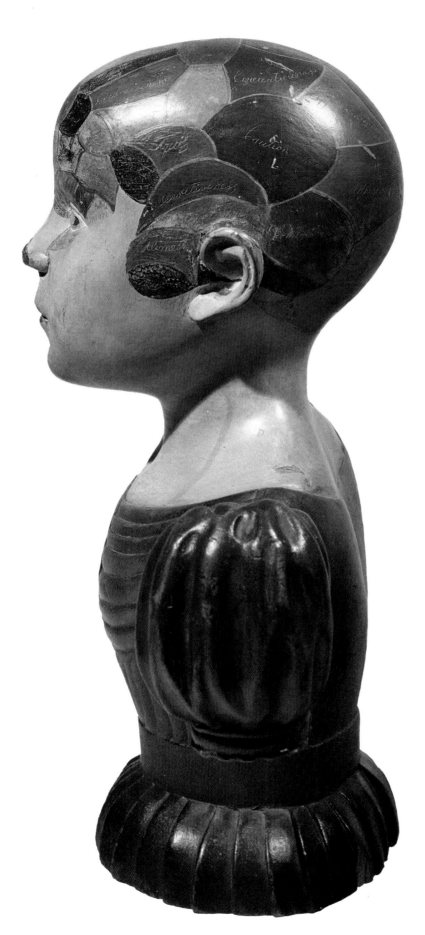

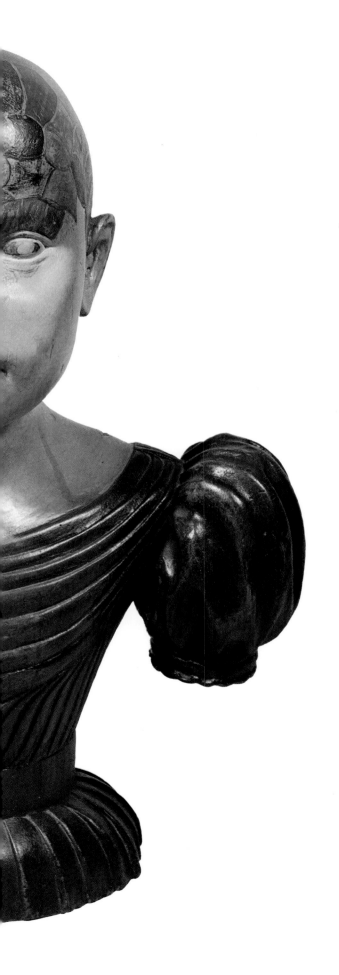
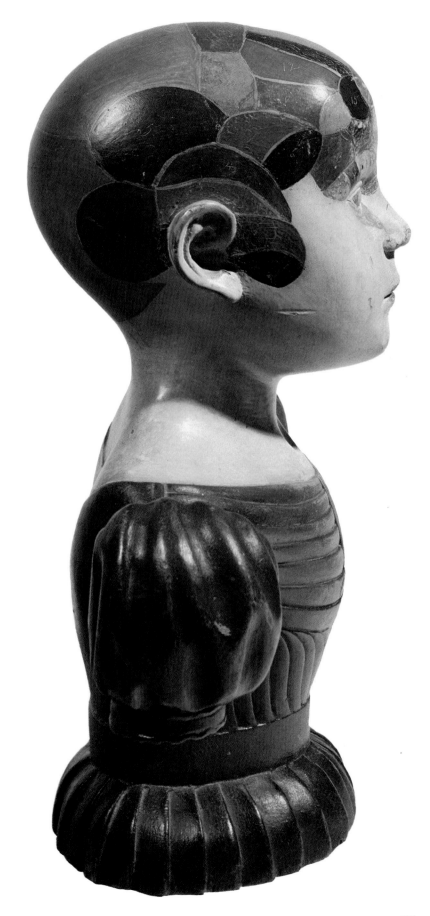

79
Doll: Raggedy Ann
Artist unknown
American; 1910-20
Stuffed cotton, muslin, shoe buttons, yarn, ribbon,
 embroidered features, 17 × 11¼ × 2⅜″
 (43.2 × 28.6 × 6 cm)
Gift of Anne Baxter Klee in celebration of her mother.
 1980.22.75

The original version of this doll was designed by
John B. Gruelle in the early 20th century.
He allegedly copied a doll owned by
his mother.

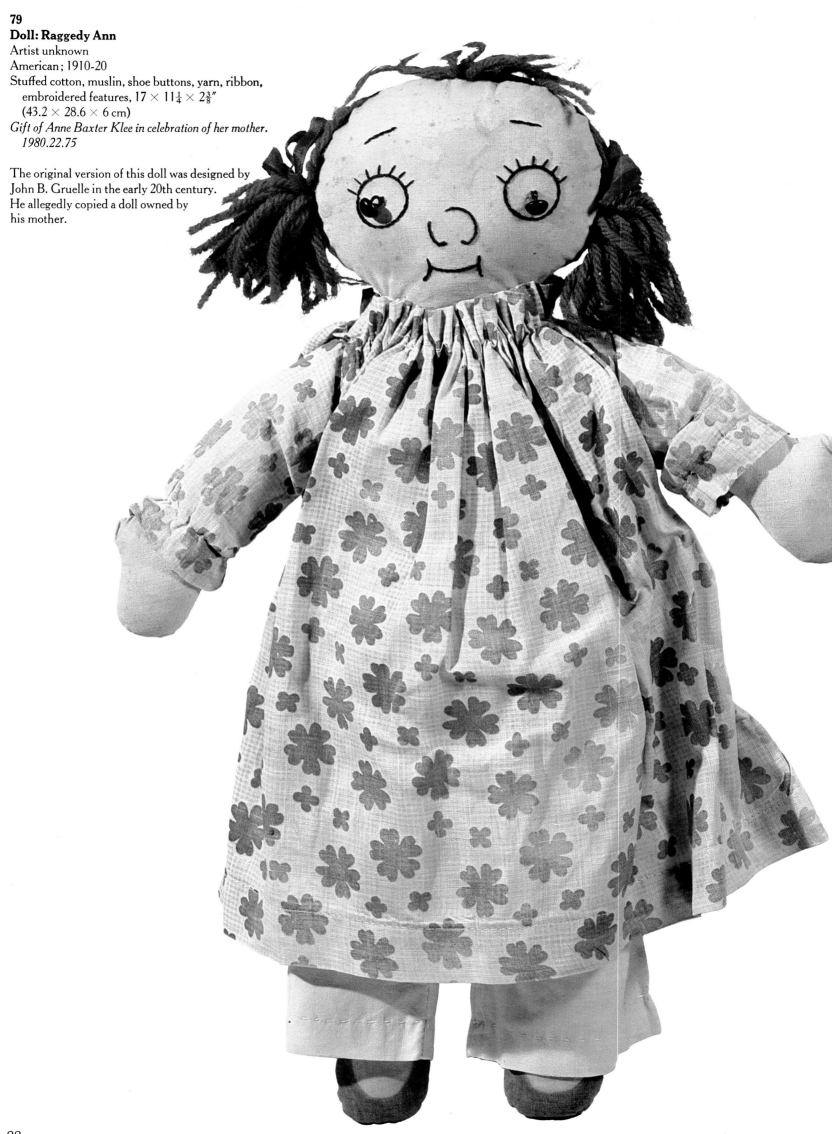

80
Doll: Pinocchio
Attributed to an Italian immigrant
American; c. 1926
Carved wood, string, flannel, glass buttons, metal,
 painted features, 12 × 6¾ × 2½" deep
 (30.5 × 17.1 × 6.3 cm)
Gift of Anne Baxter Klee in celebration of her mother.
 1980.22.99

The story of Pinocchio, the little boy puppet carved
by Gepetto, which is now well known to children
throughout the world, became especially popular in
America as the result of the animated film featuring
the legend. In the story, Pinocchio's nose grew
longer each time he told a lie, which explains the
predominant nose on this carving.

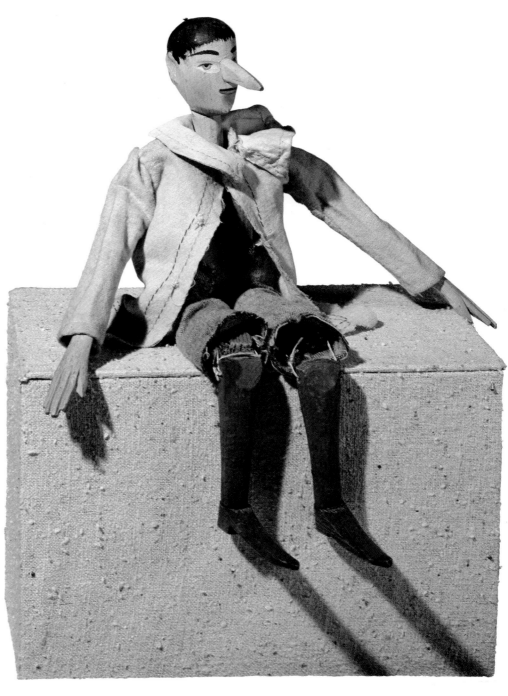

81
Paper Dolls: Soldiers and Horses
Artist unknown
Boston, Massachusetts; 1840-50
Watercolor, pen and ink on cut paper and card.
 Soldiers: 4″ × 2″ (10.2 × 5 cm);
 Horses: 4″ × 4¼″ (10.2 × 10.8 cm).
Gift of Pat and Dick Locke. 1981.8.1-11

These beautiful paper toys were carefully cut with
fine scissors or possibly a sharp blade. They are
among the best examples of their type known.
Originally they were fitted with paper folds which
made them stand.

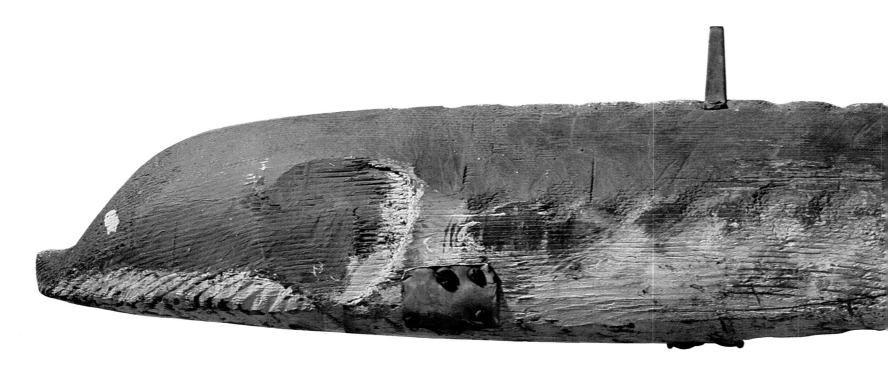

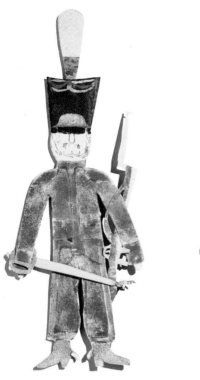
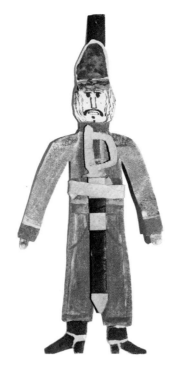
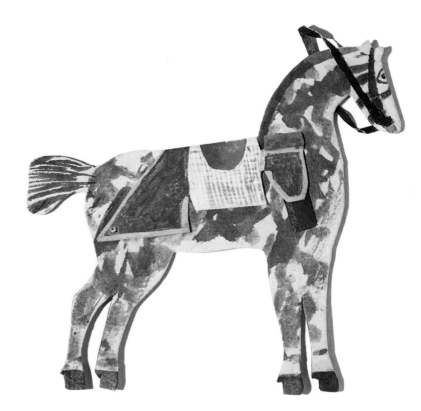

82
Decoy: Fish
Artist unknown
Midwestern; early 20th century
Painted wood, metal, $10\frac{3}{4} \times 41\frac{1}{4} \times 6\frac{3}{8}''$ deep
 $(27.3 \times 104.6 \times 16.2$ cm)
Promised anonymous gift. P78.211.4

Fish decoys were used during the 19th and the first half of the 20th centuries almost exclusively in the Great Lakes area. The body was usually fashioned from pine and hollowed out underneath, the cavity being filled with molten lead for ballast. Tin, and occasionally leather, were shaped to form the fins and tails on these unusual pieces which had no hooks. The tail and body were sometimes carved in one piece, with the tail splayed outward so that the decoy could be maneuvered in a circle.

 Fish decoys were commonly used by winter fishermen who built small shanties over large holes in the ice. The interior of the windowless shanty was usually painted black so that a curious fish, investigating the decoy that had been dropped through the hole, could be easily seen.

 Fish decoys vary in size from just a few inches in length to the granddaddy of them all, a four foot long example.

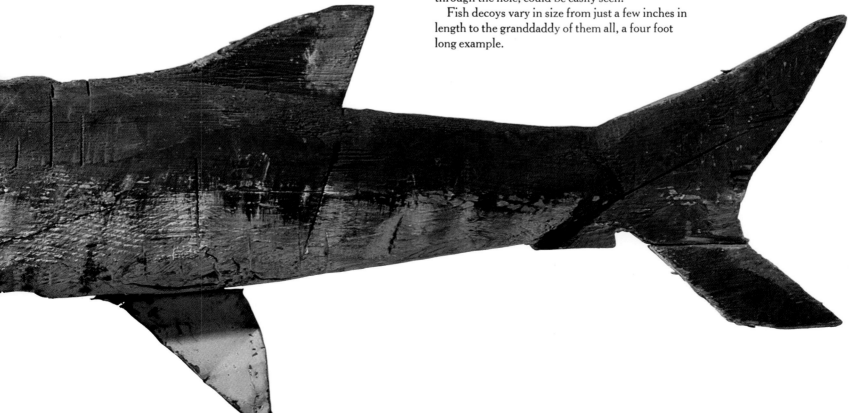

83
Decoy: Sleeping Black Duck
Charles E. "Shang" Wheeler (1872-1949)
Stratford, Connecticut; c. 1925
Painted wood and cork, glass, $5\frac{7}{8} \times 16 \times 6\frac{3}{4}''$ deep
 (14.9 × 40.6 × 17.1 cm)
Gift of Alastair B. Martin. 1969.1.15

Charles Wheeler, a part-time whittler made working
decoys as well as ornamental decoys for decorative
purposes. This working decoy was used on the
exposed mud flats of Connecticut.

84
Decoy: Bluebill Drake
Davy K. Nichol
Smithfalls, Ontario, Canada; c. 1900
Painted wood, glass, lead, leather,
 $5 \times 13\frac{3}{8} \times 5\frac{7}{8}''$ deep (12.7 × 33.8 × 14.9 cm)
Gift of Alastair B. Martin. 1969.1.82

American waterfowl hunters frequently shot in
Canadian territory and added fine local decoys to
their collections. This superb example has a
beautifully carved head and body. The detail on
the wings and tail is especially noteworthy.

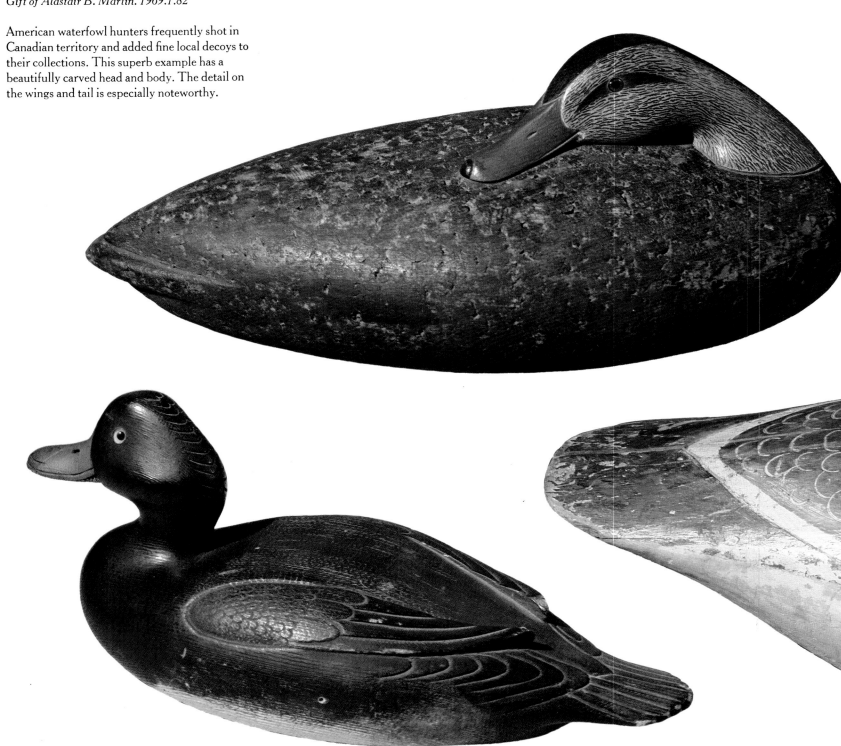

85
Decoy: Pintail Drake
Lemuel Ward (born 1896)
Crisfield, Maryland; c. 1930
Polychromed wood, glass, $7\frac{1}{8} \times 18 \times 6\frac{1}{8}''$ deep
 (18.1 × 45.7 × 15.5 cm)
Gift of Herbert Waide Hemphill, Jr. 1964.1.4

Ward pintails are distinctive for their sculptural
quality and their unusual decorative finish.
The example retains its original paint.

86
Decoy: Canada Goose
Ira Hudson (1876-1949)
Chincoteague, Virginia; c. 1925
Painted wood, $11 \times 25\frac{1}{2} \times 8\frac{1}{4}''$ deep
 (27.9 × 64.7 × 20.9 cm)
Gift of Alastair B. Martin. 1969.1.13

Decoys which retain their original condition and
paint surface are most sought after by collectors.
Few examples from the first half of the 20th
century are in such fine condition as this
Canada goose.

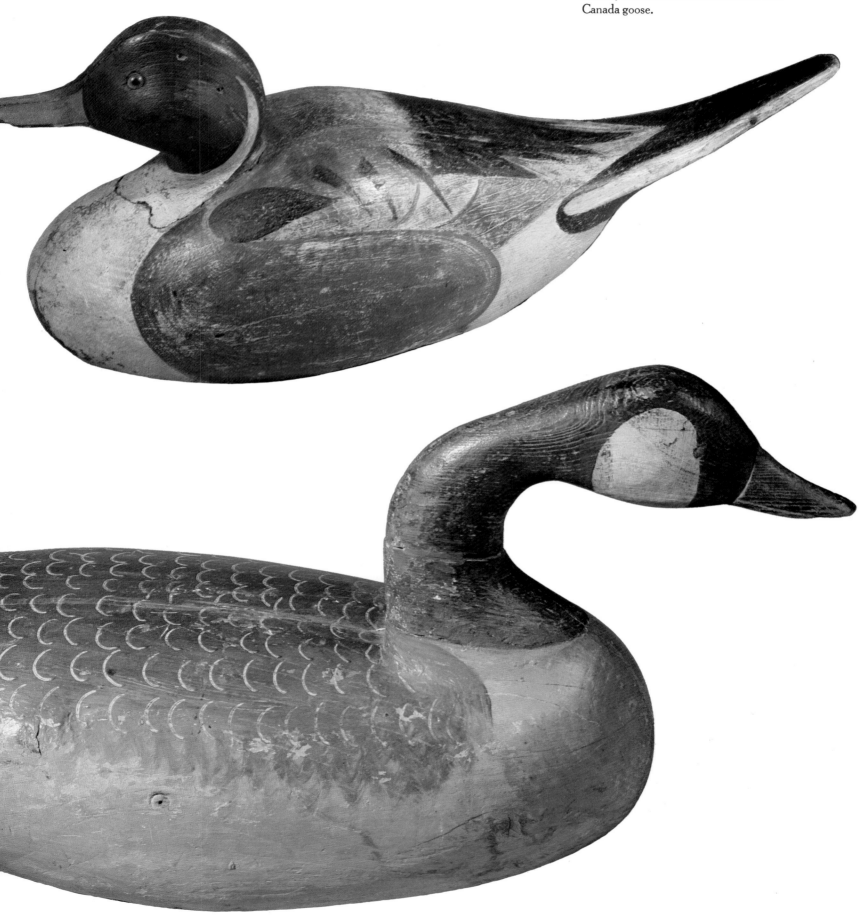

87
Decoy: Shorebird, Black Bellied Plover
A. Elmer Crowell (1862-1951)
Harwichport, Massachusetts; c. 1900
Painted wood, glass, $5\frac{5}{8} \times 9\frac{7}{8} \times 2\frac{7}{8}''$ deep
 $(14.3 \times 25.1 \times 7.2$ cm)
Gift of Alastair B. Martin. 1969.1.94

The plover has a large beak and a full plump body
which distinguishes it from other shorebirds.
There are several varieties of plover decoys but
the black breasted plover is the most popular.
The term "stick-up" is used to describe shorebird
decoys which are placed on sticks along the beaches
or marshes to lure the live birds to the close range
of hunters.

88
Decoy: Shorebird Dowitcher
Bill Bowman,
Lawrence, Long Island, New York; c. 1890
Painted wood, glass, $5\frac{1}{2} \times 10\frac{1}{4} \times 2\frac{5}{8}''$ deep
 $(14 \times 26 \times 6.6$ cm)
Gift of Alastair B. Martin. 1969.1.102

Bill Bowman, a Long Island carver was known
for shorebirds, especially the dowitcher. Besides
carving shorebirds, Bowman fashioned weathervanes
and miniature waterfowl and painted pictures
depicting bird life.

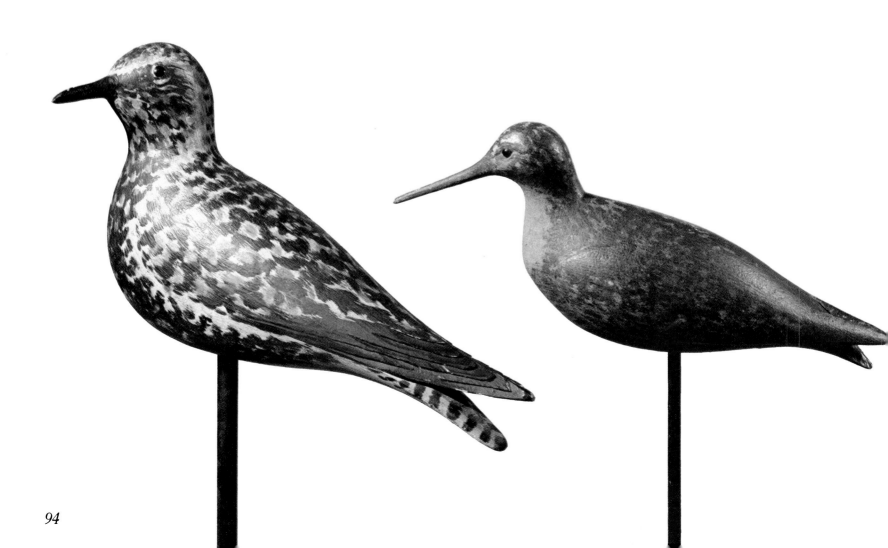

89
Decoy: Shorebird, Sandpiper
John Glover
Duxburg, Massachusetts; c. 1890
Painted wood, metal, glass, 4 × 6⅞ × 2″ deep
 (10.2 × 17.5 × 5 cm)
Gift of Alastair B. Martin. 1969.1.90

The sandpiper is a small bird, six to eight inches
in size. In this particular decoy, the carver has
captured its pert, lively stance.

90
Decoy: Shorebird, Sicklebilled Curlew
Mason Factory, Detroit, Michigan; c. 1925
Painted wood, metal, glass, 7⅞ × 17⅜ × 4¼″ deep
 (20 × 44.1 × 10.8 cm)
Gift of Alastair B. Martin. 1969.1.88

The largest of the curlews is the sicklebilled variety
which has a long bill and sculptural body. During
the last half of the 19th century, when improved
firearms and a seemingly inexhaustible supply of
wild birds gave rise to the national sport of hunting,
it became feasible to manufacture, in specialized
factories like the Mason firm, wooden birds that
were skilfully carved and beautifully painted.

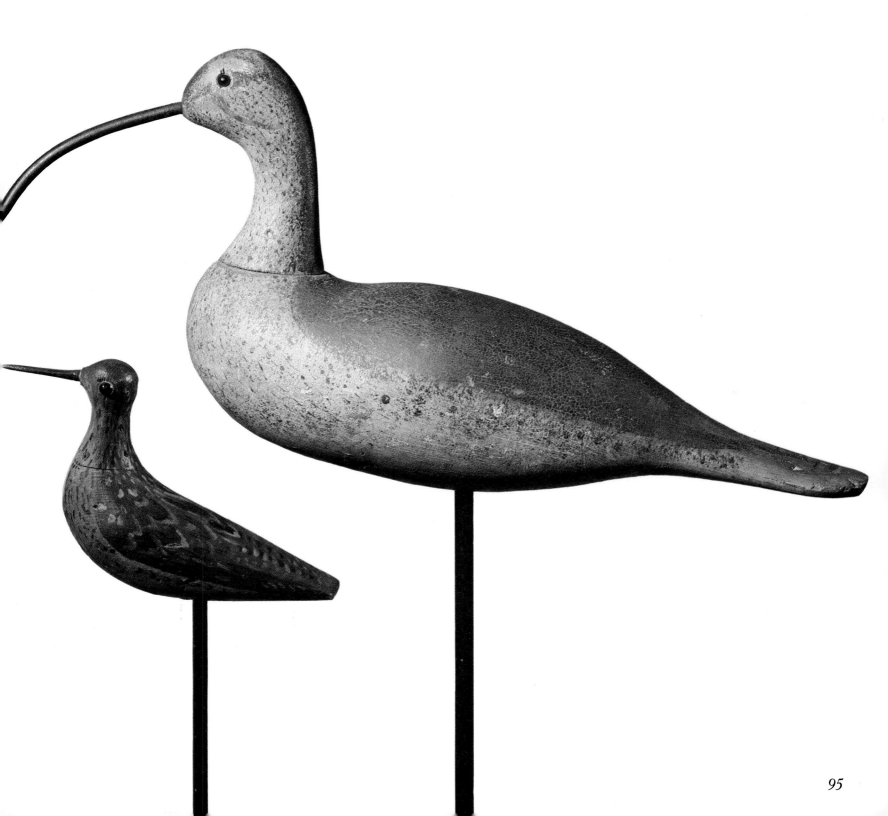

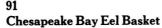

91
Chesapeake Bay Eel Basket
Artist unknown
Found in Chesapeake Bay area; c. 1900
Oak splint, wood, string, 22 × 9″ diam
 (55.9 × 22.8 cm)
Promised gift of Judith A. Jedlicka. P4.1981.2

Similar to a lobster trap, this basket is set in the
water to catch eels which are attracted to it because
of bait placed in the dark enclosed environment.
Once the eel wiggles into the cone it cannot find
its way out. Full traps are lifted out of the water
and the eels are taken from the top of the basket
by removing the lid.

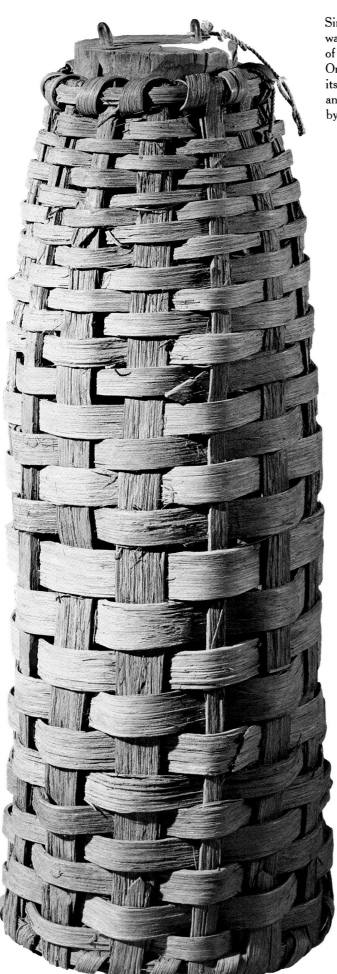

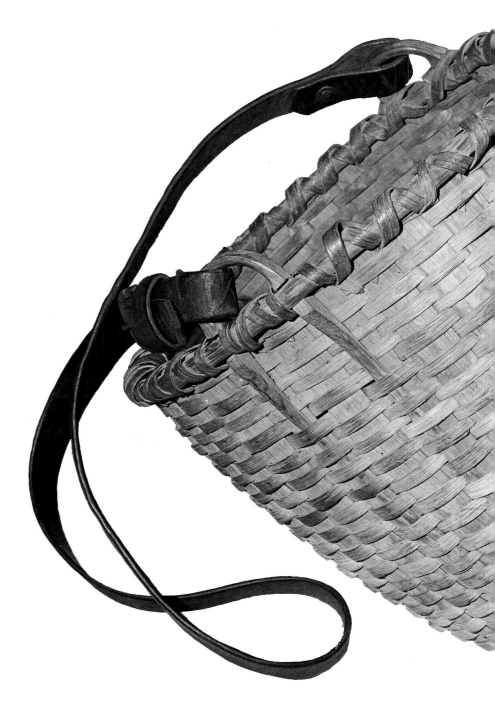

92
Horse Feeding Basket
Artist unknown
Connecticut; c. 1890
Oak splint, leather, brass, 15¼ × 13½″ diam.
 (38.7 × 34.2 cm)
Promised gift of Judith A. Jedlicka. P4.1981.3

This basket was filled with oats and hung on a
horse for feeding.

93
Sewing Basket
Artist unknown
Northeastern; c. 1920
Ash splint, red dye, wood, 5¾ × 13½″ diam.
 (14.6 × 34.2 cm)
Promised gift of Judith A. Jedlicka. P4.1981.1

Sewing baskets of this type were popular during
the first quarter of the 20th century. This unusual
form was made on a basket mold. The design was
created with very fine and medium size splints.
Red dye was applied to the splint near the bottom.
The two woven insert baskets were used to hold
pins, needles and small sewing items.

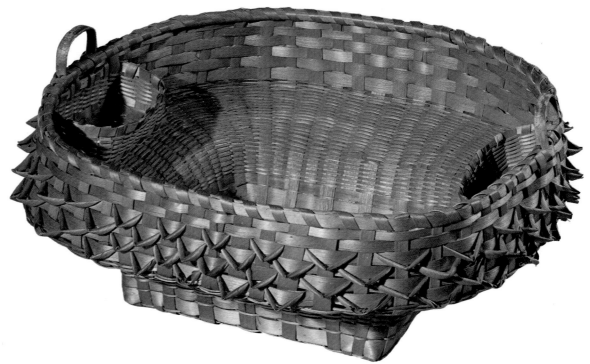

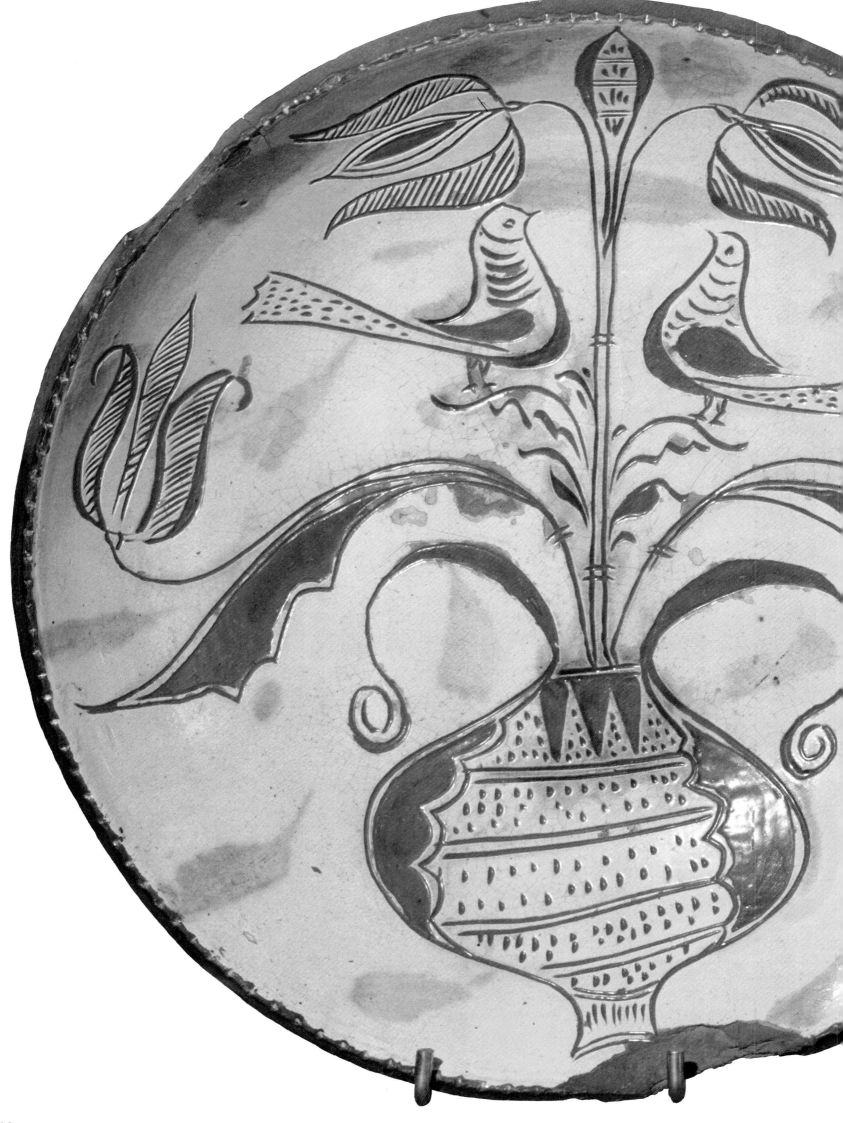

Sgraffito Plate
Artist unknown
Pennsylvania; c. 1820
Glazed redware with incised decoration,
$2\frac{7}{8} \times 12\frac{5}{8}''$ diam. (7.2 × 32 cm)
Promised anonymous gift. P79.701.1

The sgraffito technique involves laying one color
of slip glaze on top of another of a different color.
A decorative design is produced by scratching
through the outer layer of slip. This technique had
European beginnings.

95 & 96
Pair of Lions
Fenton Works, Bennington, Vermont; 1849
Glazed stoneware, 9⅜ × 11 × 5⅞" deep
 (23.8 × 27.9 × 14.9 cm)
Gift of Mrs. Gertrude Schweitzer. 1979.31.1, 1979.31.2

These ceramic lions were intended to be used as
decorative accents on top of a mantle. They were
produced by the Christopher Webber Fenton firm
of Bennington, Vermont where a vast array of
ceramic objects included many pieces in blue and
white Parian porcelain.

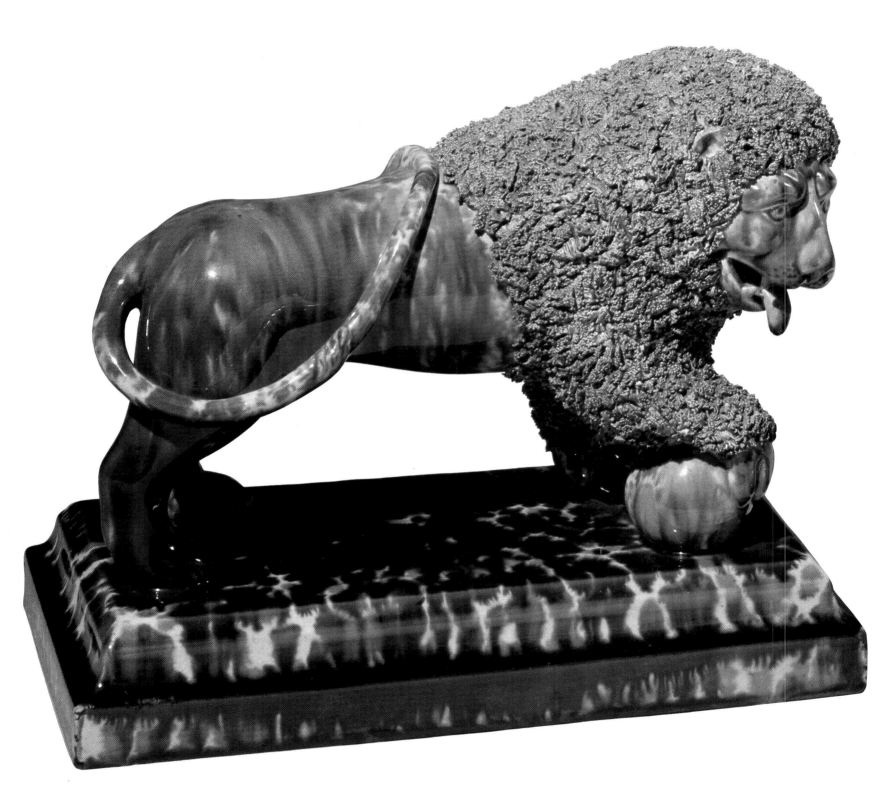

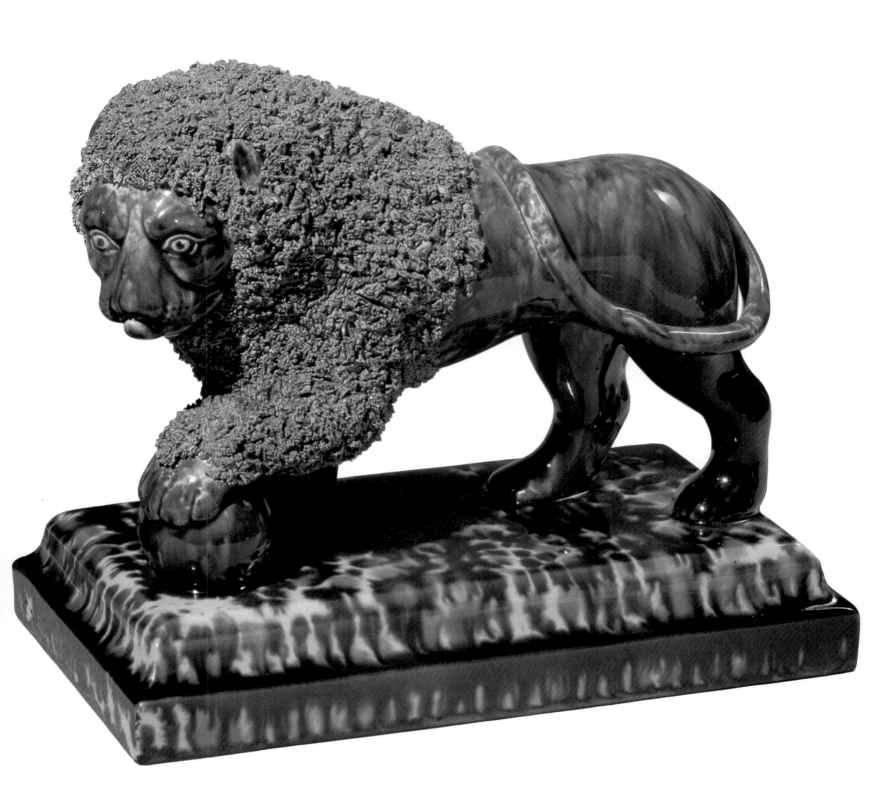

Horse and Rider
Artist unknown
Pennsylvania; 1850-75
Glazed redware, $8 \times 5\frac{3}{4} \times 2\frac{1}{2}''$ deep
 $(20.3 \times 14.6 \times 6.3 \text{ cm})$
Promised anonymous gift. P79.203.1

Utilitarian pottery wares for daily use, such as
bowls, pitchers and storage vessels, where produced
in nearly every American town were natural
materials were readily available. Several
Pennsylvania potters executed three dimensional
sculptural pieces as well.

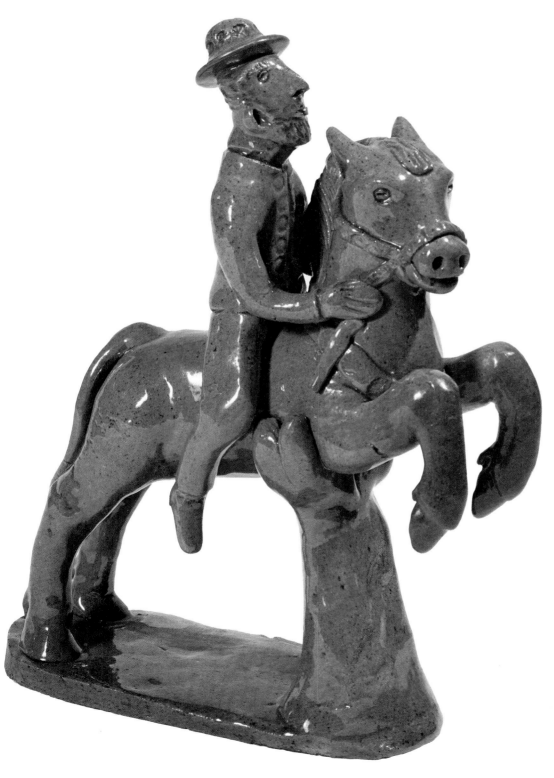

98
Pitcher
Artist unknown
Cape Cod, Massachusetts; c. 1875
Sponge-decorated stoneware, $8\frac{7}{8} \times 8\frac{1}{4} \times 5\frac{7}{8}$" deep
 (22.5 × 20.9 × 14.9 cm)
Museum of American Folk Art purchase. 1981.12.33

This sponge-decorated pitcher is a fine example
of the informal, free design of household wares
produced at potteries after the War of
Independence.

99
Nodding Head Cat
Artist unknown
American; late 19th century
Polychromed chalkware, wire, $4\frac{1}{2} \times 8\frac{3}{4} \times 4\frac{1}{2}''$ deep
 (11.4 × 22.2 × 11.4 cm)
Bequest of Effie Thixton Arthur. 1980.2.106

In the latter half of the 19th century chalkware
ornaments became more popular than pottery
household ornaments imported from Europe.
They were easy to produce and could be sold for
less. Chalkware is really a form of plaster of Paris.
The public referred to it as chalk because it left a
white smudge when rubbed. In Mark Twain's
popular novel, *Adventures of Huckleberry Finn*,
Huck observed, *Well, there was a big outlandish
parrot on each side of the clock made out of something
like chalk and painted up gaudy.*

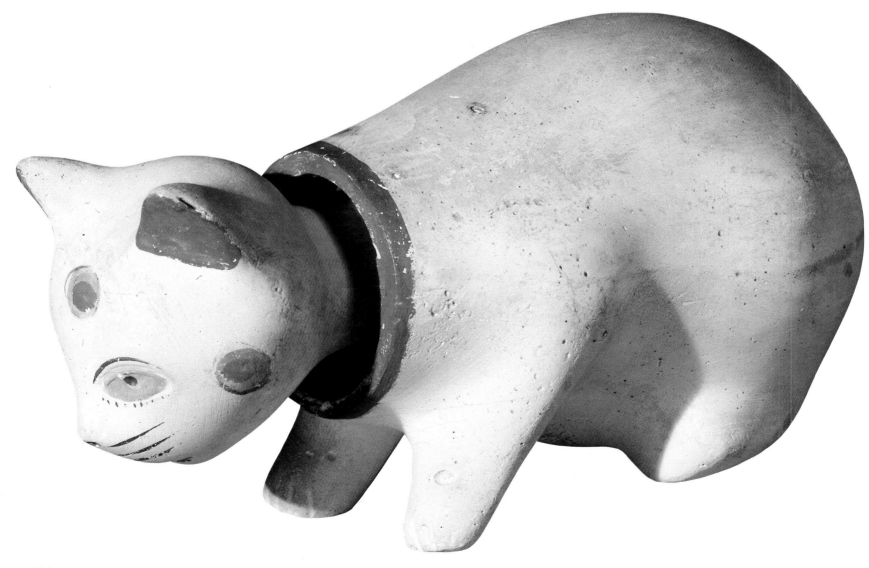

100
Nodding Head Pig
Artist unknown
American; late 19th century
Polychromed chalkware, wire, $5\frac{1}{8} \times 9\frac{1}{4} \times 3\frac{1}{4}$" deep
 (13 × 23.5 × 8.2 cm)
Bequest of Effie Thixton Arthur. 1980.2.31

Among the most prized examples of American
chalkware are the nodding head pieces.
The Museum's collection contains nodding cats,
goats, pigs and a very rare nodding head woman.

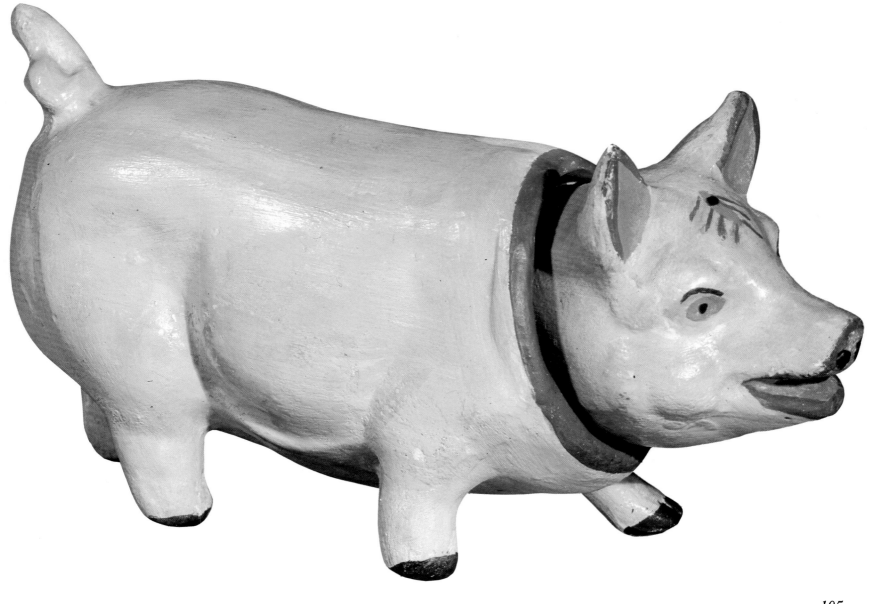

101
Nodding Head Goat
Artist unknown
American; late 19th century
Polychromed chalkware, wire, $7\frac{5}{8} \times 9 \times 3\frac{3}{8}''$ deep
 (19.4 × 22.8 × 8.5 cm)
Bequest of Effie Thixton Arthur. 1980.2.24

While there are many instances where chalk forms
are identical each piece is made distinctive by a
unique painted surface.

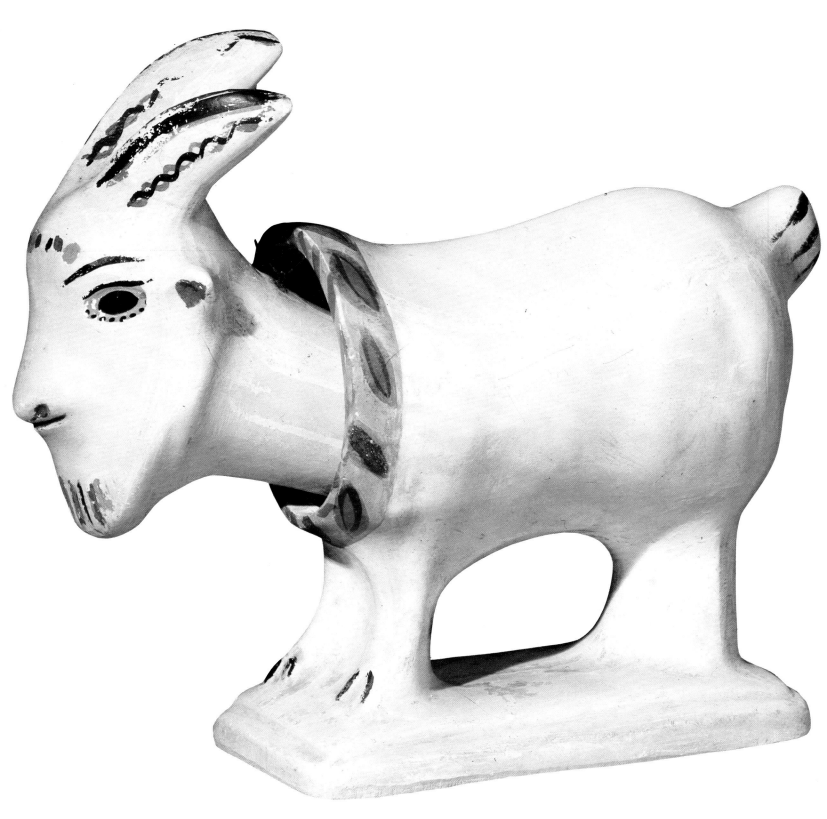

102
Nodding Head Woman
Artist unknown
American; late 19th century
Polychromed chalkware, wire, $9\frac{1}{4} \times 4\frac{5}{8} \times 4\frac{7}{8}''$ deep
 (23.5 × 11.7 × 12.3 cm)
Bequest of Effie Thixton Arthur. 1980.2.35

This form is the rareist of all known chalkware.

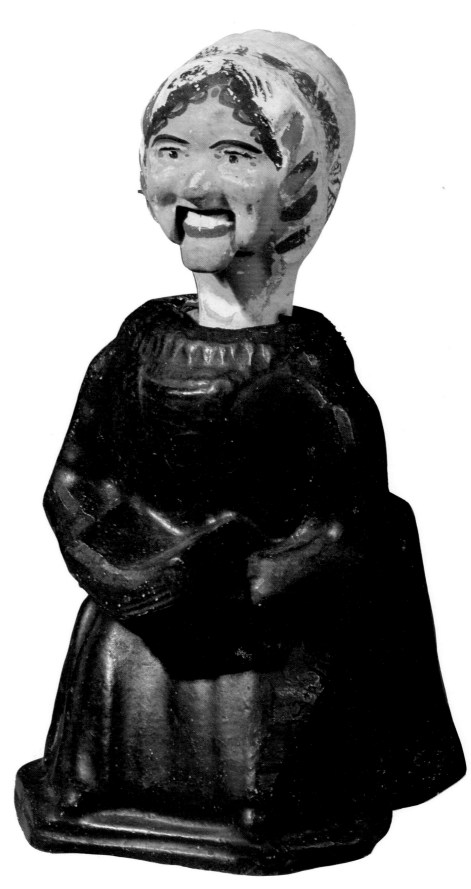

103 & 104
Pair of Compotes of Mixed Fruit
Artist unknown
American; late 19th century
Polychromed chalkware, 14 × 10 × 4¾″ deep
 (35.5 × 25.4 × 12 cm)
Bequest of Effie Thixton Arthur.
 1980.2.50, 1980.2.51

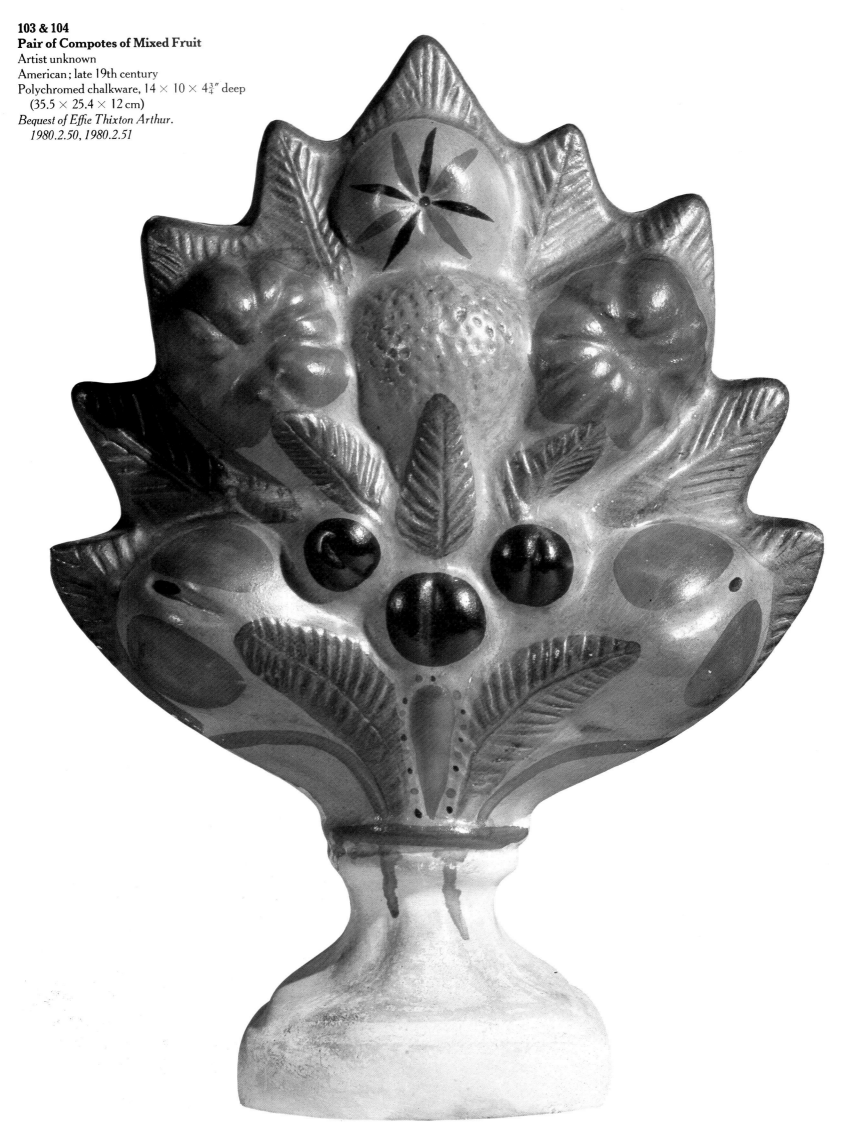

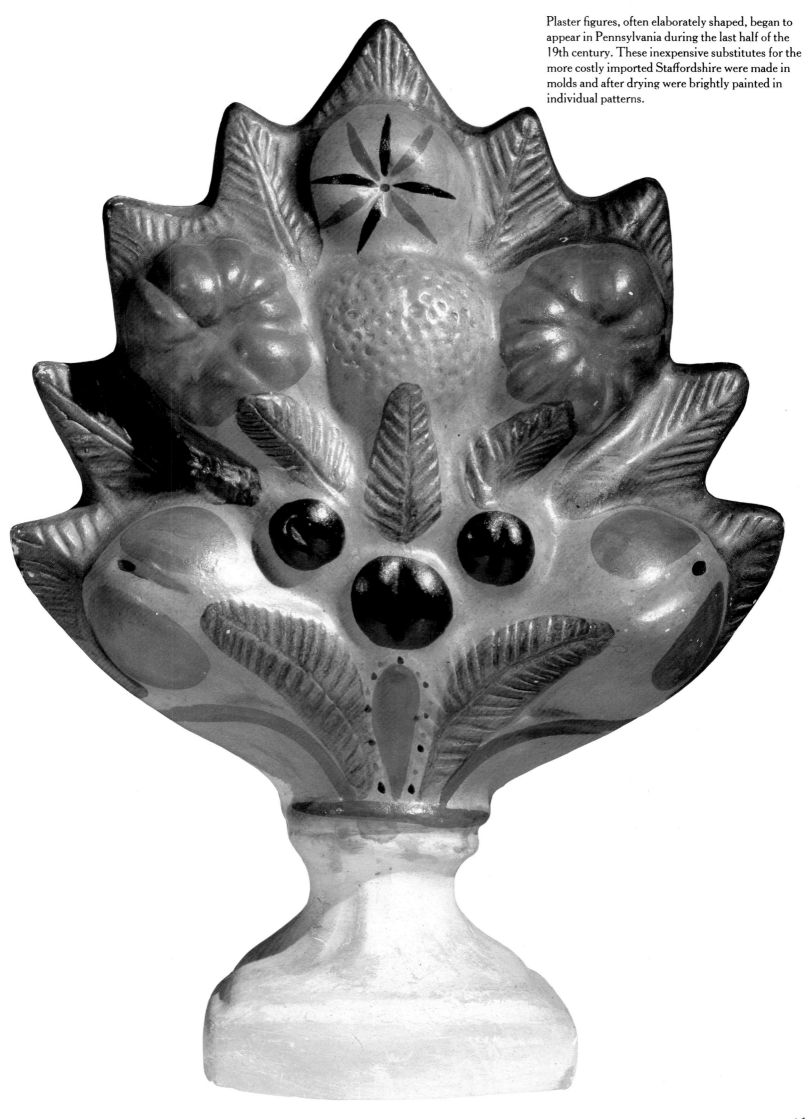

Plaster figures, often elaborately shaped, began to appear in Pennsylvania during the last half of the 19th century. These inexpensive substitutes for the more costly imported Staffordshire were made in molds and after drying were brightly painted in individual patterns.

105
Seated Cat
Artist unknown
American; 1860-1900
Polychromed chalkware, $15\frac{5}{8} \times 8\frac{3}{4} \times 10\frac{1}{8}''$ deep
 (39.6 × 22.2 × 25.7 cm)
Gift of Effie Thixton Arthur. 1963.3.1

The monumental size and imaginative paint on this
colorful piece make it distinctive.

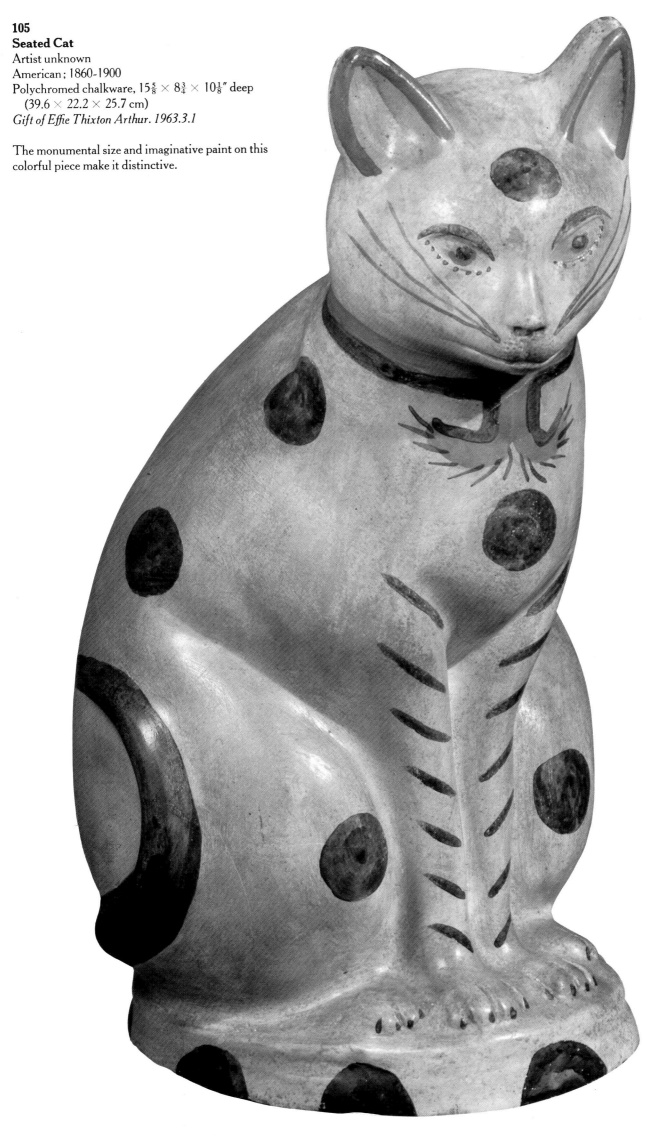

Rooster Mold for Chalkware, in four parts
Artist unknown
American; late 19th century
Painted plaster, oa: $8\frac{1}{4} \times 6\frac{3}{4} \times 4\frac{3}{4}''$ deep
(20.9 × 17.1 × 12 cm)
Bequest of Effie Thixton Arthur. 1980.2.77a-d

Chalkware molds are extremely rare and only a few
examples are known. Although simpler in
conception, chalkware is not unlike the cast plaster
mass-produced sculptural pieces created by
John Rodgers for Victorian parlors beginning in
the 1860s. By 1893 over 80,000 pieces of his
putty-colored sentimental groups were produced.

107
Rocking Chair
Unidentified Shaker
Mt. Lebanon, New York; 1850-1900
Maple, woven tape seat, 45 × 24⅞ × 25¾″ deep
 (114.3 × 63.1 × 65.4 cm)
Promised gift of Robert Bishop. P78.601.2

This chair was probably made with a specific
individual in mind. Its seat is close to the ground
and extremely wide.

108
Tripod Base Sewing Table
Unidentified Shaker
Mt. Lebanon, New York; mid-19th century
Cherry, 26 × 20 × 19¾″ deep
 (66 × 50.8 × 50.2 cm)
Promised gift of Robert Bishop. P78.604.2

This sewing table exemplifies the characteristics
of fine Shaker furniture; simplicity, utility and
refinement. It originally had metal prongs mounted
around the circumference of the top. These were
intended to hold spools of thread for Sisters while
they worked.

109
Thread Stand
Unidentified Shaker
New York State; late 19th century
Maple, stuffed cotton, metal and candlewax,
 5⅞ × 5⅝″ diam. (14.9 × 14.3 cm)
Promised gift of Robert Bishop. P1.1981.2

Thread stands were made for domestic use within
the Shaker community as well as for sale to the
"outside" world.

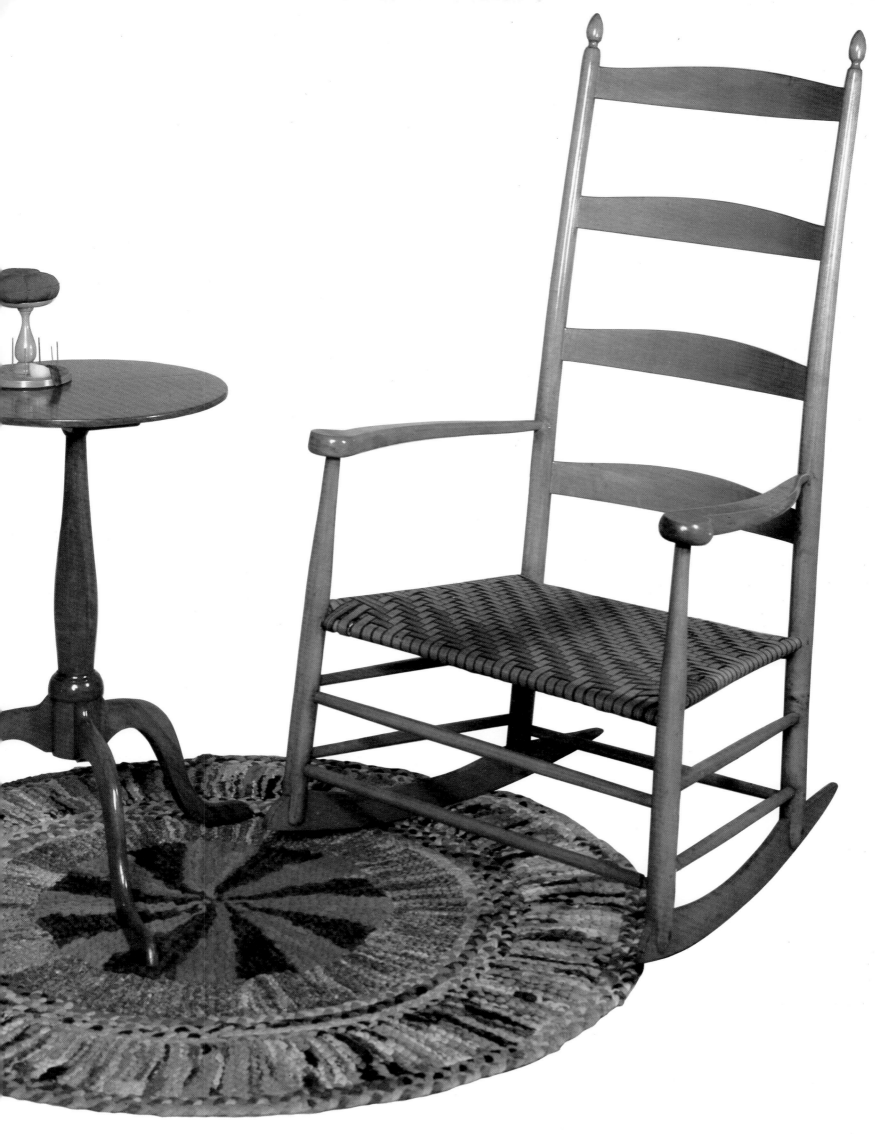

110
Shaker Chronological and Genealogical Chart
Jacob Skeen
Louisville, Kentucky; 1887
Printed in colors, sight: 33⅝ × 47⅝"
 (86 × 121 cm)
Gift of Robert Bishop. 1981.1.1

This chart was published as a joint venture by several leaders of the Shaker Society, M. B. Carter of Union Village, Ohio, Benjamin Gates of Mt. Lebanon, New York, and F. M. and W. F. Pennebaker of Pleasant Hill, Kentucky, and a "worldly" businessman, Jacob Skeen of Louisville, Kentucky. It traces Biblical history as well as giving the *Names and References to Character, Power and Influence Upon Mankind of the Devil as Recorded in the Books of the Old and New Testaments.*

FOLK TEXTILES & other arts

Folk textiles are among the most beautiful of all naive artistic expressions. Needlework bedcovers in the 17th and 18th centuries included bed rugs, linsey-woolsey coverlets (sometimes quilted), printed whole-cloth spreads, hand-embroidered or loomed candlewick spreads, woven coverlets, and the more familiar quilts of three basic types – the whole-cloth quilt, pieced quilts, and applique quilts.

The bed rug, a handsome wool covering, was made in the New World during the 17th, 18th, and early 19th centuries. Home-woven woolen cloth or linen served as the base fabric on which bold designs, generally borrowed from imported palampores, were worked in wool with a wood or bone needle. The majority of bed rugs were made with a running stitch and the surface was sometimes sheared. The bed rug is probably the rarest type of American bedcover.

Linsey-woolsey is a coarse, loosely woven fabric generally made with a linen warp and a wool weft. Nearly as soon as the first colonists cleared their land, flax seeds were sown. With the exception of food, flax contributed more toward the establishment of pioneer settlements than any other crop. It was planted early in the spring, and matured in late June or July. When harvested, it was pulled from the ground and left to dry thoroughly. After the several processes of rotting, ripping, retting, breaking, scutching, and hatcheling, it was finally possible to remove long fibers from the woody stalk, which were dressed on a distaff and spun into thread. The thread was subsequently bleached in ashes and water, rinsed, washed, dyed, and finally wound onto bobbins and spools which were used on looms to create a strong and durable fabric.

During the late 17th and early 18th centuries, the American obsession with imported East Indian printed cotton fabrics reflected English taste. Ships of English and Dutch trading companies returned from the east to English seaports, laden with blockprinted cottons in vibrant colors. Many of these fabrics reached the American colonies, where textile manufacture had been discouraged—and for some time actually forbidden—by the mother country.

Colonial desire for printed cottons led to the production of American printed textiles in the last half of the 18th century. Designs were executed on fabric in three ways. The earliest technique involved the use of wooden blocks with carved or engraved patterns on their surfaces. Since a separate block was required for each motif, the designs · remained simple. A second technique involving the use of an engraved copper plate became popular soon after the middle of the 18th century. The motifs on copper-plate printed fabric are invariably of a single color such as indigo or mulberry and are laid onto a white or neutral background. Soon after the opening of the 19th century, mass-produced roller-printed or "factory goods" greatly reduced the cost of printed fabrics and increased the number of patterns available to the middle class homemaker.

Other types of American bedcovers have enjoyed great popularity through the centuries as well. Candlewick bedspreads were made in two ways. The first was hand-embroidered. The second was woven on a loom. The hand-embroidered spreads usually have a linen or sometimes cotton background that is embellished with elaborate floral or stylized designs executed with candlewicking – a coarse cotton thread or roving. They demonstrate a freedom of design which was unachievable by the weaver who executed the loomed examples that became popular in America about 1820. The weaver picked up predetermined loops of candlewicking from the flat weaving on the loom with a "reed" that secured the loops while he treadled the warp encircling the wicking. For variation the weaver might use reeds of varying diameters allowing him to create a visual contrast between a deep pile and low pile design. Presumably most of the woven candlewick bedspreads were made by professional weavers. This is also true of many of the loomed woolen coverlets.

There are four main types of American coverlets – overshot, double-weave, summer-and-winter, and jacquard. The earliest coverlets were probably brought from Europe as household goods. When they wore out, they were replaced by pieces of domestic production. Small four-harness looms were fashioned of handhewn logs and were constructed so that they could be erected and dismantled quickly and easily, making it possible for a professional weaver to travel from town to town executing bedcovers much like his painting counterpart, the itinerant New England limner, who sought commissions for portraits. Some families possessed looms as well and it is safe to assume that young women were encouraged to develop their weaving abilities. The jacquard attachment to the home loom dramatically altered production in the last two-thirds of the 19th century. Suddenly, coverlets could be produced much more quickly – which made them accessible to the population at large.

The stenciled bedspread was another popular bedcover

type. During the first half of the 19th century a taste developed for painted and stenciled furniture, walls, floors, and bedspreads. Nearly all surviving examples of stenciled cotton bedspreads were made without a backing or lining. It seems almost certain that stenciled spreads were created by women at home and were never produced in large quantities. The flower and fruit, still life designs used by young ladies for "theorem" paintings stenciled on velvet or paper were also popular with the bedcover stenciler. The motifs on the earliest bedspreads of this type were made up of several small stencils, each contributing part of the overall design. On later examples a single stencil was used, and motifs tended to lack variety.

American women in the 19th century, making quilted bedcovers by piecing together remnants from worn-out clothing, upholstery fabrics, and window hangings, stitched a priceless legacy of beauty for posterity. Quilted bedcovers are generally divided into three main groups – the whole-cloth quilt usually made from two large pieces of fabric, one used on top and one beneath the stuffing; pieced quilts; and appliqué quilts. Both pieced and appliqué quilts are frequently referred to as patchwork.

Several theories have been advanced toward establishing that pieced quilts preceded the appliqué examples. Equally convincing evidence has been used to show that appliqué quilts predate pieced ones. Actually, it seems probable that both types developed about the same time and have coexisted through the years.

Art historians are excited by quilts in several ways. Some prefer the more elaborate appliqué pieces, which are often embellished by fine embroidery. The appliqué technique involves sewing a piece cut from one fabric onto a ground fabric, such as an individual block, or directly onto the full-sized background fabric. After all of the appliqués have been secured to the background, or the appliquéd blocks have been stitched together, the blank areas or "white spaces" left between the designs are usually quilted in decorative patterns. In some instances parts of the quilting patterns are stuffed with cotton to give a third dimension to the quilt top.

Motifs cut from the exotically designed *palampores* imported from India and England provided appliqués that were stitched to domestically produced solid color ground fabrics. Quilts using these motifs are said to have been fashioned in the *Broderie Perse* style.

Some of the finest American appliqué quilts originated in and around Baltimore, Maryland, and share an elaborate, identifiable style. Frances Trollope, a visitor to the area, must not have seen any of these great examples of needlework, for her comments about Southern women were severe:

There is an idleness, a sauntering listlessness, that gives what we call a "creole manner" to the fine ladies of Baltimore and Washington, which though not quite what would be most admired, is yet infinitely more a drawing-room manner than any thing to be seen in Ohio; but I did not find that the leisure obtained by the possession of slaves was in many cases employed in the improvement of the mind. The finest ladies I saw either worked muslin or did nothing. The very trifling attempts at music are rarely continued after marriage. The drawings I saw were always most ludicrously bad, though perhaps as good as the masters, and the stock of what is called general information less than I believe any one would believe possible who had not witnessed it.[8]

Many collectors feel the appliqué quilt lacks the inspiration of the pieced quilt and perhaps shows less inventive design, although "for show" or "best" quilts were nearly always done in appliqué'

Piecework produced the often stunning, even astonishing, geometric designs so popular today. The technique of piecework made it possible to achieve an almost endless variety of patterns.

Jonathan Holstein, in the introduction to his splendid book, *The Pieced Quilt: An American Design Tradition*, shares his enthusiasm for the pieced quilt with the reader:

I am interested more in their visual content than their craft ... If we strip away, then, the awe of handwork, much the awe of the sophisticate for the practical knowledge of the country or the skills of a previous time, and if we put aside the romantic associations of the quilt in American life, we can begin perhaps to see them in a different but equally meaningful way ... For that leaves us with surface, with pattern, color, and form.[9]

Pieced quilts were considered utilitarian and represented the everyday bedcover. They were fashioned by sewing small, straight-edged bits of fabric together to form an overall patterned top. The designs were often contained within a series of blocks or patches that could be more easily worked. The blocks were later joined to form the quilt top.

After a quilt top was completed, it was combined with an inner lining of cotton and a backing and mounted on a quilting frame. The frame securely held the three layers and

prevented them from shifting during the quilting. This was especially important, for if the material was not held firmly, the lining would puff up between the lines of stitching after washing. There were two basic types of quilting frames: one stood on legs; the other was suspended from the ceiling by pulleys which allowed it to be raised and lowered.

Nearly all quilt tops were "marked" before they were quilted. Sometimes an expecially skilled draftsman would attempt this difficult task freehand. More often, wooden or metal quilting blocks or templates made from paper or tin provided the outline that was transferred to the fabric with water soluble ink or dye. At other times, the design was pricked into the fabric with a sharp object. When this technique was used the holes were covered by the quilting stitches.

Fine, intricate quilting stitches were always considered one of the most important elements of a quilt. American women preferred the running stitch to the backstitch; it required less thread and was, therefore, more economical.

Some women chose to do their own quilting. Most, however, took their handiwork to communal bees, which became social events. Even the unskilled needlewoman was invited, for her cooking talents might be used to prepare an end-of-the-day feast for the quilters. Mrs. Trollope commented on such events:

The ladies of the Union are great workers, and among other enterprises of ingenious industry, they frequently fabricate patchwork quilts. When the external composition of one of these is completed, it is usual to call together their neighbors and friends to witness, and assist at the quilting, which is the completion of this elaborate work. These assemblings are called "quilting frolics," and they are always solemnised with much good cheer and festivity.[10]

More personal accounts, found in diaries and journals, sometimes show that sharp needles were plied by ladies with sharp tongues:

Our minister was married a year ago, and we have been peicing him a bed quilt; and last week we quilted it. I always make a point of going to quiltings, for you can't be backbited to your face, that's a mortal sertenty . . . quiltin' just set wimmen to slandern' as easy and beautiful as everything you ever see. So I went.[11]

As daily life became easier and many necessities could be purchased from a store instead of produced by hand at home, leisure time increased for the American woman. No longer was it necessary for her quilts to be purely utilitarian. She could now concern herself more with the decorative aspects of her handiwork. Several years were sometimes spent on a single quilt.

The names of many quilt patterns reflect regional folklore. Others indicate the religious bent of the quilter; some believed that to stitch a perfect quilt top would be an affront to God and intentionally worked a "mistake" into the quilt. Often the Bible served as a source for names of quilt patterns.

Whatever the inspiration for the naming of a pattern, it was meaningful to the maker, because the simplest quilt represented a considerable investment of time and energy. Once a name was firmly established, it was handed down from one generation to the next. As people moved about the ever-expanding country, this tradition was altered. A pattern called by one name in the east might be known by a totally different one on the western frontier. Those who have studied quilts seriously have gathered several thousand names in their efforts to categorize the multitude of patterns used by the American quiltmaker.

Quilts are seldom of a standard size. The earliest beds slept many and were short and wide, so it is not surprising that most 18th century quilts are as wide as they are long. But each successive generation grew taller, and it became necessary to lengthen beds. Consequently, most quilts made after 1800 are longer than they are wide.

Variations of the quilting tradition were developed by ethnic or social groups. For instance, the pieced bedcovers made by the Amish and Mennonites in Pennsylvania and in the Midwest are distinctively designed and have their own palettes and quilting motifs. The "Plain People" living in agrarian communities in Pennsylvania tended to produce quilts which were conservative in design in that they adhered to abstract patterns executed primarily in wool. In Michigan, Ohio and Indiana, Amish needlewomen selected more flamboyant designs which related more closely to those utilized by non-Amish neighbors.

Nearly everyone agrees that the tradition of a young girl's attempting to fashion a "baker's dozen" quilts for her dowry is based upon fact. Girls were taught to sew at a very early age. One woman reminisced:

Before I was three years old, I was started at piecing a quilt. Patchwork, you know. My stint was at first only two blocks a day, but these were sewn together with the greatest care or they were unraveled and done over. Two blocks was called "a single," but when I got a little bigger I had to make two

pairs of singles and sew the four blocks together, and I was pretty proud when I had finished them.[12]

The execution of a sampler served several purposes in the education of a young woman. It taught her the letters of the alphabet and provided basic instruction in the numerical system as well. It also gave her a sewing ability – a much needed skill in days when a woman made all the clothes for herself and her family. Samplers were also intended to be viewed as pictorial art and framed and prominently displayed in the home.

During the second half of the 18th century and continuing into the 19th century there developed a fad for needlework pictures. Young women were given special instruction and developed "accomplishments" which included fancy needlework pictures, needlework chair seats and elaborate crewel work for bed hangings and curtains. The designs of these textile efforts frequently relate directly to the social, historical, and political currents of American life.

While many 19th century families living in cities and towns could and did afford imported floor coverings, the preponderance of handcrafted rag hooked rugs in rural households during that period is well documented. The hooked rug was executed on a loose burlap backing with a pattern drawn or stenciled on it. Cut-up rags and remnants of unused fabric provided the materials for creating the design. Hooked rugs were created in great variety – some were pictorial, others purely abstract. Many were executed in a manner that would recall imported Oriental carpets.

Another popular floor covering was the braided rag rug, which was also made from bits of salvaged material. These bright, bold, decorative pieces provided a degree of liveliness in many American homes in the 19th century.

The folk arts – from painting to potterymaking, from basket-weaving to needlework, from furniture-making to weathervanes and whirligigs – all have their roots in the craft traditions.

It is the eye of the artist directing the hand of the craftsman that gives it the aesthetic validity.[13]

[8] Trollope, Frances. *Domestic Manners of the Americans.* Donald Smalley, ed. New York: Vintage Books, 1949, p. 414.

[9] Holstein, Jonathan. *The Pieced Quilt: An American Design Tradition.* Greenwich, Conn.: New York Graphic Society, Ltd., 1973, pp. 7-8.

[10] Trollope. *Domestic Manners of the Americans.* p. 416.

[11] "The Quilting at Miss Jones's," *Godey's Lady's Book,* January 1868.

[12] Rawson, Marion Nicholl. *When Antiques Were Young.* New York: E. P. Dutton & Co., Inc., 1931, p. 129.

[13] Lipman, Jean and Winchester, Alice. *The Flowering of American Folk Art 1776-1876.* New York: The Viking Press in cooperation with the Whitney Museum of American Art, 1974, p. 14.

111
Braided Rug
Unidentified Shaker
New York State; late 19th century
Cotton and wool, 44″ diam. (111.7 cm)
Promised gift of Robert Bishop. P1.1981.3

Braided Shaker rugs are distinctive for their bright
colors and for their fine craftsmanship. This
example remains bright and fresh. The Shakers
made and used rugs of this type for use within the
community. They also sold them to visitors in shops
which dealt with the outside "world."

112
Hooked Rug
Artist unknown
New England; mid-19th century
Wool and cotton on burlap, 105½ × 109″
 (268 × 276.9 cm)
Anonymous gift. 1978.32.1

Floral hooked rugs were especially popular during
the second half of the 19th century in rural America.
This outstanding example is noted for its size and
beautiful overall design.

121

113
Sampler
Hannah Staples
Connecticut; 1786
Silk threads on linen, sight: $10\frac{3}{4} \times 10\frac{5}{8}''$
 $(27.3 \times 27$ cm)
Gift of Louise Nevelson and Mike Nevelson.
 1978.31.19

Working samplers provided young women with
many skills. They learned a variety of plain and
fancy stitches that could be used for family sewing.

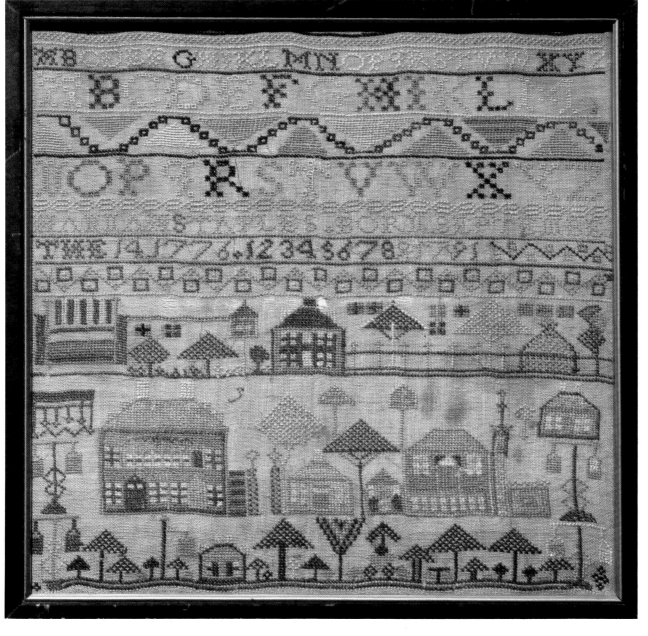

114
Thread Painting: "Trapped"
Mary K. Borkowski
Dayton, Ohio; 1968
Cotton and silk threads on polyester,
 sight: $26\frac{3}{4} \times 32\frac{1}{2}''$ (67.9 × 82.5 cm)
Gift of Jacqueline L. Fowler. 1981.2.2

Borkowski is among America's leading 20th century
needlewomen. In her early years she executed many
extraordinary quilts. As a mature artist she turned
to "thread painting" or needlework pictures.
This example details a burning house.

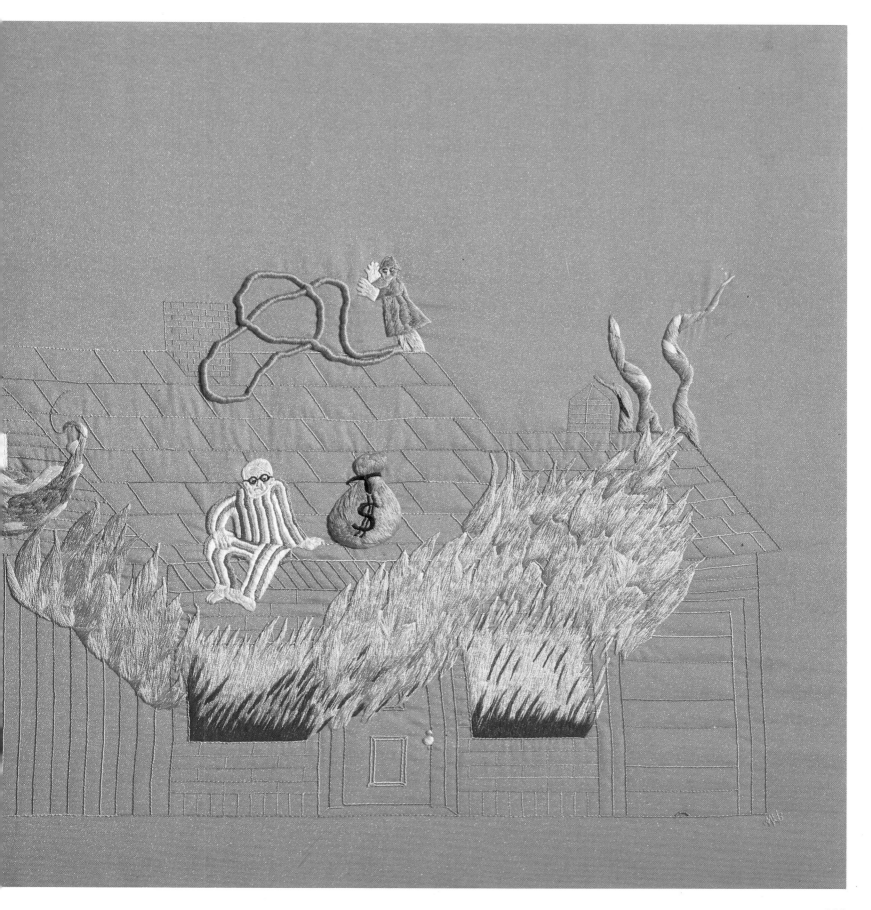

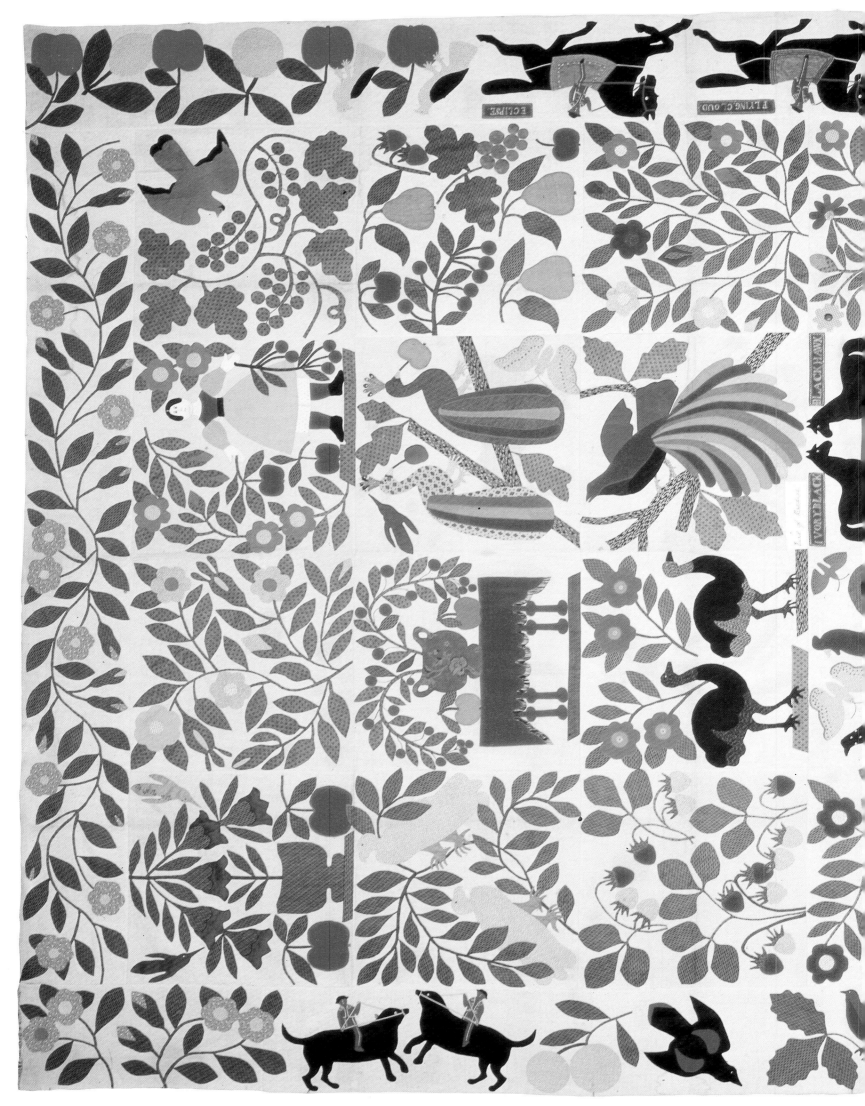

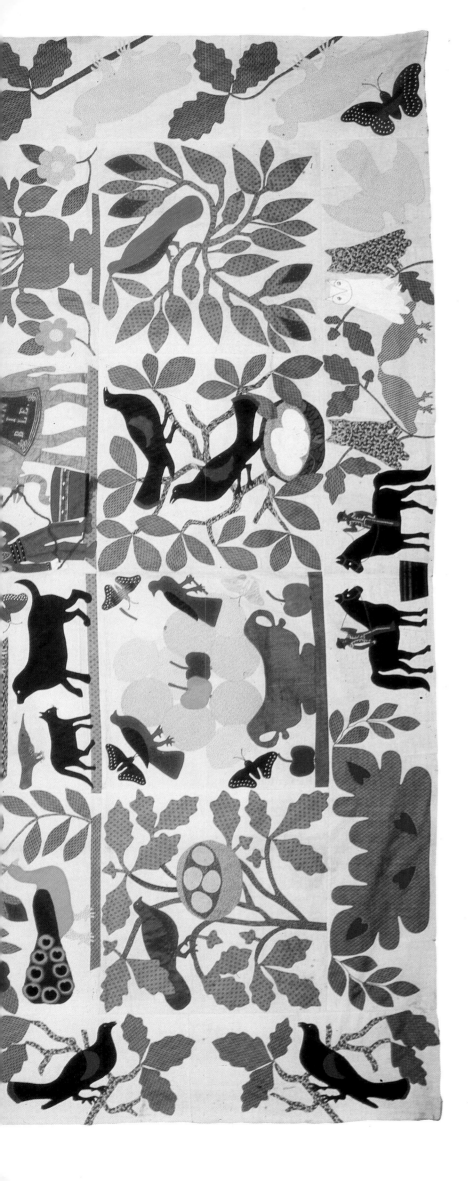

115
Bride's Quilt Top—"Bird of Paradise"
Artist unidentified
Albany area, New York State; 1858-63
Appliquéd cotton, wool, silk and velvet on muslin,
sight: $84\frac{1}{2} \times 69\frac{5}{8}$" (214.6 × 176.8 cm)
*Gift of the Trustees of the Museum of American
Folk Art. 1979.7.1*

The Bird of Paradise quilt top is a splendid example
of an appliquéd quilt. Each of the beautiful animals,
birds and flowers were cut and sewn onto the quilt
top. Because of the skillful design and vivid color,
this quilt top is considered one of the great
masterpieces of American needlework art. The
cover was never backed or quilted. The words
"Birds of Paradise" appear near the center below
a brilliantly colored bird of the same name.

116
**Portrait of the unknown needlewoman
believed to have stitched the
"Bird of Paradise" bride's quilt top**
Photographer unknown
New York State; 1858-63
Photograph in case, sight: $1\frac{3}{4} \times 1\frac{3}{8}$" (4.5 × 3.5 cm)
*Gift of the Trustees of the Museum of
American Folk Art. 1979.7.3*

125

117
**Patterns for "Bird of Paradise" Bride's
 Quilt Top**
Artist unknown
New York State; 1858-63
Cut and pinned newspaper and paper,
 Bride: $10\frac{1}{8} \times 7''$ (25.7 × 17.8 cm);
 Bridegroom: $10\frac{3}{4} \times 8''$ (27.3 × 20.3 cm);
 Elephant: $7\frac{3}{8} \times 9\frac{3}{8}''$ (18.7 × 23.8 cm)
*Gift of the Trustees of the Museum of
 American Folk Art. 1979.7.2a-k*

The newspaper patterns were used to create the
appliquéd designs on the quilt top. Most of the
animals and birds appear in pairs. Among the paper
patterns is one for the figure of a man which
matches the appliquéd form of the woman who
appears in the upper right portion of the quilt top.
The man's form was never appliquéd to the work
nor was the quilt completed. These factors
probably indicate that the maker never married.
Perhaps her intended husband was lost in the War
between the States.

118
Sunburst Quilt
Possibly Rebecca Scattergood Savery
Philadelphia, Pennsylvania; 1835-40
Pieced cotton chintz, $118\frac{1}{2} \times 125\frac{1}{8}''$
 $(301 \times 317.6$ cm)
Gift of Marie D. and Charles A. T. O'Neill.
 1979.26.2

This pieced quilt was created by sewing small pieces
of fabric together to create an overall pattern.
Pieced quilts were considered utilitarian and used
as an everyday bedcover. The small floral or
scroll fabrics in diamond shaped pieces radiate from
the center of an eight-pointed star to the quilt's
outer edge, creating a dramatic effect. The maker
of this quilt was very skilled, not only in the precise
way she cut and stitched the sunburst, but in the
placement of the ligher colored fabrics to accentuate
her design.

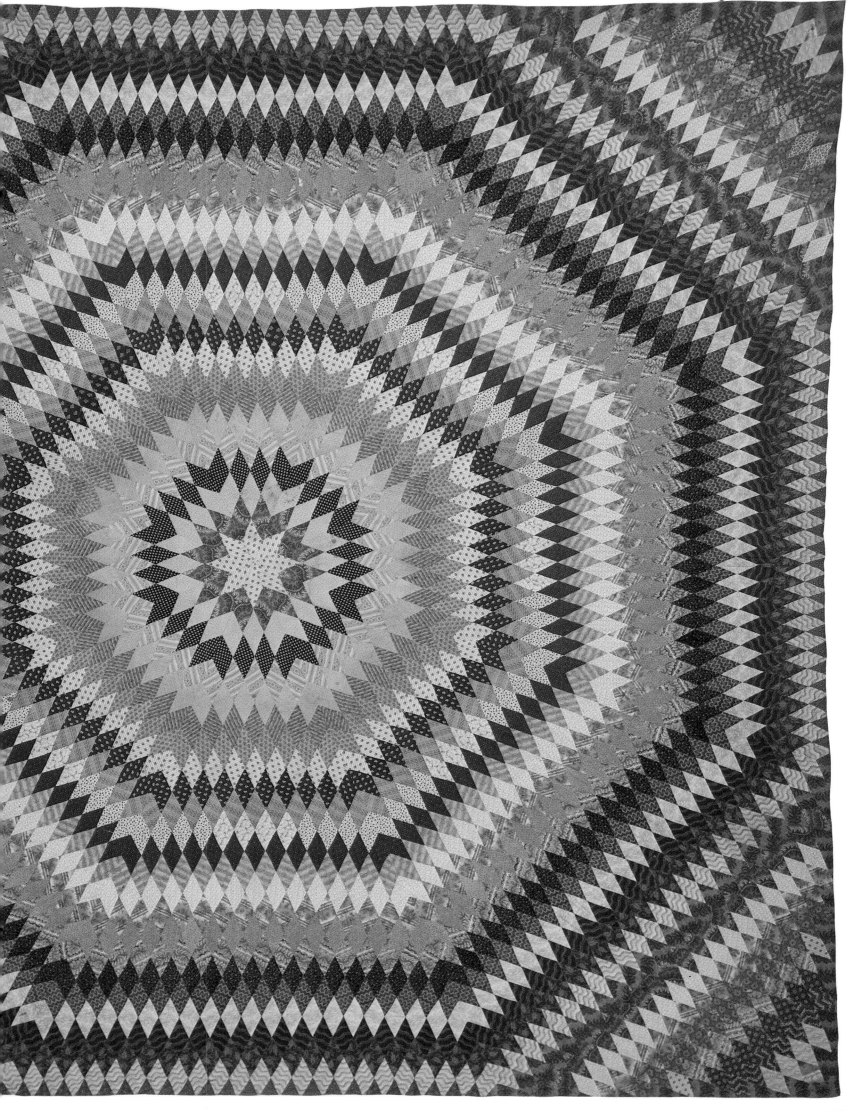

119
Bedspread
Artist unknown
New England; 1825-33
Stenciled cotton, 91¾ × 86″ (232.9 × 218.4 cm)
Gift of George E. Schoellkopf. 1978.12.1

During the first half of the 19th century, stenciled
bedspreads became popular. These summer
bedcovers were made without a backing and lining;
therefore, they are unquilted. The flower and fruit
still life designs used by young ladies for "theorem"
paintings stencilled on velvet or paper were
utilized by the bedcover stenciler as well.

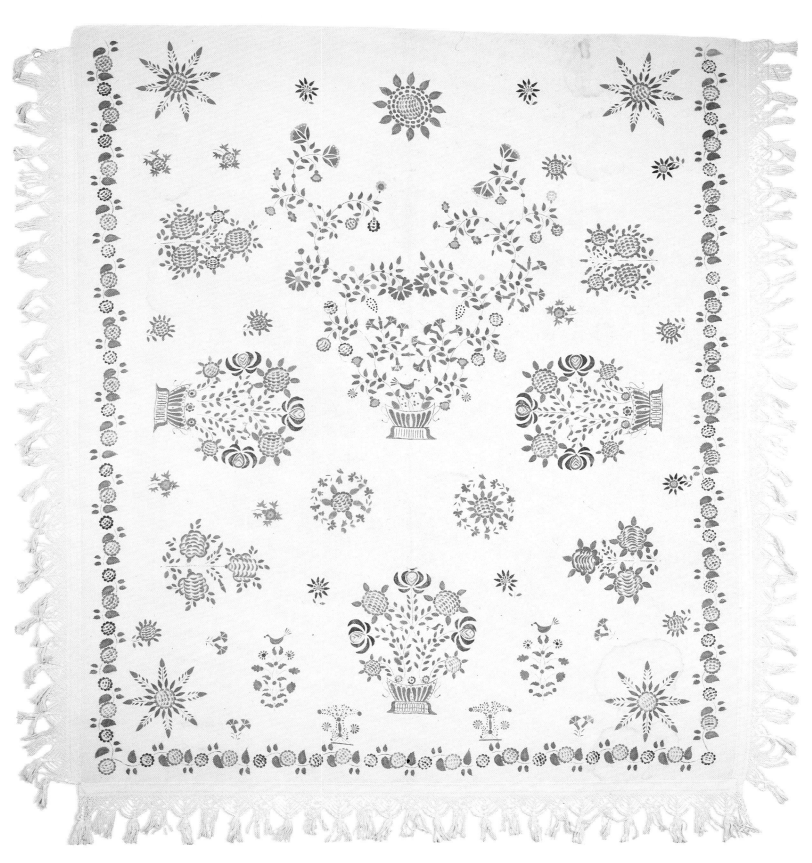

120
Tablecloth
Artist unknown
Found in Connecticut; c. 1825
Stenciled cotton, $40\frac{1}{4} \times 49\frac{1}{4}''$ (102.2 × 125.1 cm)
Museum of American Folk Art purchase. 1981.12.23

Fabrics stenciled with watercolor from the early
19th century are extremely rare for they could not
be laundered. This example incorporates an oak
leaf motif which was also popular with American
quilt makers.

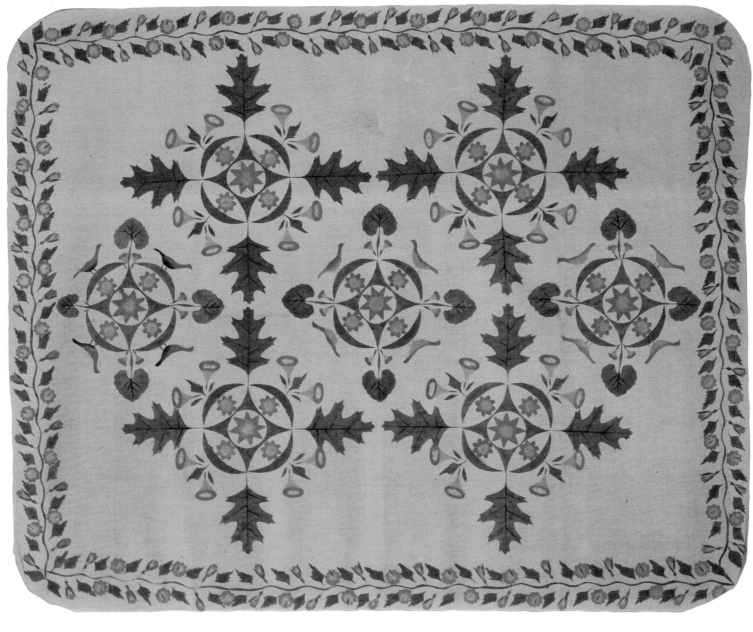

121
Candlewick Spread, initialled "AFX"
Artist unknown
New York; 1832
Woven cotton, 85 × 79¾″ (216 × 202.4 cm)
Promised gift of Jay Johnson. P3.1980.1

This woven candlewick spread was crafted of thick
cording or "roving" similar to the wicks used in
making candles. Woven candlewicks made at home
or by itinerant weavers were popular during the
second quarter of the 19th century. This spread
was made from threads of uniform size and has a
stepped square in the center surrounded by a
series of borders. The same motifs found in
patchwork quilts—pine trees, eight pointed stars
and stylized flowers and urns are found in this
spread as well.

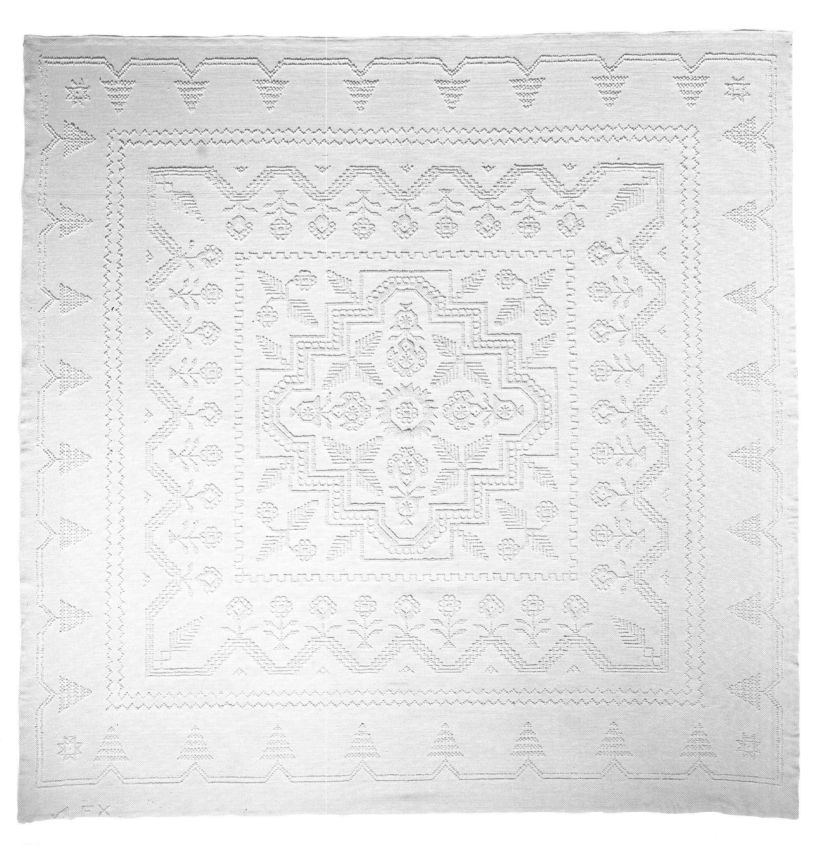

Quilt: Friendship Album Pattern
Sewing Society of the Methodist Episcopal Church,
Elizabethport, New Jersey; 1852
Appliquéd cotton, $99\frac{1}{4} \times 100''$ (252.1 × 253.8 cm)
Gift of Phyllis Haders. 1980.1.1

The various signed blocks in this album quilt
include a church, Bible, and floral and animal
motifs, in solids and large floral patterns on a
white background. The blocks were executed
by the women of the Sewing Society of the
Methodist Episcopal Church and assembled as a
present for Mr. and Mrs. Dunn, missionaries in
the South Pacific.

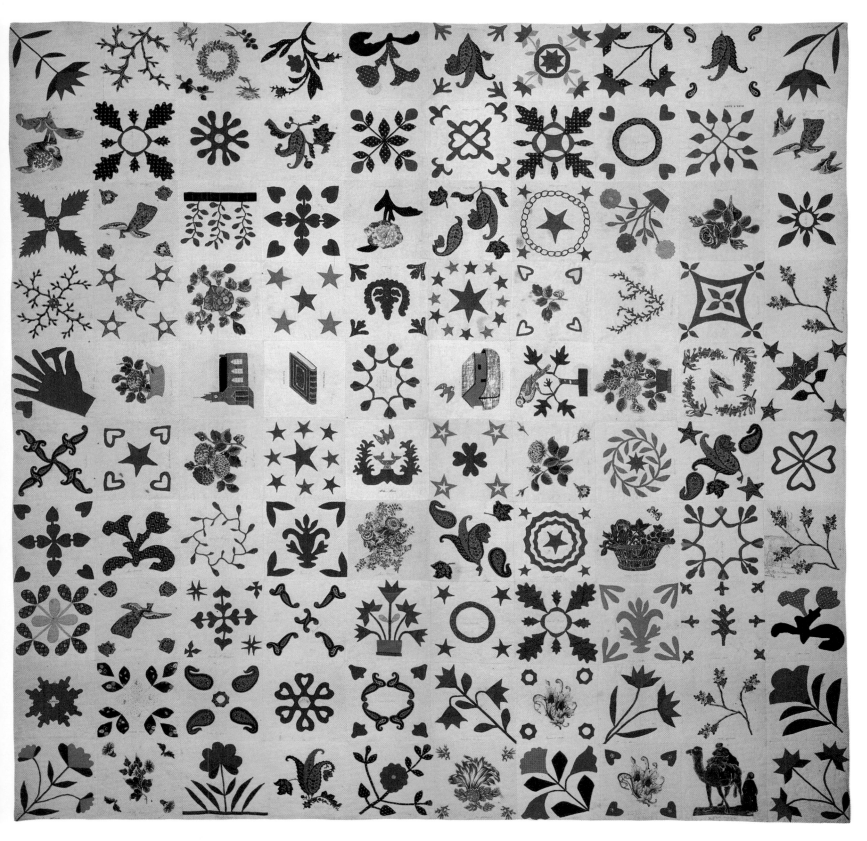

123
Coverlet: "Hemfield Railroad"
Possibly Daniel Campbell
Pennsylvania; c. 1856
Double weave Jacquard wool, $90\frac{1}{4} \times 81''$
 (229.5 × 205.6 cm)
Gift of Stephen L. Snow. 1980.13.1

Joseph Jacquard, a French weaver, invented a sophisticated type of loom that arrived in America in the early 19th century. It was operated by hand and featured a flying shuttle attachment. The attachment could be added to looms already in use and made it possible to create large unseamed coverlets with handsome and complicated patterns. Elaborate borders became a distinguishing feature of this type of bedcover. Weavers could now include information about the owner and sign the piece as well. This double weave jacquard coverlet is a rare example; only a few examples are known to exist. It commemorates the opening of the Hempfield Railroad. The profile in the corners is believed to be a portrait of the first president, T. McKennan. Weavers who are known to have made Hempfield Railroad coverlets are Daniel Campbell, William Harper, Martin Burns, George Coulter and Harvey Cook.

124
Quilt: "Centennial"
G. Knappenberger
Probably Pennsylvania; 1876
Pieced and appliquéd cotton, $71\frac{1}{2} \times 83\frac{1}{2}''$
 (181.5 × 212.1 cm)
Gift of Rhea Goodman. 1979.9.1

This pieced and appliquéd quilt was made to
commemorate America's Centennial celebration.
It most likely was executed by an artist from
Pennsylvania. Hearts and flowers are appliquéd
onto the quilt and are favorite motifs of the region.

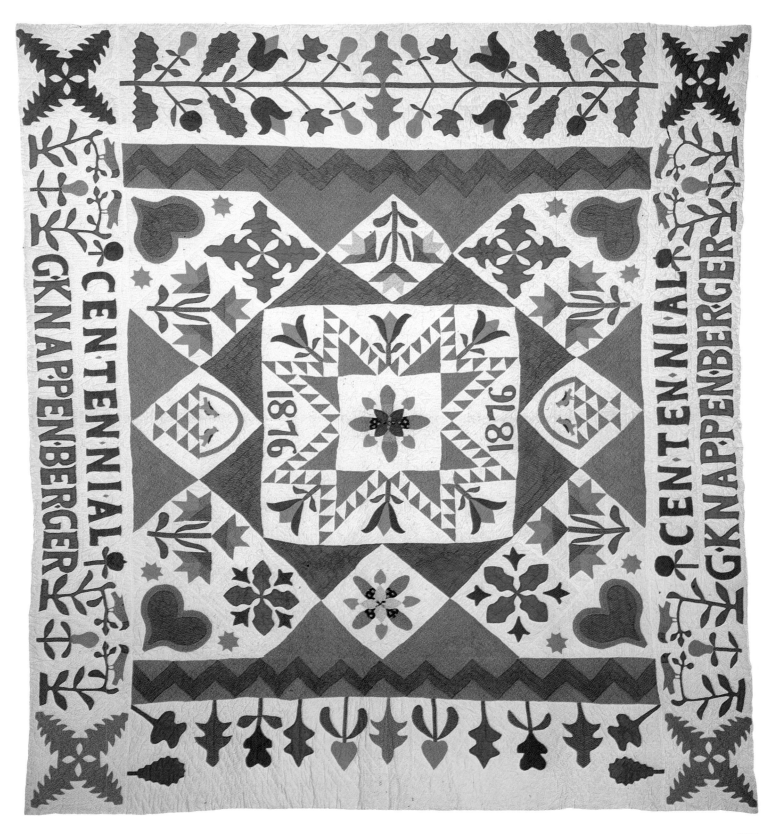

125
Quilt Top: Geometric Pattern
Artist unknown
Massachusetts; 1870-80
Pieced cotton and chintz, 90½ × 90½
 (229.8 × 229.8 cm)
Promised gift of Cyril I. Nelson. P77.402.2

This quilt is a marvelous combination of color,
geometric design and craftsmanship. The artist
cut fabric into squares, triangles, diamonds and
rectangles, then stitched them together to create an
overall pattern.

126
Quilt: Mariner's Compass Pattern
Artist unknown
Maine; c. 1885
Appliquéd and pieced cotton, hand-quilted,
$88\frac{1}{8} \times 83\frac{3}{8}''$ (223.8 × 211.8 cm)
Promised gift of Cyril I. Nelson. P77.402.1

The nautical design is carried out not only in the central compass, but also in the blue cotton with its tiny white anchors. Two corner patches are initialed *B.B.*

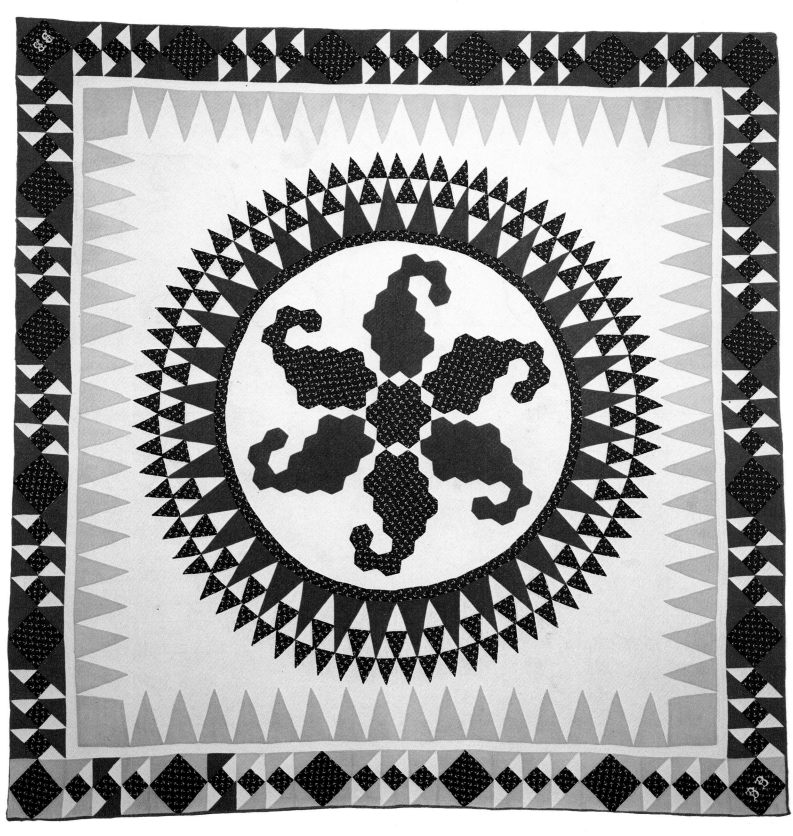

127
Crib Quilt: "Baby"
Artist unknown
Kansas; c. 1861
Pieced, appliquéd and embroidered hand-dyed
 home-spun cotton, $36\frac{7}{8} \times 36\frac{3}{4}''$
 (93.6 × 93.3 cm)
Gift of Phyllis Haders. 1978.42.1

Pieced and appliquéd, hand dyed homespun
cotton. *Baby* is embroidered in white in the center
of the blue five-pointed star. Patriotic symbols were
always popular with American quilt makers.

128
Crib Quilt: "Gingham Dog and Calico Cat"
Artist unknown
Probably Pennsylvania; c. 1910
Appliquéd and pieced cotton, embroidered and
 hand-quilted, $34\frac{5}{8} \times 28\frac{3}{8}''$ (87.9 × 72 cm)
Gift of Gloria List. 1979.35.1

The design of this crib quilt includes the
nursery rhyme:
 *THE GINGHAM DOG WENT
 'BOW WOW-WOW'."
 THE CALICO CAT REPLIED "ME-OW"*

129
Quilt: Center Diamond Pattern
Artist unknown
Lancaster County, Pennsylvania; c. 1910
Pieced wool, hand-quilted, 84 × 80½″
 (213.5 × 204.4 cm)
Gift of Paige Rense. 1981.4.1

The earliest Amish quilts from Pennsylvania are usually geometric in design, reflecting the extreme conservative nature of the sect. Quilts from the Western Amish communities tend to be more flamboyant and on occasion incorporate representational elements.

130
Quilt; Tumbling Blocks
Mrs. Ed. Lantz
Elkhart, Indiana
c. 1910
Pieced and hand-quilted wool and cotton,
 wool backing, 81 ¾ × 67″ (206.7 × 170.2 cm)
Gift of David Pottinger. 1980.37.62

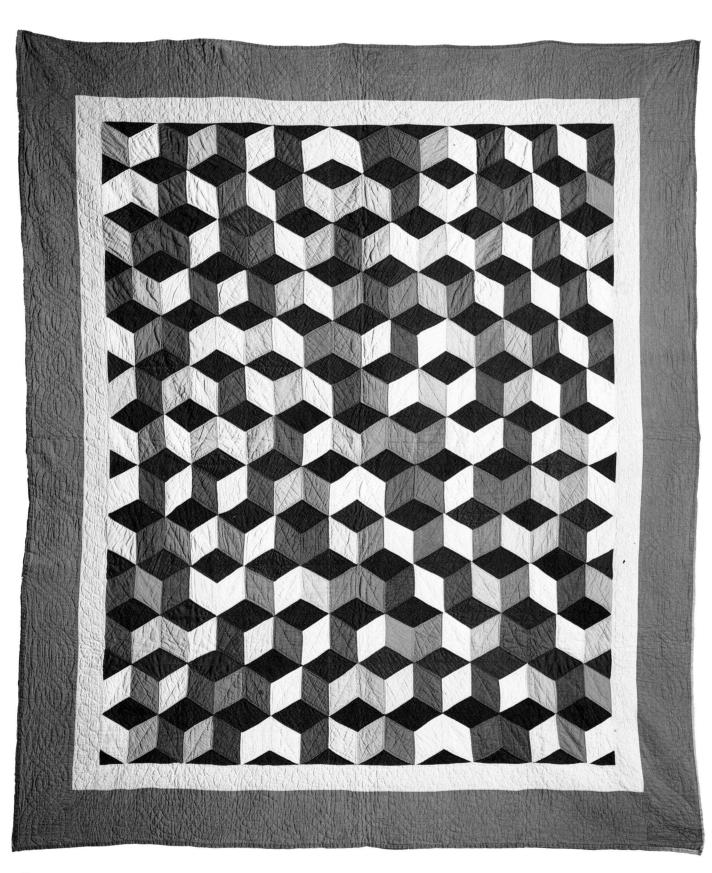

131
Quilt; Chinese Coins
Mrs. Sarah Miller
Haven, Kansas
c. 1935
Pieced and hand-quilted cotton
$82\frac{5}{8} \times 62\frac{3}{4}''$ (209.7 × 159.4 cm)
Gift of David Pottinger. 1980.37.1

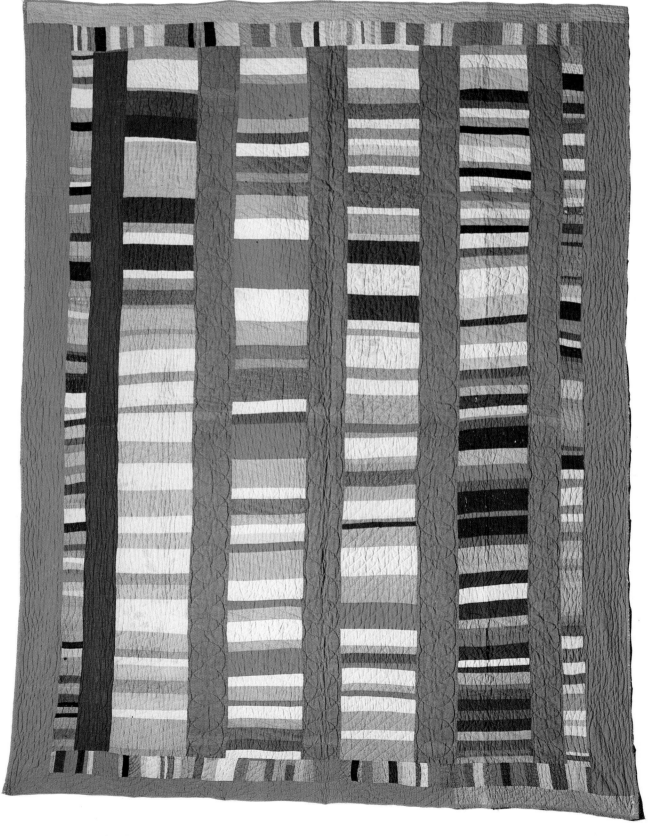

132
Quilt: Sailboat Pattern
Amanda Lehman
Topeka, Indiana; c. 1960
Pieced cotton, hand-quilted, $87\frac{1}{2} \times 72\frac{3}{4}''$
 (222.2 × 184.7 cm)
Gift of David Pottinger. 1980.37.26

Toward the end of the 19th century the Amish
needlewoman began to fashion her bedcovers of
cotton, a fabric which had become available in a
far greater range of colors than the wool which
she had used almost exclusively previously.
Amish women continue to make quilts today.

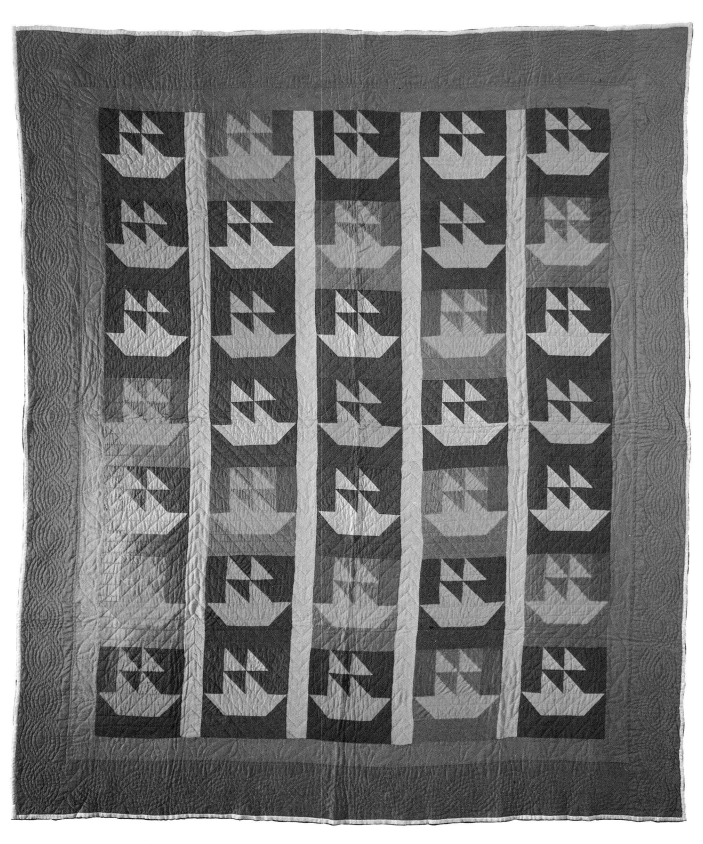

Adams, Ruth. *Pennsylvania Dutch Art*. Cleveland, Ohio: World Publishing Co., 1950.

American Federation of Arts. *101 Masterpieces of American Primitive Painting*. New York: The American Federation of Arts, 1961.

Ames, Kenneth L. *Beyond Necessity, Art in the Folk Tradition*. Winterthur, Delaware: Henry Francis DuPont Winterthur Museum, 1977.

Andrews, Edward D. *Religion in Wood, A Book of Shaker Furniture*. Bloomington, Indiana: University Press, 1971.

—— *Shaker Furniture*. New Haven, Conn.: Yale University Press, 1957.

Andrews, Ruth, ed. *How to Know American Folk Art*. New York: E. P. Dutton, 1977.

Barber, Edwin Atlee. *Tulipware of the Pennsylvania German Potters*. Philadelphia: Philadelphia Museum and School of Industrial Arts, 1926.

—— *Pottery and Porcelain of the United States*. New York: Putnam, 1909.

—— Barbar, Joel. *Wild Fowl Decoys*. New York: Dover Publications, Inc. 1954.

Barrett, Richard Carter. *Blown and Pressed American Glass*. Manchester, Vt.: Forward Publishing, 1966.

Bestor, Arthur. *Backwoods Utopias The Sectarian Origins and the Owenite Phase of Communitarian Socialism in America: 1663-1829*. Philadelphia: University of Pennsylvania Press, 1950.

Bishop, Robert and Coblentz, Patricia L. *A Gallery of American Weathervanes and Whirligigs*. New York: E. P. Dutton & Co., 1981.

—— *Folk Painters of America*. New York: E. P. Dutton & Co. Inc., 1979.

—— *New Discoveries in American Quilts*. New York: E. P. Dutton, & Co., Inc. 1975.

—— *American Folk Sculpture*. New York: E. P. Dutton & Co., Inc., 1974.

—— *American Folk Sculpture*. New York: E. P. Dutton & Co., Inc., 1974.

—— How to Know American Antique Furniture.

—— *How to Know American Antique Furniture*. New York: E. P. Dutton & Co., Inc., 1973.

—— and Safanda, Elizabeth. *A Gallery of Amish Quilts*. New York: E. P. Dutton & Co., Inc., 1976.

Black, Mary, and Lipman, Jean. *American Folk Painting*. New York: Clarkson N. Potter, Inc., 1966.

Blair, Claude. *European and American Arms, 1100-1850*. New York: Bonanza Books, 1962.

Blum, Stella. *Victorian Fashions & Costumes from Harper's Bazaar: 1869-1898*. New York: Dover Publications, Inc., 1974.

Borneman, Henry S. *Pennsylvania German Bookplates*. N.P.: Pennsylvania German Folklore Society, 1953.

—— *Pennsylvania German Illuminated Manuscripts*. N.P.: Pennsylvania German Folklore Society, 1937.

Boston Museum of Fine Arts. *M. & M. Karolik Collection of American Water Colors and Drawings*. Boston: Boston Museum of Fine Arts, 1962.

Brazer, Ester S. *Early American Decoration*. Springfield, Massachusetts: The Pond-Ekberg Company, 1940.

Brooklyn Museum. *Popular Art in America*. Brooklyn, New York: Brooklyn Museum, 1939.

Camposantos. Fort Worth. Amon Carter Museum of Art, 1966.

Carlisle, Lilian Baker. *18th and 19th Century American Art at Shelburne Museum*. Shelburne, Vermont: Shelburne Museum, 1961.

—— *Hat Boxes and Band Boxes at Shelburne Museum*. Shelburne, Vermont: Shelburne Museum, 1960.

—— *Pieced Work and Applique Quilts at Shelburne Museum*. Shelburne, Vermont: Shelburne Museum, 1957.

Christensen, Erwin O. *The Index of American Design*. New York: the McMillan Company, 1958.

—— *Popular Art in the United States*. London, England: Penguin Books, 1948.

Cooke, Lawrence S., ed. *Lighting in America from Colonial Rushlights to Victorian Chandeliers*. Antiques Magazine Library/Maine Street Universe Books, 1975.

Craven, Wayne. *Sculpture in America*. New York: Thomas Y. Crowell Co., 1968.

Davidson, Marshall B. *American Heritage History of Antiques from the Civil War to World War I*. New York: American Heritage Publishing Co., 1969.

—— *American Heritage History of American Antiques from the Revolution to the Civil War*. American Heritage Publishing Co., 1968.

—— *American Heritage History of Colonial Antiques*. New York: American Heritage Publishing Co., 1967.

Davis, Mildred J. *Early American Embroidery Designs*. New York: Crown Publishers, 1969.

Davison, Mildred, and Mayer-Thurman, Christa C. *Coverlets*. Chicago: The Art Institute of Chicago, 1973.

Hooked Rugs in the Folk Art Tradition. New York: Museum of American Folk Art, 1974.

Dewhurst, C. Kurt, MacDowell, Betty, and MacDowell, Marsha. *Artists in Aprons, Folk Art by American Women*. New York: E. P. Dutton, 1979.

Dilliard, Maud Esther. *An Album of New Netherland*. New York: Bramhall House, 1963.

Distin, William, and Bishop, Robert. *The American Clock*. New York: E. P. Dutton and Co., Inc., 1976.

Downs, Joseph. *Pennsylvania German Arts and Crafts*. New York: Metropolitan Museum of Art, 1949.

—— *The House of the Miller at Millbach*. N.P.: Pennsylvania German Folklore Society, 1929.

Drepperd, Carl W. *Pioneer America, Its First Three Centuries*. Garden City, N.Y.: Doubleday and Company, 1949.

—— *American Pioneer Art and Artists*. Springfield, Massachusetts: Pond-Ekberg Publishing Company, 1942.

Earle, Alice Morse. *Two Centuries of Costume in America 1620-1820*. 2 vols. New York: Dover Publication, Inc., 1970. (reprint of 1903 publication).

Early Texas Furniture and Decorative Arts. N.P.: Trinity Press, 1973.

Earnest, Adele. *The Art of the Decoy*. New York: Clarkson N. Potter, Inc., 5.

Ebert, John, and Ebert, Katherine. *American Folk Painters*. New York: Charles Scribner's Sons, 1975.

Ericson, Jack T., ed. *Folk Art in America, Painting and Sculpture*. New York: Mayflower Books, Inc., 1979.

Fales, Dean A. and Bishop, Robert. *American Painted Furniture 1660-1880*. New York: E. P. Dutton Publishing Company, 1972.

Fales, Martha Gandy. *American Silver in the Henry Francis DuPont Winterthur Museum*. Winterthur, Delaware: Winterthur Museum, 1958.

Fennelly, Catherine. *Textiles in New England, 1790-1840*. Sturbridge, Massachusetts: Old Sturbridge Village, 1961.

Fitzgerald, Ken. *Weathervanes and Whirligigs*. New York: Clarkson N. Potter, Inc., 1967.

Flayderman, E. Norman. *Scrimshaw and Scrimshanders*. New Milford, Connecticut: N. Flayderman & Co., Inc., 1972.

Flower, Milton E. *Wilhelm Schimmel and Aaron Mountz*. Williamsburg, Virginia: Abby Aldrich Folk Art Collection, 1965.

Ford, Alice. *Edward Hicks*. Philadelphia, Pennsylvania: University of Pennsylvania Press, 1952.

—— *Pictorial American Folk Art, New England to California*. New York: Studio Publications, 1949.

Fried, Frederick. *Artists in Wood*. New York: Clarkson N. Potter, Inc., 1970.

—— *A Pictorial History of the Carousel*. New York: A. S. Barnes and Company, 1964.

Fuller, Edmund L. *Visions in Stone*. Pittsburgh: University of Pittsburgh Press, 1973.

Gould, Mary Earle. *The Early American House*. Rutland, Vermont: Charles E. Tuttle Co., 1965.

—— *Early American Wooden Ware and Other Kitchen Utensils*. Springfield, Massachusetts: The Bond-Ekberg Company, 1942.

Gowans, Alan. *Images of American Living*. Philadelphia: J. B. Lippincott Company, 1964.

Guilland, Harold F. *Early American Folk Pottery*. Philadelphia: Chilton, 1971.

Haders, Phyllis. *Sunshine & Shadow*. New York: Universe Books, 1976.

Hausen, H. S. *European Folk Art in Europe and the Americas*. New York: McGraw Hill, 1968.

Hayward, Arthur H. *Colonial Lighting*. New York: Dover Publications, Inc., 1962.

Hemphill, Herbert W., Jr. *Folk Sculpture U.S.A.* New York: The Brooklyn Museum, 1976.

—— and Weissman, Julia. *Twentieth Century Folk Art and Artists*. New York: E. P. Dutton & Co., Inc., 1974.

Holstein, Jonathan. *The Pieced Quilt: An American Design Tradition*. New York: New York Graphic Society, 1973.

—— *American Pieced Quilts*. Washington, D.C.: Smithsonian Institution, 1972.

Hornung, Clarence P. *Treasury of American Design*. New York: Harry N. Abrams, Inc., N.D.

Hunter, Frederick William, A. M. *Stiegel Glass*. New York: Dover Publishing Co., 1950.

Janis, Sidney. *They Taught Themselves, American Primitive Painters of the 20th Century*. New York: Dial Press, 1942.

—— *Early American Ironware*. Camden, N.J.: Thomas Nelson, 1966.

—— *Pennsylvania Dutch American Folk Art*. New York: American Studio Books, 1946.

Ketchum, William C., Jr. *Early Potters and Potteries of New York State*. New York: Funk & Wagnalls, 1970.

Knittle, Rhea Mansfield. *Early Ohio Silversmiths and Pewterers, 1787-1847*. N.P.: Privately published, 1943.

—— *Early American Glass*. New York: Century Publishing Co., 1927.

Kopp, Joel and Kate. *American Hooked and Sewn Rugs*. New York: E. P. Dutton & Co., Inc., 1975.

Krueger, Glee. *A Gallery of American Samplers, The Theodore H. Kapnek Collection*. New York: E. P. Dutton in association with the Museum of American Folk Art, 1978.

Larkin, Oliver W. *Art and Life in America*. New York: Rinehart and Company, 1949.

Lichten, Frances. *Pennsylvania Dutch Folk Art from the Geesey Collection and Others*. New York: Metropolitan Museum of Art, 1958.

—— *Folk Art Motifs of Pennsylvania*. New York: Hastings House, 1954.

—— *Folk Art of Rural Pennsylvania*. New York: Charles Scribner's Sons, 1946.

Lipman, Jean. *American Folk Art in Wood, Metal and Stone*. Meriden, Conn.: Meriden Gravure Company, 1948.

—— *American Primitive Painting*. London, England: Oxford University Press, 1942.

—— and Meulendyke, E. *American Folk Decoration*. New York: Oxford University Press, 1951.

—— and Winchester, Alice. *The Flowering of American Folk Art 1776-1876*. New York: Viking Press, 1974.

—— *Primitive Painters in America, 1750-1950*. New York: Dodd Mead & Company, 1950.

Little, Nina F. *American Decorative Wall Painting 1700-1850*. New York: E. P. Dutton & Co., Inc., 1972.

—— *Floor Coverings in New England Before 1850*. Sturbridge, Massachusetts: Sturbridge Village, 1967.

—— *Abby Aldrich Rockefeller Folk Art Collection*. Williamsburg, Virginia, Colonial Williamsburg, 1958.

—— *The Abby Aldrich Rockefeller Collection*. Boston, Massachusetts: Little, Brown Company, 1957.

—— *American Decorative Wall Painting*. New York: Studio Publications, 1952.

Lord, Priscella S., and Foley, Daniel J. *The Folk Arts and Crafts of New England*. Philadelphia, Pennsylvania: Chilton Books, 1965.

Mackey, William. *American Bird Decoys*. New York: E. P. Dutton & Co., Inc., 1965.

Meader, Robert F. W. *Illustrated Guide to Shaker Furniture*. New York: Dover Publications, 1972.

Mercer, Henry C. *The Bible in Iron*. Doylestown, Pennsylvania: Bucks County Historical Society, 1961.

Metropolitan Museum of Art. *Pennsylvania German Arts & Crafts, a Picture Book*. New York: Metropolitan Museum of Art, 1946.

Montgomery, Charles F. *A History of American Pewter*. New York: Praeger Publishers, 1973.

Montgomery, Florence M. *Printed Textiles: English and American Cottons and Linens, 1700-1850*. New York: Viking Press, Inc., 1970.

Montgomery Ward and Company. *Catalogue and Buyers' Guide No. 57 Spring and Summer 1895*. Reprint. New York: Dover Publications, Inc., 1969.

Morton, Robert. *Southern Antiques & Folk Art*. Birmingham, Alabama: Oxmoor House, Inc., 1976.

Museum of Modern Art. *American Folk Art: The Art of the Common Man in America 1750-1900*. New York: Museum of Modern Art, 1932.

National Gallery of Art. *American Primitive Paintings*. Vols I and II. Washington, D.C.: National Gallery of Art, 1954.

Newark Museum. *American Folk Sculpture*. Newark, New Jersey: The Newark Museum, 1931.

Orlofsky, Patsy and Myron. *Quilts in America*. New York: McGraw-Hill Book Co., 1974.

Pendergast, A. W. and Ware, W. Porter. *Cigar Store Figures*. Chicago, Illinois: The Lightner Publishing Company, 1953.

Peters, Harry T. *Currier & Ives, Printmakers to the American People*. Garden City, N.Y.: Doubleday, Doran & Co., Inc., 1942.

Peterson, Harold L. *Americans at Home*. New York: Charles Scribner's Sons, 1971.

—— *Encyclopedia of Firearms*. New York: E. P. Dutton & Co., Inc., 1964.

—— *American Knives*. New York: Charles Scribner's Sons, 1958.

—— *Arms and Armor in Colonial America, 1526-1783*. Harrisburg, Pennsylvania: Stackpole Company, 1956.

Philadelphia Museum of Art. *Pennsylvania Dutch Folk Art from the Geesey Collection and Others*. Philadelphia: Philadelphia Museum of Art, 1958.

Ramsey, John. *American Potters and Pottery*. New York: Tudor Publishing, 1939.

Roth, Rodris. *Floor Coverings in 18th Century America*. United States National Museum Bulletin 250, paper 59. Washington, D.C.: Smithsonian Institution, 1967.

Rushlight Club, The. *Early Lighting: A Pictorial Guide*. Hartford, Connecticut: The Findlay Bros. Publishing, 1972.

Safford, Carleton and Bishop, Robert. *America's Quilts and Coverlets*. New York: E. P. Dutton & Co., Inc., 1972.

Sears, Clara E. *Some American Primitives*. New York: Houghton Mifflin and Company, 1941.

Shelley, Donald A. *The Fraktur Writings or Illuminated Manuscript of the Pennsylvania Germans*. N.P.: Pennsylvania German Folklore Society, 1959.

Smith, Elmer L., Stewart, John C., and Kyger, M. Ellsworth. *The Pennsylvania Germans of the Shenandoah Valley*. N.P.: Pennsylvania German Folklore Society, 1964.

Sonn, Albert H. *Early American Wrought Iron*. New York: Charles Scribner's Sons, 1928.

Spargo, John. *Early American Pottery and China*. New York: Century Publishing Company, 1926.

Stoudt, John J. *Early Pennsylvania Arts and Crafts*. New York: A. S. Barnes Publishing, 1964.

Swank, James M. *History of the Manufacture of Iron in All Ages*. Philadelphia American Iron and Steel Association, 1892.

Thwing, Leroy L. *Flickering Flames: A History of Domestic Lighting Through the Ages*. Rutland, Vermont: Charles E. Tuttle Co., 1958.

Trollope, Mrs. Frances. Donald Smalley, ed. *Domestic Manners of the Americans*. New York: Vintage Books, 1949.

Van Rensselaer, Stephen. *Early American Bottles and Flasks*. Peterborough, New Hampshire: New York Transcript Printing Company, 1926.

Waring, Janet. *Early American Stencils on Walls and Furniture*. New York: William R. Scott, 1937.

Warren, William L. *Bed Ruggs 1722-1833*. N.P.: Wadsworth Atheneum, 1972.

Watkins, Lura Woodside. *Early New England Potters and Their Wares*. Cambridge, Massachusetts: Harvard University Press, 1950.

Webster, David Blaker. *Decorated Stoneware Pottery of North America*. Rutland, Vermont: Tuttle, 1971.

Webster, David S. and Kehoe, William. *Decoys at Shelburne Museum*. Shelburne, Vermont: Shelburne Museum, 1961.

Welch, Peter C. *American Folk Art*. Washington, D.C.: Smithsonian Institution, 1965.

Library of Congress, Catalog Card Number 83–60191
ISBN 0912161 83 1

© Museum of American Folk Art, 1983
Designed by Derek Birdsall
Color prints by Quicksilver
Typesetting by CMS Typesetters
Reproduction by Peak Litho Plates
Printed in England by Penshurst Press

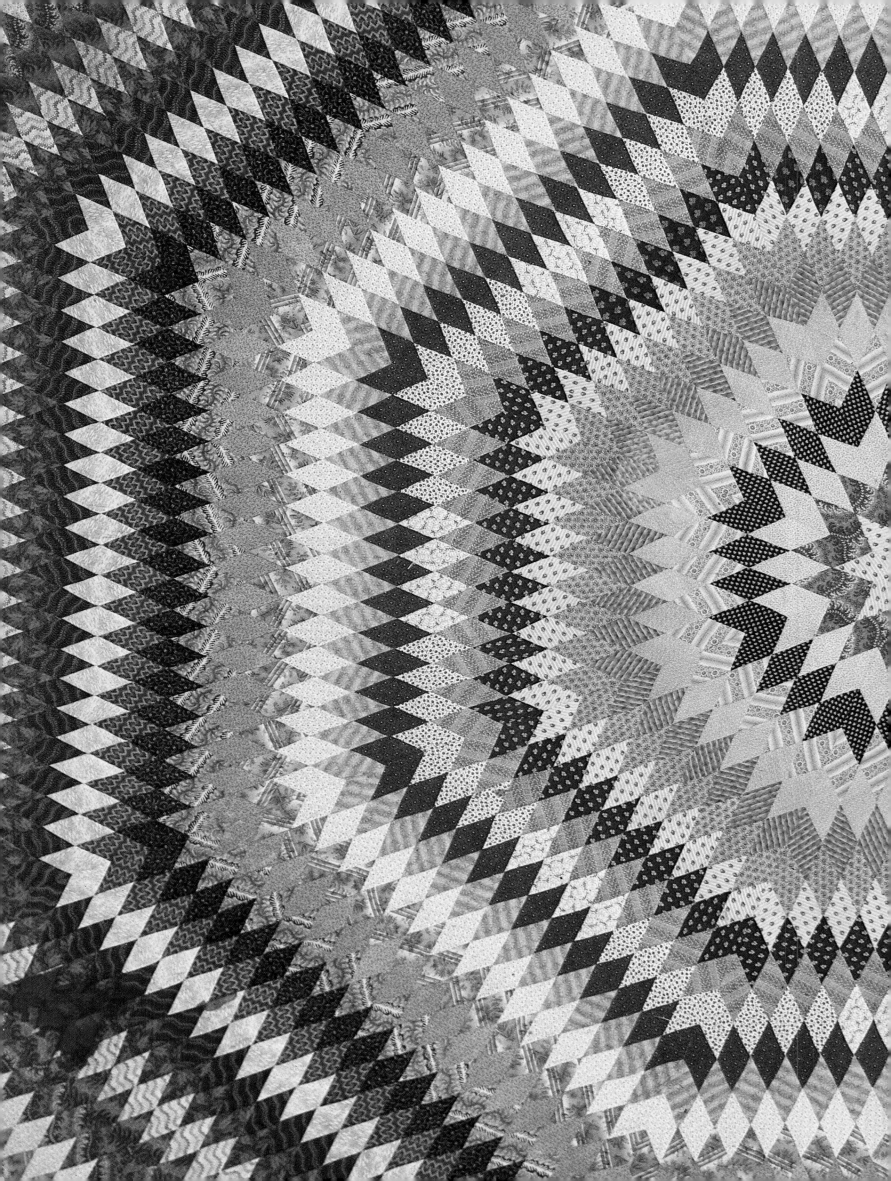